Edward Lucie-Smith
was born in Jamaica and educated at
Merton College, Oxford, where he read History.
Well known as a poet, novelist, biographer, broadcaster and
critic, he is the author of numerous books – among them
*The Thames & Hudson Dictionary of Art Terms, Furniture,
Movements in Art Since 1945, Symbolist Art*
and *Sexuality in Western Art* (all
in the World of Art).

Thames & Hudson world of art

This famous series
provides the widest available
range of illustrated books on art in all its aspects.
If you would like to receive a complete list
of titles in print please write to:
THAMES & HUDSON
181A High Holborn, London WC1V 7QX
In the United States please write to:
THAMES & HUDSON INC.
500 Fifth Avenue, New York, New York 10110

Printed in Singapore

Edward Lucie-Smith

Latin American Art
of the 20th Century

Second edition

178 illustrations,
45 in color

Thames & Hudson world of art

To Sylvia Condylis
of the Latin American Arts Association
who first fired my enthusiasm for Latin American art

Very many people have played a part in making this book possible. I owe
particular thanks to Ruth Benzacar, Rosa M. Brill, Jorge Glusberg, Jorge
and Marion Helft, and Alina Molinari (Argentina); Raquel Arnaud, Ana-Mae
Barbosa and Sheila Leirner (Brazil); David Gallagher, Pedro Labowitz and
Luz-María Williamson (Chile); Celia Sredni de Birbragher and Santiago
Cardenas Arroyo (Colombia); Feliciano Bejar and Martin Foley (Mexico);
Angel Kalenberg (Uruguay). Also to Clara Diamant Sujo (New York), the late
Dr Damian Bayon (Paris); and to Sylvia Condylis (and the staff of the Latin
American Arts Association), Raul Ortiz, Cultural Attaché at the Mexican
Embassy, and Ofelia Rodríguez in London.

First published in 1993 in paperback in the United States of America by
Thames & Hudson Inc., 500 Fifth Avenue, New York, New York 10110

thamesandhudsonusa.com

Second edition 2004

Library of Congress Catalog Card Number 2002109034
ISBN 0-500-20356-3

Printed and bound in Singapore by C.S. Graphics

Contents

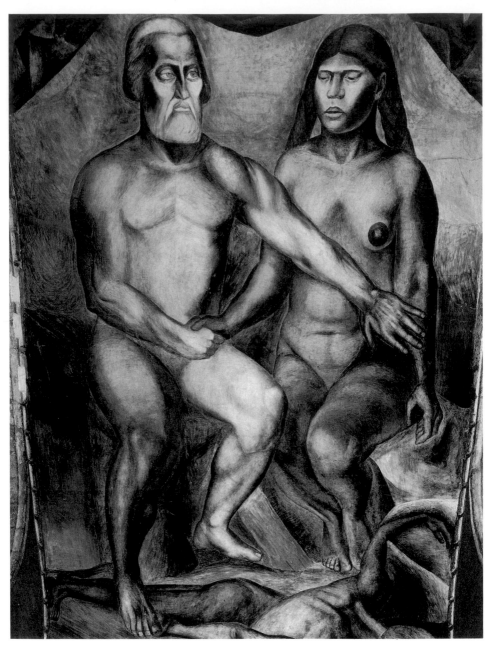

1 José Clemente Orozco *Cortés and Malinche*, from the Escuela Nacional
Preparatoria mural, Mexico City, 1926–7

Introduction

Until recently, the art of twentieth-century Latin America was undervalued by European and North American critics. It was denigrated as derivative, imitative of the mainstream Modernism of Western Europe and the United States. At the same time, it was dismissed as essentially hybrid, a fusion of traditions which was weaker than any of its progenitors. In the second of these accusations there is an implication of the racial prejudice which has marked the history of Latin America ever since the Spanish conquest of Mexico in the early sixteenth century. The mixture of races in Latin America is now extremely complex. Caucasian invaders soon interbred with the native American Indians – a process begun by Cortés himself, who had a son by his Indian interpreter and guide Malinche. The new Spanish and Brazilian dominions soon began to attract Jewish traders and merchants, who found a more liberal atmosphere there than in the Iberian peninsula. Both the Spanish and the Brazilian settlers started to import blacks from Africa as slaves. These too interbred with their white masters and also with the Indians. There was a significant influx, especially along the Pacific coast, of Chinese and Filipinos – the Philippines were also a Spanish possession and had become an important staging post between the Americas and the Far East. During the twentieth century, there was massive Japanese emigration to Brazil; as a result, São Paulo has become one of the largest Japanese cities in the world.

Nevertheless it is now beginning to be realized that it is precisely this hybridization which accounts for one of the strengths of Latin American art and which lies at the roots of its vitality, originality and constant power to surprise. It is also beginning to be understood that the Latin American visual arts relate more closely to their social and political context than do European and North American equivalents. Marxist theory, for example, has had a powerful influence on the visual arts in many Latin American countries, as upon life in general.

This situation is, paradoxically, partly a result of the notorious volatility and weakness of Latin American political institutions.

1

7

Because political structures have failed at times to support a sense of national identity, Latin American audiences have consistently turned to literature and the visual arts to discover the real truths about themselves, truths for which they would have searched in vain elsewhere. This tends to place both writers and artists in a very special position. It is they, rather than political leaders, elected or imposed, who enjoy credibility among the public as representatives of the national genius. No European Modernist, not even Picasso, has enjoyed a position comparable with that of, say, Diego Rivera in Mexico.

The deep respect for artists, and the tendency to see them as embodiments of the national consciousness, ought to simplify the task of writing about Latin American art. The artist equals the nation; a sum total of nations equals Latin America. Unfortunately, matters are not as easy as that. While the various Latin American nations undoubtedly assert their identity through the visual arts, Latin America as a total concept remains stubbornly elusive. Diego Rivera, for example, is often accepted as a spokesman not only for Mexican culture (a role he quite consciously assumed) but for the whole Latin American sensibility – a position which cannot be conceded to him. There are in fact many Latin American contexts into which he does not fit.

The Latin America dealt with in this book can be rather crudely defined in purely geographical terms. It consists of the Spanish-speaking regions of North, Central and South America, together with Cuba and the Dominican Republic in the Caribbean. To this can be added Brazil, which forms part of South America but whose language is Portuguese rather than Spanish. The following areas are omitted: Haiti, because it has a separate and very distinctive French-speaking culture; English-speaking islands in the Caribbean and English-speaking fragments of the South American continent, such as Guyana and Belize; and finally, perhaps with less justification, Puerto Rico, since it is difficult to draw an absolutely firm line between twentieth-century Puerto Rican art and that of the United States.

I have also omitted any discussion of the new Hispanic art which is being produced by artists of Latin American ancestry born and brought up in the mainland United States – in Florida, Texas, New York, Chicago and southern California. However, and perhaps at the risk of causing confusion, a good deal of space is devoted to Latin American artists in exile, some working in Europe and still others in

English-speaking North America. This is unavoidable, since the phenomenon of the artist in exile from his homeland – for political, material or purely cultural reasons – is so much a part of the story of Latin American Modernism. The same is true of twentieth-century Latin American writers.

The various regions of Latin America can be classified culturally in different ways, none wholly satisfactory. One can contrast, for example, the countries in which there is a strong Indian (for convenience this term will be used rather than the clumsier Native American) presence with those where there is not. Mexico, Peru, Ecuador and Bolivia are thus opposed to the nations of the so-called 'Southern Cone' – Argentina, Chile and Uruguay. What the Colombian critic Marta Traba called 'open' countries can be contrasted with those she described as 'closed' – by these terms she meant countries which seemed especially open to foreign, particularly European, influences, such as Argentina and Venezuela, compared with others which seemed to resist them: Peru, Bolivia, Paraguay and Ecuador. As Traba pointed out, most of her closed countries were either landlocked or faced the Pacific rather than the Atlantic. None of these classifications takes into account the special situation of Brazil – immense, with many primitive Indian tribes, Portuguese- rather than Spanish-speaking and heavily influenced by the heritage brought with them from Africa by successive generations of slaves. Nor do such classifications seem useful when dealing with Cuba.

The attempt to classify Latin American countries according to the degree of Indian influence to be found in their art leads straight to the question of *indigenismo*. The search for indigenous roots has certainly preoccupied many, though not all, Latin American Modernists. Paradoxically, its origins lie in European ideas, in the sense that it stems from the vision of the 'noble savage' originally put forward by Jean-Jacques Rousseau and imported into Latin America as part of a whole cargo of Enlightenment ideas which helped to fuel the rebellion against the Spanish monarchy.

In mid-nineteenth-century Mexico this vision expressed itself in art through works such as *The Tlaxcotlán General Tlahuitcole doing Battle* 2 *at the Gladiator's Stone of Sacrifice*, a sculpture by the Catalan immigrant Manuel Vilar (1812–59). This has a close relationship to Hellenistic sculptures such as *The Dying Gaul* and also to similar later Neo-Classical statues being produced at the same moment in Europe. *The Discovery of Pulque*, an ambitious historical composition by the 3 Mexican painter José Obregón (1832–1902) shows a comparable

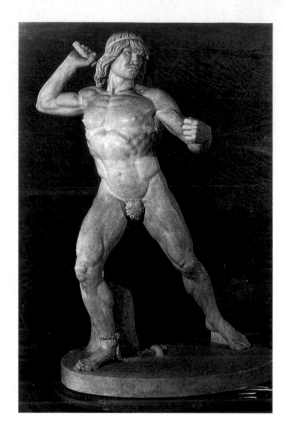

2 Manuel Vilar
*The Tlaxcotlán General
Tlahuitcole doing Battle at
the Gladiator's Stone of
Sacrifice* 1851

inclination to adapt Indian historical subject matter to suit European notions.

Indigenismo as an identifiable cultural and political movement only began to get off the ground in 1900, with the publication of *Ariel*, an influential essay by the Uruguayan journalist José Enrique Rodó. Rodó contrasted two forms of society. One, identified with Caliban, was materialist and utilitarian – this Rodó linked to the influence of the United States. The other, symbolized by Ariel, was the product of an élite capable of sacrificing material advantage to spiritual concerns. For Rodó himself, this altruism was still part of the philosophical heritage of ancient Greece, but gradually *Arielismo* came to be associated with a search for national essences, which, in turn, were

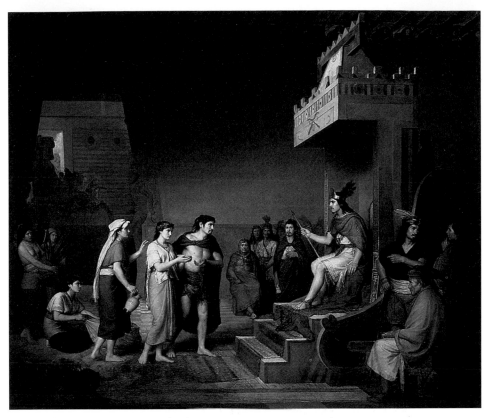

3 José Obregón *The Discovery of Pulque* 1869

increasingly thought to possess Pre-Columbian roots. One of those who read Rodó's text in this sense was José Vasconcelos, the first Mexican minister of culture after the bloody revolution of 1910–20 which changed the face of Mexican life. It was Vasconcelos, in turn, who became the patron of Rivera, Orozco and Siqueiros, and thus the true founder of the Mexican Muralist movement, one of the most important events in the history of twentieth-century Latin American art.

In the strict sense, however, *indigenismo* was a literary, not an artistic, phenomenon, and its most characteristic manifestations were in Peru and Guatemala, both of which, like Mexico, had been the sites of major Pre-Columbian civilizations. In Peru one of the chief

ideologists of the movement was José Carlos Mariátegui, author of *Seven Interpretative Essays on Peruvian Reality* (1928). For Mariátegui, who was a Marxist, the lost empire of the Incas provided the prototype for a new, egalitarian socialist society. Indian peasants, not the ragtag of the industrial protelariat in Lima, were the material from which a revolution could be made. This premise continues to underlie the activities of the Sendero Luminoso (Shining Path) guerillas who today threaten the existence of the Peruvian state.

In Guatemala, a major protagonist of *indigenismo* in the arts was one of Latin America's greatest novelists, the Nobel Prize-winner Miguel Angel Asturias. One of his best-known books, *Hombres de maíz* (*Men of Maize*, 1949), maize being the typically Indian crop, focuses directly on the theme of opposition between traditional organic culture and modern capitalist development. Tradition is articulated in the novel through Asturias's use of Mayan myth.

Neither Peru nor Guatemala has been in the forefront of the Latin American visual arts during the Modernist epoch. Indeed, in the case of Peru it seems to have been the very marked fissure between Indian and European culture which prevented the development of a brilliant new hybrid style such as sprang up in Mexico.

In the circumstances, it is interesting to compare what happened in countries where the Spaniards found highly developed Indian cultures and in those where such cultures were absent. The obvious example to choose is Argentina, which had no equivalent of the Aztecs, Incas or Mayas. The Argentinian hero is not the Indian but the white gaucho, whose image is enshrined in the nineteenth-century narrative poem *Martín Fierro* by José Hernández (Part One was published in 1872, Part Two in 1879). The poem is a lament for the free life of the pampas, the great Argentinian grasslands – a freedom which was disappearing as the work was being written. Martín Fierro, the Argentinian equivalent of the idealized North American cowboy, is conscripted for service to fight the nomadic Indian tribes who contest possession of the plains. Mistreated, he deserts and takes refuge with these opponents, but eventually finds them too 'barbarous' and reluctantly returns to a civilization he now knows to be corrupt. Here the lost paradise is not Pre-Columbian society before the coming of the Europeans but a conservative Spanish patriarchy forced by lust for material progress to break faith with its own people.

What emerges from this brief examination of the contested subject of *indigenismo* is not the viability of the Indian past as an alternative to ideas brought from Europe, but the universal need felt in Latin

American cultures, whatever their background, for the presence of a native enabling myth. The myth itself has varied widely according to context.

If the relationship of Latin American art to the Indian background forms one important theme, another contrasting one is its relationship to European Modernism, which has often been perceived in Latin American countries as a 'liberating', anti-authoritarian movement. Latin American attitudes to European Modernism show a certain ambivalence, however, having both welcomed it and rejected it in favour of native traditions. It is obvious that Modernism itself is not a Latin American invention, though a handful of writers, such as the Chilean Vicente Huidobro (1893–1948) made still underrated contributions in the pre-World War I period to the development of the Modernist sensibility. Huidobro's association with the Parisian avant-garde came about through his friendship with and influence over the French poet Pierre Reverdy (1889–1960), with whom he collaborated on the important review *Nord-Sud*.

The formal beginnings of Modernism in Latin America itself must be placed as late as the 1920s, a decade punctuated by a whole series of landmark events, among them the 'Semana de arte moderna' (Modern Art Week) in São Paulo in 1922, the foundation of the artistic and literary review *Martín Fierro* in Buenos Aires in 1924, and the revolt against the Cuban Academia de San Alejandro led by the painter Victor Manuel in 1927. Most of these activities involved close links between the visual arts and literature.

This association between the literary avant-garde (which often led the way) and painting and sculpture had a number of effects. Chiefly it prevented the development of a closed art world where different styles could follow one another in a smooth, seemingly logical progression. It also tended to direct the attention of artists towards social and political problems which otherwise might not have seemed to concern them closely.

This social commitment is reflected in the Latin American art of the 1920s and 1930s which has achieved the highest profile with non-Latin American spectators – Mexican Muralism, still sometimes thought of as the only 'genuine' Latin American art of the twentieth century. Muralism got its start when Diego Rivera, a one-time Paris Cubist, returned to settle permanently in his native Mexico in 1921, though it rapidly left any Cubist roots it may have had.

Muralism is sometimes contrasted with the Surrealism practised by leading Latin American painters in exile, chief among them the

Cuban Wifredo Lam and the Chilean Matta (Roberto Matta Echaurren). In 1938, André Breton, the founder of the European Surrealist movement, visited Mexico and expansively declared that Mexico was a 'naturally surrealist' country. In 1940, Mexico City was the scene of a major Surrealist exhibition which included among its participants both Diego Rivera and his wife Frida Kahlo. Though Rivera, Kahlo and a number of the other exhibitors soon renounced any connection with Surrealism, this exhibition is sometimes represented as a momentous coming together of the two chief tendencies in twentieth-century Latin American art – European Surrealism on the one hand, *indigenista* Muralism on the other.

In fact, as this book will show, the relationship between Latin American artists and European Modernism is far more complex than this scenario allows. Almost every major European art movement, from Impressionism and Symbolism onwards, made some kind of an impact among the painters and sculptors of Latin America. Two which had special importance were Constructivism and Expressionism.

Much Latin American Constructivism can be traced to an absolutely specific source – the Uruguayan artist Joaquín Torres-García, who returned to Montevideo in 1934 after forty years' residence in Europe and the United States. During that time he had

4 Joaquín Torres-García
Abstract Forms 1929

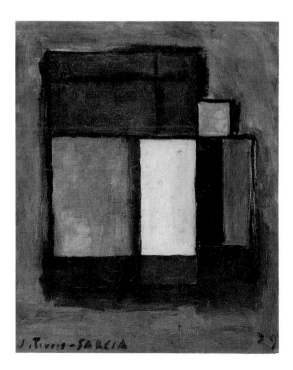

14

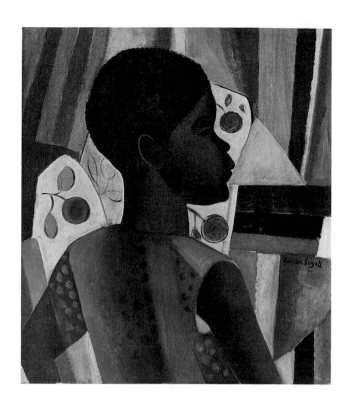

5 Lazar Segall
Profile of Zulmira 1928

been a central figure in a number of avant-garde groups, among them Cercle et Carré, all of which were affiliated to international Constructivism. In Montevideo Torres-García set up an Asociación de Arte Constructivo, and later, in 1944, the Taller Torres-García, as a workshop in which to train his followers.

Expressionism had a more diffused and generalized influence, so much so that it is difficult to be certain what came from Europe and what was native to Latin America itself. The Expressionist painter Lazar Segall (1891–1957), born in Vilna, Russia, and trained in Berlin and Dresden, was one of the earliest European Modernists to visit South America. He arrived in Brazil in 1913, went back to Europe at the outbreak of war and returned to settle permanently in 1923. In São Paulo he was active as a teacher and an organizer, and his work had an impact on several generations of Brazilian artists.

However, what one might call Expressionism in a more general sense is a persistent feature of twentieth-century Latin American art. It recurs in widely different contexts. In this respect Latin American art

6 André Derain
The Italian Woman, c. 1920–24

7 Mario Sironi *Multiplication*
c. 1941

can be described as 'naturally expressionist', invoking the same nuance Breton gave to the phrase 'naturally surrealist'. Good examples of this non-specific Expressionism occur in the work of Diego Rivera's colleagues in the Mexican Muralist movement, José Clemente Orozco and David Alfaro Siqueiros.

There is also a third major influence on Latin American Modernism, seldom discussed because of its unacceptable political connotations. This is the collective impact of the various conservative and classical styles which flourished in Europe between the wars.

6 Part of this influence came from the later work of André Derain (1880–1954), a favourite with wealthy Latin American patrons. Derain had gradually departed from pre-war Fauvism, and was now thought of as forming a link between the Modern Movement on the one hand and the established French tradition represented by artists like Corot and Courbet on the other. He appealed not only to collectors but also to artists. The seduction he exercised over some of the leading Brazilian painters of the inter-war period, such as Emiliano Di Cavalcanti, is clearly visible in their work.

If Derain was important to Latin American art, so too were the classical artists of the Italian Novecento group, typified by Mario
7 Sironi (1885–1961). Their influence is very marked in the work of a

number of leading Argentinian artists of the 1920s and 1930s, chief among them Lino Spilimbergo (1896–1964), who, as his name suggests, was of Italian descent. Latin American artists responded readily to the ideas of the Novecento for a number of easily explicable reasons. One was the fact that there were many Italian immigrants in Latin America, especially in Argentina, who continued to look to their country of origin for cultural leadership. Another was political. Novecento art, thanks to Mussolini's enthusiastic patronage, became identified with Italian Fascism. This, in turn, was an important role model in the Latin American politics of the period. Argentina became a military dictatorship in 1930; the régime lasted until 1943, when it was replaced by the corporate state created by General Juan Perón. There was a similar revolution in Brazil, where in 1930 the army put Getúlio Vargas in power, and he too subsequently constructed a régime which had many of the trappings of Mussolini's dictatorship. While artists were seldom supporters of authoritarian régimes, they could not help being affected by the cultural climate these created. The effect was intensified by a propaganda effort directed from Italy itself. Aware of the substantial Italian element in some Latin American populations, Mussolini's government cultivated cultural links as a way of trying to win their sympathy.

It remains to say something about the actual formats and materials adopted by twentieth-century Latin American artists, since it is these basic elements which are the most truthful witnesses to the historical situation and social functions of the artist in Latin American society. Hybrid imagery counts for much less. It tells us about the artist's aspirations but not how the work is actually used.

At the beginning of the century both formats and functions were purely European. Paintings were in oils on canvas, and were displayed in frames; work of this type had of course existed in Latin America only since the Spanish Conquest. By the end of the nineteenth century religious art of the type made for churches had almost died out, and paintings were made, just as they were in Europe, either as collectors' pieces or, on a larger scale, for display in museums and official buildings of various types. Sculpture was devoted to the commemoration of significant national events and the personification of civic virtues, or served as a memorial to national heroes or to civic or military leaders. Often these functions overlapped.

Just as it did elsewhere, Modernism freed Latin American artists from the need to use specific, instantly recognizable subject matter. This liberation, at first slower to make itself felt in sculpture than it did in painting, ended by transforming the nature of three-dimensional work in particular. By the mid-1950s the transformation was almost complete, and commemorative sculptures of the old type, though they continued to be made from time to time, had begun to look like anachronisms.

One significant difference between Latin American and European art during the first half of the twentieth century was the importance in Latin America of large-scale mural paintings, the products of artists affiliated to the Mexican mural movement and of non-Mexicans who were in some way affected by it. There was a tendency among artists, and among critics following their lead, to ascribe to these public paintings Pre-Columbian roots, and thus to present them as an aspect of indigenous culture which had miraculously re-emerged after the destruction brought by the Conquest. This theory will not withstand serious critical examination. While mural paintings were made by certain Pre-Columbian civilizations – for example, by the Maya – Latin American murals find much more precise parallels in similar paintings produced in Europe over the centuries. Their direct ancestors are the frescos of the Renaissance. Rivera, for instance, undertook a study of the work of Piero della Francesca shortly before
8 he returned to Mexico. Orozco's murals in the Hospicio Cabañas in

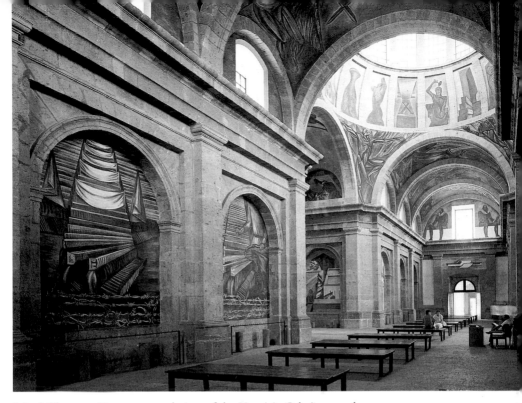

8 José Clemente Orozco, general view of the Hospicio Cabañas murals, Guadalajara, 1938–9

Guadalajara suggest a comparison with Michelangelo's Sistine 41–2
Chapel.

Muralism's significance lies in the stress it lays on the continuing viability of public art which is given a new role by being made to activate the search for national and cultural identity and convey political ideology. This is an element which is generally missing from European Modernist art of the same epoch, and which is less strongly felt, though it is present, in the art of the United States.

The past three decades, not only in Latin America but in late Modernist art in general, have seen an increasing impatience both with categorizations based on format and with technical boundaries of all kinds. Artists feel free to use any material in any fashion which appeals to them. They ignore distinctions between what used to be called painting and what used to be called sculpture and, equally, the

traditional division between fine art and craft. Many art works, not content with being three-dimensional, take on an environmental character.

In Latin America, however, these explorations have had one specific effect which is not as easily observable elsewhere. There has been an effort to return to ideas and techniques which are at least vestigially present in the folk or tribal cultures which continue to exist side by side with the urban or sophisticated one to which modern artists belong (whatever their actual origins in terms of race or class). This doubling of cultures is almost entirely absent from contemporary Europe and from the United States, though there the Navajo of the American South-West offer a partial exception, as do some aspects of Afro-American and Hispanic culture. This doubling is something which makes much of Latin America culturally distinct.

An interest in folk and primitive art is of course inherent in the history of Modernism, but the original Modernists did not have the direct access to such sources enjoyed by their Latin American successors. The African artifacts admired by Picasso were for him exotic objects, totally divorced from their original context.

In many Latin American cultures, the artist can legitimately feel that indigenous ethnographic or archaeological objects are part of himself or herself. There is an actual bond, perhaps even one of blood, with the people who made such things. Modernist primitivism thus becomes charged with special meanings; the appeal of the primitive is now not merely exotic or imbued with the sentiments of Rousseau and the eighteenth-century Enlightenment – it is perceived as a return to native origins. Today the claim that Latin American art is essentially hybrid is increasingly often made in a positive sense rather than in the negative one which used to be customary. This interpretation becomes easier to sustain and justify the nearer one comes to the present moment.

Forerunners and Independents

Latin American Modernism is best understood by looking first not at structured art movements such as Mexican Muralism, which was understood by the participants as a kind of crusade, but at the activity of individuals. All those briefly discussed here were born before the beginning of the twentieth century and in some cases well before. All were influenced, to a greater or lesser extent, by what was happening in Europe when they were young men. The majority, indeed, studied in Europe for a period. Some, such as the Colombian painter Andrés de Santa María (1860–1945), spent the greater part of their lives living and working in Europe.

Those who are best remembered now, and who seem somehow to have contributed significantly to our understanding of contemporary Latin American sensibility, were essentially loners. Some could be described as stubbornly eccentric. Even those whose pattern of development was more conventional tended to produce work which resists rigid stylistic categorization according to the European canon. Santa María, just mentioned, is a case in point. Sometimes described as Impressionist, his work is in many ways closer to that of the Fauves, rich in colour, heavily impasted, as if the aim were to transmute what was being painted into the very substance of the paint. His paintings, with their built-up surfaces, prompt a comparison with those of his Italian contemporary Antonio Mancini (1852–1930), another artist who hovers on the edge of Modernism without being fully modern.

Santa María's value was chiefly that of an exemplar. He showed Latin American artists – men from remote and often poor countries – that one of their number could become a success on the international scene. Born in Bogotá, he left for Europe with his family at the age of two, and did not set foot in Colombia again until 1893 when, by now in his thirties, he returned to take up a teaching post. In 1904 he was appointed director of the School of Fine Arts in Bogotá but resigned in 1911 and spent the rest of his long life in Europe. What is interesting about Santa María's work, in comparison with that of his European contemporaries, is a certain irrepressible exoticism, a lushness which

9

10

9 Andrés de Santa María
The Annunciation 1934

10 Antonio Mancini
Return from Piedigrotta

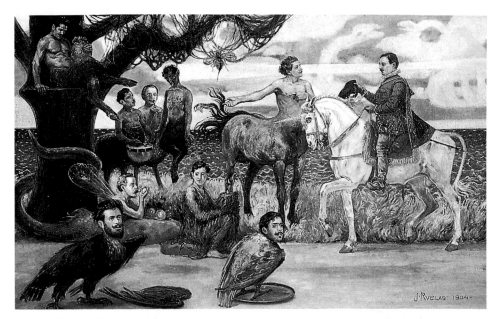

11 Julio Ruelas *The Initiation of Don Jesús Lujan into the 'Revista Moderna'* 1904

goes beyond the demands of the subject matter. It seems as if the artist were unconsciously reminding himself of his own origins.

A similar feeling that things are slightly off-key pervades the output of the Mexican painter and illustrator Julio Ruelas (1870–1907). Much of his work is derivative; he owed a great deal to the erotic Belgian Symbolist Félicien Rops, making near copies of some of Rops's ideas and paraphrasing others. He often gives one the feeling that the standard tropes of European *fin de siècle* decadence fitted uneasily into the harsh realities of the Mexican context (which were to become harsher, after Ruelas's death, before the outbreak of the bloody Mexican Revolution, whose civil wars devastated his country for ten years). Other aspects of Symbolism, themselves obviously attractive to Ruelas, slotted with surprising neatness into the existing Mexican context. Examples are the preoccupation with death and the emblematic use of skeletons and skulls – elements perfectly in keeping with the idioms of Mexican popular culture.

There was another Mexican artist of this period who took a much more direct interest in the popular culture of his country. Saturnino

12 Saturnino Herrán
Woman from Tehuantepec 1914

12 Herrán (1887–1918) made powerful paintings showing indigenous Mexicans whom he endowed with heroic force and dignity. The figures owed something to long-established traditions in Spanish art: they are the direct descendants of Velázquez's *The Water Seller of Seville* and of the beggar-philosophers of Jusepe de Ribera. The paintings are more decoratively treated than the work of these precursors, however. The colour is broken up into broad planes, and it is no surprise to find that Herrán made occasional designs for stained glass.

 Towards the end of his brief career, Herrán began to nurture
13 ambitions to be a mural painter. His unrealized project *Our Gods*, which occupied him from 1914 until his death, is a celebration of the

24

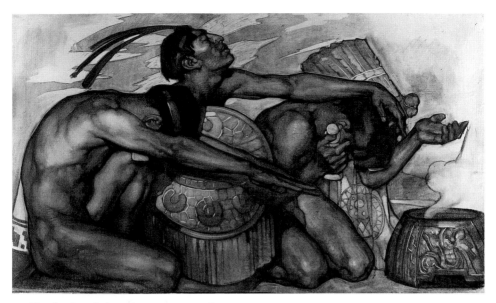

13 Herrán *Our Gods* project, 1904–18

Mexican Indian, who appears both as the traditional 'noble savage' and as the prototype of Mexican nationalism, which had been intensified by the pressures of the Mexican Revolution, now well under way. Herrán's Indians are depicted in a heroic mode which owes little to Pre-Columbian art but much to the more academic aspects of Symbolism. His manner may seem to derive from that of the French academic Symbolist Puvis de Chavannes (1824–98) and may bring to mind the murals of the British artist Frank Brangwyn (1867–1956) or the American John Singer Sargent's decorations for the Boston Public Library.

Herrán was not the only artist working in Mexico at this time who was interested in making murals. Another was the extraordinary Dr Atl (Gerardo Murillo Cornado, 1875–1964), who had studied Italian frescos with enthusiasm during a period in Europe from 1897 to 1903, and who had even painted some murals in a private villa in Rome in 1901. After his return to Mexico he began urging the government to invite artists to decorate the walls of public buildings – a plan which could not be pursued until revolutionary conflicts had finally burnt themselves out.

Dr Atl's own achievements lay elsewhere. He conceived a passion for the Mexican landscape and began producing panoramic views on 14

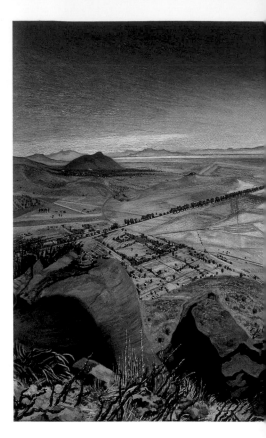

14 Dr Atl
Valley of the Rocks 1942

15 José María Velasco
The Hacienda of Chimalpa 1893

a monumental scale. These took their inspiration from the somewhat smaller, but still panoramic, paintings produced by the nineteenth-century landscapist José María Velasco (1840–1912), whose views of the Valley of Mexico have a wonderfully limpid precision, making him one of the greatest Realist artists of his epoch. Dr Atl (the name, in Nahuatl, the language of the Aztecs, means 'water') had a stormier temperament, and developed an intense and lifelong interest in volcanos, part mystical and part scientific. There is of course no shortage of volcanos in Mexico. Dr Atl first painted many views of Popocatépetl and Ixtaccíhuatl, the two largest in the country, then built himself a house near Paricutín, in order to record every aspect of the violent eruptions which began in 1943 and lasted for the next three years. His paintings, with their sharply defined planar construction, often bear a marked resemblance to the work of the Russian artist Nicholas Roerich (1874–1957), who was more or less his exact

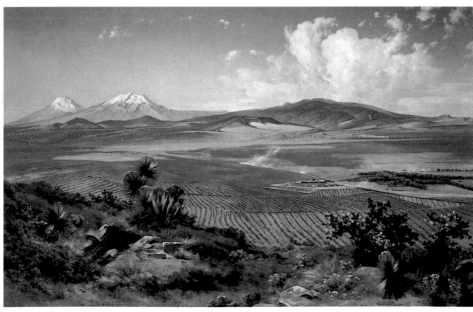

contemporary. This resemblance is partly due to a simple coincidence of subject matter. In later life, after exiling himself from Russia, Roerich painted the Himalayas as obsessively as Dr Atl painted Mexican mountains. There was also a real similarity in temperament – intense scientific curiosity combined with an element of inherent hostility towards science. The result, in both cases, was that the work fell short of what the artist aspired to. Although he was venerated as a sage by the Mexican painters of the next generation (Rivera and Orozco were his pupils when he taught at the Escuela Nacional Preparatoria), Dr Atl's achievement as a painter is limited both by its repetitiveness and by its inability to shake off the chains of nineteenth-century scientific naturalism.

A much more remarkable artist of the same epoch, in fact the most remarkable working in Mexico before the return of Rivera (Orozco, it must be remembered, had not as yet found himself), was Francisco Goitia (1882–1960). If there has been a tendency, especially among Mexican critics, to overrate artists like Ruelas, Herrán and Dr Atl, Goitia, though now rescued from obscurity, has still to be assessed at his true value. He is an artist who encompasses a wide range but who nevertheless always remains himself. At moments his work may appear to be like Goya's, at other moments like Caspar David Friedrich's, and at others still like that of the romantic engraver Rodolphe Bresdin (1825–85).

This description incorrectly makes Goitia sound like an out-and-out romantic, the prisoner of his own subjectivity. Although he *is* romantic, he is also passionately interested in facts. He brings the two things together in an imaginative and disturbing way with a distinctive Mexican flourish. When he paints what is horrific – and horror is quite frequent in Goitia's work – this is, in many cases, what he has actually observed. Goitia, like Dr Atl, spent a period studying abroad, and thereafter, again like Dr Atl, decided to devote himself to painting his native Mexico. In his case this meant plunging directly into the civil wars. He served as a staff artist in Pancho Villa's army. An unforgettable painting, *Landscape at Zacatecas I* (*c.* 1914), was inspired by the murder of an enemy general, shot in the back having been taken prisoner after a brave resistance, then hung naked from a tree. Goitia exhumed several enemy corpses and hung them from the same tree to serve as models. 'Then I had to go to Mexico City,' he recorded, 'and as the air [in the state of Zacatecas] is very dry, the corpses don't rot. So I had a hut built around the tree and put a caretaker there, and I have it for when I can return to continue my

16

16 Francisco Goitia *Landscape at Zacatecas I, c.* 1914

studies.' His version of the event was actually less macabre than the reality. The general had been feasting on a steer when he was attacked, and after he was killed and hung up the murderers substituted the steer's head for his own.

Later in his career, after the Revolution was over, Goitia was employed to make documentary paintings of Mexican landscapes (often archaeological sites) and peasants for the government anthropological department. He would accept very little money for his work, and insisted on living on the same level as his subjects. 'To paint them,' he said, 'I must live with them so that they will have confidence in me. I must know their customs, analyse their tastes, eat with them. In a word, be like them.' *Man Seated on a Trash Heap*, painted in

17

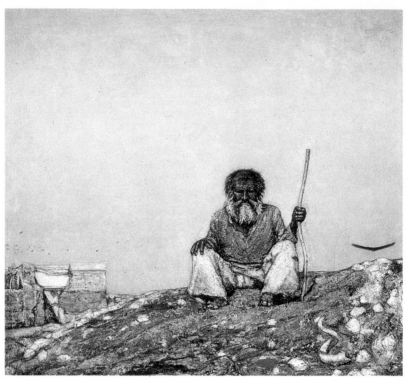

17 Francisco Goitia *Man Seated on a Trash Heap* 1926–7

17 1926–7, belongs to this phase of his work. Goitia described his subject as 'the happiest man I ever saw. He owned not one thing in the world, not even a hat, and he sat there every day and enjoyed the blue sky.' It has been suggested that this painting is an emblematic or anticipatory self-portrait. Goitia ended his days living as a kind of hermit in a suburb of Mexico City, inhabiting an adobe shack, its roof held down by large stones. He taught drawing in a primary school and supplemented his income by making coffins; he was even reputed to sleep in one of them.

An artist who carved out an equally strange existence for himself was the best Venezuelan painter of the first half of the century, Armando Reverón (1889–1954). Reverón studied in Spain, first in Barcelona then in Madrid, receiving a solid academic training before returning to Caracas where, like a number of Venezuelan artists of the same generation, he became an enthusiast for French Impressionism, a

30

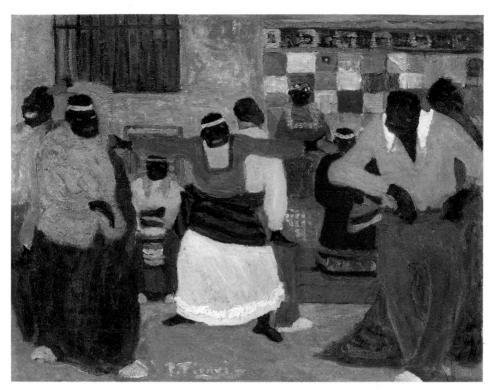

18 Pedro Figari *Candombe* 1920–30

style he knew almost entirely through reproductions. The decisive
moment in his career came in 1921, when he decided to leave Caracas
for Macuto, a small village near the Caribbean coast. Here he and his
companion, an Indian woman named Juanita, built a simple thatched
hut. Later a second hut was added to serve as a studio and the whole
property was ringed with a dry-stone wall to ensure privacy. This was
what the artist called his *castillete*, or little castle.

Reverón's characteristic paintings are of two kinds. First there are
landscapes, generally almost monochromatic, almost completely 19
white at first and later taking on a sepia tone. Their near-whiteness is
an attempt to render the blinding intensity of tropical light. Secondly
there are paintings of female nudes and semi-clothed female figures, 20
alone or in groups. Here Reverón gave full rein to his erotic fantasies.
These figure paintings, too, are predominantly light in tonality, the
figures half-dissolved by the atmosphere that surrounds them.

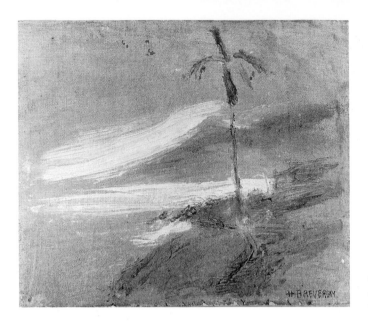

19–21 Armando Reverón
Coco-palm 1944 (*left*); *Five
Figures* 1939 (*below*);
Aviary, c. 1940

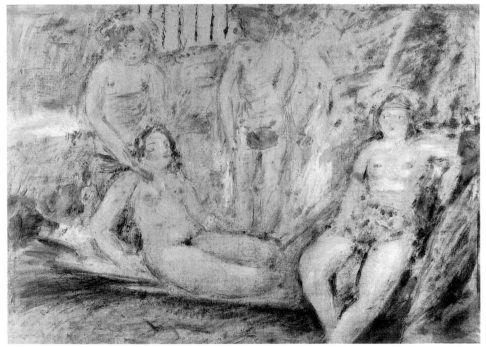

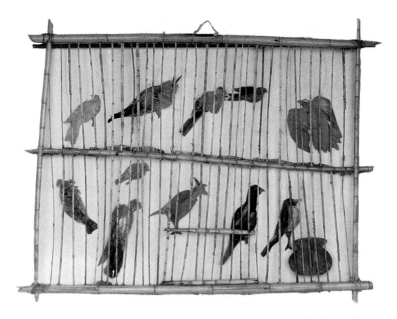

As well as acting as his companion, bedmate and housekeeper, Juanita modelled for the artist. Strangely, however, these paintings of nudes seem quite often to have been made using mannequins rather than a living model. Reverón and Juanita created life-size rag dolls which he endowed with roguish, often grotesque, expressions and realistically depicted genitals. These were used not only as models but as actors in improvised plays. Reverón also made props – furniture, musical instruments, even a cage full of pet birds – all put together from found materials: cardboard and paper, bamboo, wire, feathers and thread. In the *castillete* there were balls and other entertainments, even mock orgies, all reflections of the artist's fantasies.

21

Despite the erotic character of the figure paintings, and also some of these entertainments, Reverón had a masochistic, not to say puritanical, streak. A friend, José Nucete Sardi, described his way of preparing himself for work:

If he doesn't feel like doing anything, he rubs his arms with a rough cloth until he draws blood. Then he goes outside to warm up his sight, driving it to ecstasy in the bright colours of the sunlit landscape around him. This is followed by the dance of the colours in which he needs to sense the colours by touch, feeling the paints before he uses them. He works almost nude to prevent the colours of his clothes coming between his work and his eyes. Sometimes he binds his limbs with ropes so that reflex movements will not jar his hand.

Sardi adds that the painter would sometimes gird his waist with a belt, drawn very tight, so as to prevent the impulses of his lower body – what he called his 'inferior zone' – passing through to his thorax and head. Reverón's personal rituals have been compared to the consciousness-altering rites practised by Indian tribes, and commentators have speculated that Juanita may have been the source of them. This hypothesis, however, remains unproven.

There is a strange affinity between Reverón's paintings and the work of Bonnard. The soft dissolving touch of his landscapes, and still more the obsession with the naked female body, rendered through a style of draughtsmanship which is deliberately soft and blunted, are startlingly similar to the techniques which Bonnard was using at the same epoch, from about 1920 onwards. The major difference lies in colour. Bonnard, working in a temperate climate, opts for rich, saturated hues; Reverón, working in a tropical one, bleaches colour away with the sheer violence of the light.

While it seems unlikely that Reverón can have known much, if anything, of Bonnard's work, there was certainly one important Latin American artist who was acquainted with it. This was the Uruguayan Pedro Figari (1861–1938). Figari was not as odd a character as Goitía or Reverón, but the pattern of his artistic career was quite unlike a normal European one. Latin American writers often pursue multiple careers, and to a lesser extent this is true of Latin American artists. Figari pushed this pattern to an extreme. He had an important public career for many years before finally deciding to devote himself to art. He was first a successful lawyer, then a journalist and editor (he founded the Montevideo newspaper *El Diario*). Later still he was a member of the Uruguayan Chamber of Deputies, an essayist, a philosopher and a journalist. Only in 1921, when he moved to Buenos Aires, did he begin to paint full time. In 1925 he moved to Paris, and lived there until 1933.

Figari's work shows the direct influence of the French intimists, that of Vuillard perhaps even more clearly than that of Bonnard, spiced with a certain deliberate naïveté. His thematic range, however, is wider than that of either of the two French artists. It is also specifically Latin American, since it includes not only bourgeois interiors but historical and literary scenes, and also Creole and Afro-American subjects, notably in paintings which show *candombe* rituals. These *candombe* works are exotic even in Uruguyan terms, since Uruguay, unlike its neighbour Brazil, does not have a large African population.

18

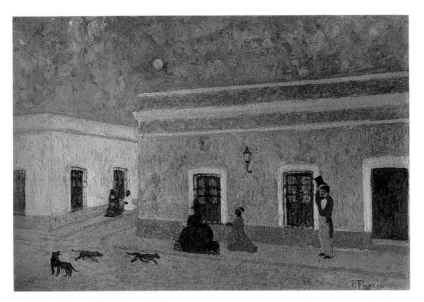

22 Pedro Figari *The Prayer Bell*

What divides Figari most decisively from Vuillard and Bonnard, however, is not his wider and more exotic range of subject matter but his completely different attitude to time. In the works of the French intimists, time is always the here-and-now, the eternal present. Figari is acutely conscious of the passage of time, and the losses which this brings with it. 'My intention', he said, 'is to stir certain memories, call to mind some episodes that genuinely reflect our social life, so that artists see the area they can embellish upon in those memories.' On a different occasion he wrote: 'I do not try to define or give a precise view of everyday objective reality; rather I offer, through glimpses of reality more or less poeticized through my personal manner of reacting, the reality I have been able to locate in my observation and my memories.' In this respect the true comparison is not with Vuillard's intimist interiors but with Watteau's *fêtes galantes*.

22

The artists brought together in this chapter indicate some of the relationships which, in the opening years of the twentieth century, already existed between Latin American artists and European art styles. More clearly still, they also indicate the intractable strangeness and uniqueness of some aspects of the Latin American sensibility.

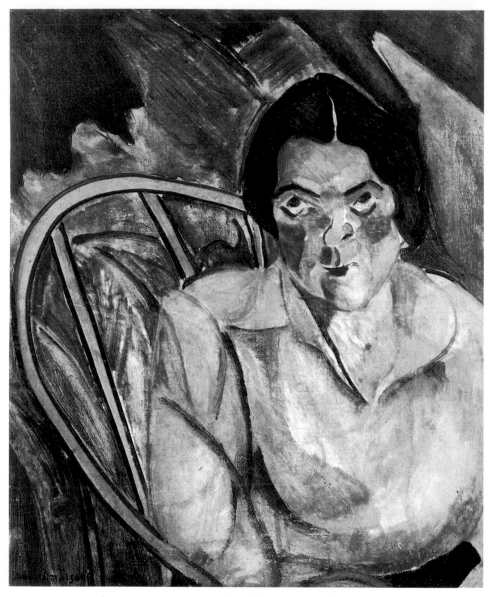

23 Anita Malfatti *The Idiot* 1915/16

The First Modern Movements

The formal beginnings of Latin American Modernism have already been touched on in the introduction to this book. Until the 1920s, Latin American assimilation of the various European art movements of the late nineteenth and early twentieth centuries had been slow and irregular. Impressionism continued to be thought of as a radical style. Where it appeared, it was usually filtered through the work of the so-called Spanish Modernists, Joaquín Sorolla y Bastida (1863–1923) and Ignacio Zuloaga (1870–1945), whose art, rather like that of Sargent, represented a compromise between the painterly freedom of Impressionist technique and traditional academic values. This compromise was mediated by what Impressionism itself had taken from Velázquez.

Post-Impressionism, even the work of major figures such as Paul Cézanne and Vincent van Gogh, was even slower to make its effect. In fact the only Post-Impressionist who would eventually have a significant influence in Latin America was (the partly Peruvian) Paul Gauguin, and this influence did not appear until after the First World War, when it manifested itself as part of the mixture of styles which went to create Mexican Muralism.

The end of the war, even in Latin America, which had remained remote from the conflict, marked a time of new beginnings. Where much of the European avant-garde often drew back from the wilder experiments made before 1914, Latin American artists were at last ready to commit themselves to the new way of thinking. The 1920s saw a series of significant artistic events.

One of these was the 'Semana de arte moderna' held in São Paulo in 1922. The Semana was a mixture of events incorporating music, literature and poetry as well as art. An important element in it was the desire first for a real confrontation with the bourgeois public of the city (a boom town whose inhabitants were less interested in the arts than they were in making money) and, secondly, to assert a new cultural nationalism, for the event coincided with the centenary of Brazilian independence. At the centre of the Semana was an exhibition held in the foyer of the Teatro Municipal. The participants

had come together *ad hoc*, and their work was of variable standard. The public labelled most of it 'Futurist', since Italian Futurism was an art movement they had at least vaguely heard of. The artists sometimes used titles suggesting an affinity with Cubism – though this was not always borne out by the paintings themselves.

In terms of the future of Brazilian art, the three most important painters present were Anita Malfatti (1889–1964), Emiliano Cavalcanti (1897–1976), usually referred to in Brazil as Di Cavalcanti, and Vicente do Rego Monteiro (1899–1970). All were very different in style. Malfatti ranks as the true pioneer. She came from a reasonably wealthy family and was able to travel widely. She studied first at the Berlin Academy under Lovis Corinth, and during this period was able to see works by the leading French Impressionists and Post-Impressionists on exhibition in Germany. During the war years she went to New York, where she met Marcel Duchamp (an introduction which seems to have led her to Cubism rather than to the still-emergent Dada). She also continued her studies at the Independent School of Art in New York. Malfatti exhibited in São Paulo in 1914, after her return from Europe, and then again in 1917, after coming home from the United States. The second of these exhibitions aroused vigorous polemics among Paulista intellectuals, and made her the emblem of revolt against nineteenth-century academicism.

Malfatti was perhaps unfortunate in attracting so much attention so soon, as the paintings of this period show that she was a gifted but not fully mature artist, struggling to assimilate an overwhelming variety of influences. Her portrait *The Idiot* (1915–16), one of the strongest of her early canvases, is a blend of Expressionism and simplified Cubism. Discouraged by the criticism her early work aroused, she never took things further. Her later paintings are a step backwards, naïve and cheerfully folkloristic.

Di Cavalcanti was a prolific artist, who was to have a much more distinguished public career. The works he showed in 1922 were immature and eclectic, a jumble of Symbolism, Impressionism and Expressionism. In the following year he left for Europe, as correspondent of the newspaper *Correio da Manhã*, and attended classes at the Académie Ranson in Paris. Among his contacts were the writers Jean Cocteau and Blaise Cendrars, and the painters Braque, Picasso, Léger and Matisse. While there he also took the opportunity to travel widely in Europe.

Di Cavalcanti's paintings of the late 1920s are examples of what one might call popular Cubism; the figures and backgrounds are made up

23

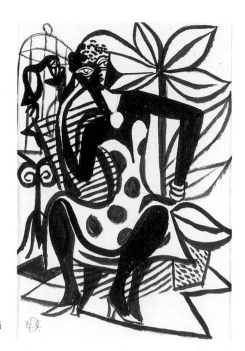

24 Emiliano Di Cavalcanti
Mulatta with Parrot

of interlocking planes, but are neither densely faceted, as in Analytic
Cubism, nor coded so as to create a parallel reality where
representation is only vestigially present, as with its successor,
Synthetic Cubism. Cubist devices are used for purely decorative ends,
as they are in the figure paintings of the same period made by the
Polish–French Tamara de Lempicka. His most typical work dates not
from this period but from the 1930s and 1940s, and is indebted to
André Derain, the patron of the new school of 'conservative'
Modernism. The paintings are not as solidly constructed as Derain's
work, but have a charm unlike that of the French artist. There is a
characteristic native mood of smiling irony in Di Cavalcanti's 24
depictions of street scenes featuring Brazil's kaleidoscopic mixture of
races. Much loved in Brazil for these works, he had long lost any
ambition to be a revolutionary figure by the time he produced them.

Rego Monteiro is the most bizarre and in some ways the most
striking artist in the group. He came from Recife, in the tropical north
of Brazil, and belonged to a family of artists. He was in Paris by 1911,
and frequented the Académie Julian in his early teens. He exhibited in
1913 at the Salon des Indépendants, then (having returned to Brazil)
began to show his work in his own country at the age of twenty.

Thereafter he returned to Paris, and during the 1920s was linked to L'Effort Moderne, a group led by Amédée Ozenfant (1886–1956), who described himself as a Purist, and by the minor Cubist Jean Metzinger (1883–1957).

By the middle of the decade Monteiro had evolved an extraordinary and instantly recognizable idiom. He painted figure compositions with primitive figures stylized and locked together so that the whole painting looked like a carving in shallow relief. The effect was accentuated by the fact that the pictures were in virtual monochrome. These compositions owe less to Cubism than to the Art Deco style then dominant in the decorative arts and in architecture, which experienced a tremendous success in Latin America.

Questioned by an interviewer about his artistic influences, Monteiro supplied a long list: 'Futurism, Cubism, Japanese prints, black art, the Parisian School, Brazilian baroque and above all the art of the American Indians on the island of Marajo.' It was significant in the circumstances that he chose to stress local ethnographical influences, but his was, nevertheless, a quintessentially urban art, marked chiefly by a feeling of brittle fashionability.

Not surprisingly, Rego Monteiro seems eventually to have found the mannerist idiom he had developed too constricting to take further. His later paintings are quite different – still lifes executed in a style which owes a good deal to another minor Cubist very fashionable in Paris during the interwar period: Roger de La Fresnaye (1885–1926).

His interest in ethnic cultures, and in the Amerindian background in particular, links Monteiro to a more important artist, Tarsila do Amaral (1886–1973), who has been described as 'the Brazilian painter who best achieved Brazilian aspirations for nationalistic expression in a modern style'.

Tarsila (always so called in Brazil) began to study painting in 1916 but did not exhibit in the Semana de arte moderna because she was in Paris when it took place. This was her second visit. During her first period in Europe she had studied with the conservative French painter Émile Renard (1850–1930) and it was only during a brief return to Brazil in 1922 that she became a thorough convert to Modernism. It was at this point that she became friendly with Malfatti and with the Brazilian poet and critic Osvaldo de Andrade, a major writer who was to influence her greatly. She was back in Paris by the end of the same year, and now studied with André Lhôte (1885–1962), Fernand Léger (1881–1955) and Albert Gleizes (1881–1953). Only Léger was a

25 Rego Monteiro
Deposition 1924

26 Tarsila do Amaral
The Black Woman 1923

major artist but all three were among the leading artistic opinion-formers of the time.

Tarsila's second visit to Europe was fairly brief, but it had a decisive effect. In April 1923 she wrote to her family:

I feel myself ever more Brazilian. I want to be the painter of my country. How grateful I am for having spent all my childhood on the farm. The memories of these times have become precious for me. I want, in art, to be the little country girl from São Bernardo, playing with straw dolls, like in the last picture I am working on ... Don't think that this tendency is viewed negatively here. On the contrary. What they want here is that each one brings the contribution of his own country. This explains the success of the Russian ballet, Japanese graphics and black music. Paris had had enough of Parisian art.

She returned home in December 1923, accompanied by Andrade and the avant-garde Swiss poet Blaise Cendrars, who was in some ways a precursor of Surrealism. The trio began to explore the popular culture of Brazil. In Holy Week they made a trip to the historic towns

27 Emilio Pettoruti *Fruit Dish* 1947

28 Tarsila do Amaral *Abaporu* 1928

of Minas Gerais, with their rustic houses and eighteenth-century Baroque churches. 'I found in Minas', Tarsila wrote, 'the colours I had adored as a child. I was later taught that they were ugly and unsophisticated.' Under this stimulus, she began to paint a new kind of picture: a mixture of local naïve art and of the Cubism she had absorbed from Léger. By 1928 she had moved towards a more complex style, and was at the beginning of her most creative period – that of Anthropophagy or Cannibalism, so named from the manifesto *Antropófago* which Andrade published later in the same year.

The central tenet of Anthropophagy was that the Brazilian artist must devour outside influences, digest them thoroughly and turn them into something new. Tarsila's first painting in her new manner, presented to Andrade as a birthday gift in January 1928, was entitled *Abaporu*. In the Tupi-Guarani language, the word means 'man who eats'. The painting represents a single monstrous figure, with a tiny head and enormous hands and feet. These, resting on the ground, symbolize intimate contact with the soil. The sun shines in the sky, and the landscape setting is reduced to a single gigantic cactus.

Tarsila has here combined the influence of Léger's paintings of reclining women with Surrealism. Information about this new movement (Surrealism had been founded as recently as 1924) must have travelled swiftly to Brazil. The tendency to combine apparently incompatible European styles was to be typical of Latin American Modernism, and Tarsila's Anthropophagist paintings supply an early example.

The formal appearance of Modernism in Buenos Aires lagged only a little behind the Semana de arte moderna, but cultural conditions in Argentina and Brazil were very different. Far from having an ethnically mixed culture, Buenos Aires was 90 per cent white and only 10 per cent mestizo. The population balance had been transformed by a flood of European immigrants, most of whom arrived between 1905 and 1910. Because they were so recently arrived, they were anxious to retain familiar European ideas but, at the same time, this impulse meant that they were instinctively conservative in cultural matters. The Europe they respected was the one they already knew.

A few intellectuals were, however, restive. The foundation of the magazine *Martín Fierro* in 1924 served as a rallying point for avant-garde writers and artists. It also witnessed a major artistic scandal, provoked by a modest exhibition in a commercial gallery in the Calle Florida, the smartest shopping street in Buenos Aires. The artist

responsible was Emilio Pettoruti (1892–1971), an Argentinian painter already in his thirties, with considerable experience of the European avant-garde to draw upon. Pettoruti had first shown his work in Argentina in 1911, but this had been an exhibition of topical caricatures. The next year the government of the Province of Buenos Aires awarded him a travelling scholarship and he went to Italy, where he soon fell in with the group of Italian Futurists gathered round the magazine *Lacerba*. Later, his work attracted the attention of Herwarth Walden, one of the most important art impresarios of the immediate post-war period, and he was invited to exhibit at Walden's *Der Sturm* gallery in Berlin. From Berlin he went to Paris, where he met Juan Gris. The influence of Gris was decisive: Pettoruti returned to Buenos Aires a committed Cubist, and it was thirteen paintings of this type which he showed in the Calle Florida.

Today it is hard to see why they caused such a scandal. They seem elegant, decorative exercises in an already established idiom. The reason was not their inherent originality, but the fact that they threatened the existing cultural order, which was already unsure of its own values.

A more original contemporary of Pettoruti's was Alejandro Xul Solar (Schultz Solari, 1897–1963), who attracted less attention than Pettoruti because he worked on a small scale and often in watercolour. Like his compatriot, Xul Solar was affected by Cubism, as can be seen from the faceted and fragmented forms which appear in his work. Xul Solar travelled widely in Europe from 1911 (he began to paint when he was sixteen) to 1924. It seems possible, because of this, that he had some knowledge of Berlin Dadaism as well as of Cubism, and in particular of the early drawings of George Grosz. His drawings, like those of Grosz, often make use of lettering and graphic signs, such as an arrow to indicate in which direction a figure is looking. Another influence seems to have been that of Paul Klee, who also employed cryptic symbols. Xul Solar developed these letters and signs to create a pictographic language he called *criollismo*, based largely on Spanish and Portuguese, however, rather than on anything Pre-Columbian. His range of intellectual influences was very wide, as his friend the writer Jorge Luis Borges observed in a preface written for an exhibition of Xul Solar's work held in 1939. Borges mentioned Swedenborg and William Blake – Solar was also interested in Sufism and the Cabala. Pre-Columbian influence seems to have been limited, which is not wholly surprising since Argentina was never the seat of a great Indian civilization.

29 Alejandro Xul Solar *Honourable Chief* 1923

In Cuba, another place where the Modern movement began to take
root in the course of the 1920s, the situation was different again. The
Cuban economy was dominated by sugar. In 1920 the market for
sugar crashed, and North American companies, already influential on
the island, started to buy up bankrupt mills and plantations. This led
to a strong revival of Cuban nationalism, especially among intellec-
tuals who now, for the first time, began to take an interest in Afro-
Cuban culture. Gerardo Machado was elected president of Cuba in
1924, and established an increasingly repressive régime, opposed by
strikes and student protests. In 1928 he forced the Cuban congress to
grant him a second six-year term, but in 1933 this was cut short by a
revolution which, in turn, led to the first period in power (1933–44) of

46

30 Amelia Peláez *Still Life* 1942

the military populist Fulgencio Batista. These events provide the background to the first period of Cuban Modernism. The decisive moment of change did not come until 1927, when the First Exhibition of New Art was held in Havana. A wide spectrum of progressive artists took part. One was Victor Manuel (1897–1968), generally regarded as the leader of the revolt against still lingering nineteenth-century academicism. Manuel's paintings are deliberately 'primitive' but also, in terms of their time, rather timid. Some – for example, *Gypsy Girl from the Tropics* (1929) – take occasional hints from 31 Gauguin. Others resemble the landscape paintings Tarsila was producing immediately before her Anthropophagist period, but are less decisively painted and less brilliant in colour.

47

31 Victor Manuel
Gypsy Girl from the Tropics
1929

The most attractive painter in this group of Cuban modernists is
Amelia Peláez (1896–1968), though her best work seems to have been
produced not at this time but towards the end of her career. Her most
typical paintings make use of a very Cuban motif. They show abstract
30 still lifes, generally of fruit, against brilliantly coloured backgrounds
derived from the stained-glass windows and transoms often found in
old-fashioned houses in Cuba. The saturated tropical colour, as well as
the actual subject matter, make a definite statement of Cuban identity.

The situation of the experimental Cuban artists of the period was
not an enviable one. The cultivated class was aesthetically conserva-
tive and the economy uncertain even before the worldwide
depression began in 1929. Patronage came from visiting Americans as
much as it did from Cubans – in this sense, Cuban art provided a
mirror of the Cuban situation as a whole. Batista's seizure of power
did nothing to improve the situation. He was a mulatto who had
begun his career as a sergeant in the army, and he rapidly became the
sworn enemy of the middle- and upper-class nationalists who had
agitated against Machado, and who, by the end of the latter's period in
power, had been fighting pitched battles in the streets with the police.
The artists belonged to the same social stratum as the nationalist
revolutionaries, and Batista's régime was no more likely to sympath-
ize with and patronize them than Machado's had been.

Mexican Muralism

The political situation in Mexico during the 1920s was very different from that in Cuba, and more favourable to the development of a national art. In the public eye, the primary role in the development of this new art was played by Diego Rivera (1886–1957), one of the great hero-figures in the history of twentieth-century Latin American culture. Rivera, born in the mining town of Guanajuato, was the son of a school-teacher. At the time of his birth, Mexico was ruled by Porfirio Díaz, an efficient dictator acting in the interests of the Mexican upper class. His policies included the 'scientific' use of land, brought together to form large-scale haciendas, and the encouragement of foreign investment.

Rivera's art education was thorough, and thoroughly conventional. His family had moved to Mexico City in 1892, and he studied at the official Academia de San Carlos (established in 1781) for seven years. In 1906 he was awarded a government travelling scholarship, and went first to Spain, then to Paris, arriving there in 1908. He gradually absorbed the Parisian avant-garde styles of the day, moving from Neo-Impressionism to Cubism. During this time he paid one visit to Mexico, in 1910, just before the outbreak of the savage revolution which lasted for the next decade and devastated the country. 32

By 1918 Rivera, still working in Paris, was well known in avant-garde circles. In common with a number of leading artists of the time (they included, for a brief period, Picasso) he had abandoned Cubism and was working in a consciously 'classical' style inspired by Cézanne. In 1920 he made a crucial trip to Italy, studying Giotto, Uccello, Piero della Francesca, Mantegna and Michelangelo. This trip was undertaken at the urging of Alberto J. Pani, the Mexican ambassador to France. Through Pani Rivera was in touch with José Vasconcelos, then rector of the University of Mexico. Both men encouraged Rivera to come home and devote his artistic skills to his country. In 1920, when Vasconcelos became Minister of Education in the new government of Alvaro Obregón, which finally put an end to the civil wars, Rivera decided the moment had come.

32–4 Diego Rivera *Sailor at Lunch* 1914 (*left*); *Creation*, from the Anfiteatro Bolivar mural, Escuela Nacional Preparatoria, Mexico City, 1922–3 (*below*); *The Offering*, from the Secretaría de Educación Pública murals, Mexico City, 1923–8 (*right*)

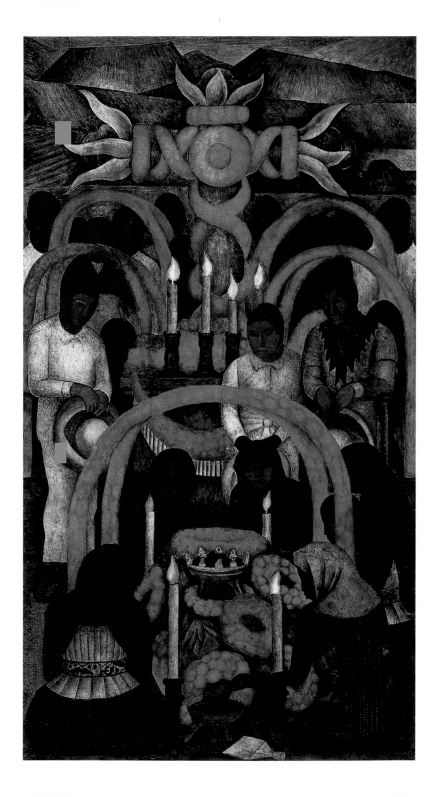

On his return to Mexico in 1921, Rivera was immediately drawn into the government mural programme planned by Vasconcelos but envisioned before the revolution by Dr Atl and others. His first murals, in the Anfiteatro Bolivar of the Escuela Nacional Preparatoria, were not as advanced as the work he had done during his Cubist period in Paris. The style was a version of what would later come to be recognized as Art Deco. Rivera's political ideas were at this point more radical than his artistic ones. In 1922 he was the leading figure in the formation of a new Union of Technical Workers, Painters and Sculptors whose manifesto borrowed the language of Russian revolutionary Constructivists, proclaiming a collective repudiation of 'so-called easel-painting and all the art of ultra-intellectual circles' in favour of art works which would be accessible, physically and intellectually, to the mass public.

Looking for an idiom in which to make good this promise, Rivera turned to the flora and fauna of Mexico itself (which he tended to see through the eyes of Gauguin and Le Douanier Rousseau), and to Pre-Columbian art. The first murals in his fully mature style, a fusion of many elements taken from the Cubists, from Gauguin, from Rousseau, from Pre-Columbian narrative reliefs and perhaps most of all from fifteenth-century Italian fresco painting, were done for the east patio of the Secretaría de Educación Pública in Mexico City in 1923. This gigantic series of compositions (117 fresco panels covering almost 1600 square metres of wall) was not finished until just over four years later. Rivera worked on them for up to eighteen hours a day. This mental and physical effort rightly established him as the leader of the new Mexican school, which the Obregón régime regarded as one of the chief means of creating a new identity for the country after so many years of turmoil.

There were, however, ironic aspects to Rivera's position. One was that, while his political beliefs implied opposition to the United States, his reputation was greatly helped by North American enthusiasm and patronage. His finest series of murals, in the loggia of the Palacio de Cortés in Cuernavaca, was commissioned in 1929 by the American ambassador to Mexico, Dwight D. Morrow. Rivera was to paint important murals in the United States itself – for the San Francisco Stock Exchange, for the Detroit Institute of Arts and for the Rockefeller Center in New York. The last of these was destroyed when only half completed, after Rivera refused to remove a likeness of Lenin. The resultant scandal raised his public profile even higher. His work had tremendous impact on the American painters of the

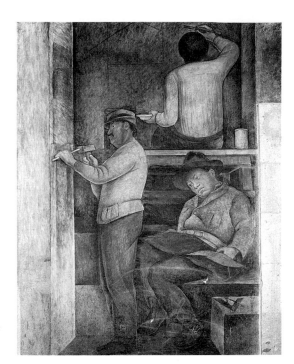

35 Diego Rivera, self-portrait from the Secretaría de Educación Pública murals, 1923–8

time, most of all upon the Regionalists, such as Thomas Hart Benton (1889–1975), who certainly did not share Rivera's political views.

Rivera's own political career, conducted very much in public, was stormy and sometimes had deleterious effects on his art. He regarded himself as a natural Communist but was frequently on bad terms with both the Mexican Communist Party and with the official Communists in the Soviet Union. He resigned from the party in 1925, was re-admitted in 1926, and then in the following year paid an official visit to Russia, from which he was ignominiously expelled at the request of the Soviet government. By 1932 he was seriously at odds with orthodox Communism and was denounced as a 'renegade'; the situation worsened when, in 1937, he was instrumental in getting President Lázaro Cárdenas to grant asylum to the exiled Leon Trotsky, who for a while lived in Mexico as Rivera's guest. The two men quarrelled before Trotsky's assassination in 1940, but Rivera, who now desperately wanted to be re-admitted to the party, had great difficulty in obtaining forgiveness. This was granted only in 1954, after many genuflections to the official Communist line, and a number of artistic compromises.

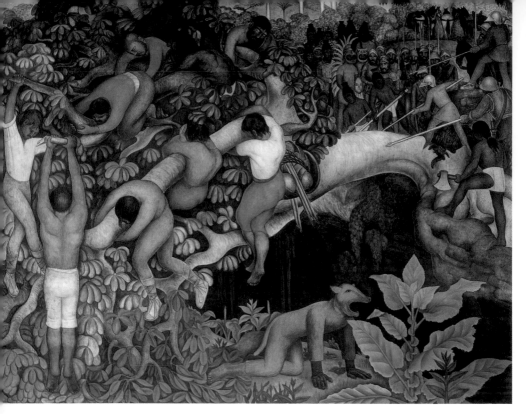

36 Diego Rivera *Crossing the Barranca*, from the Palacio de Cortés murals, Cuernavaca, Mexico, 1930–31

Rivera's stormy relationship with Communism is relevant to his relationship with the idea of Modernism. For much of his career he was trying to make art which would achieve objectives closely related to those of Soviet Socialist Realism. Rivera was a greater artist than any Stalin had at his disposal, and his work was less closely controlled than that of his Russian contemporaries. To say this, however, does not really address the main issue – that of Rivera's own aims. These were to speak directly to the Mexican people, and in order to achieve them he had to abandon much that was typical of modern art, at least in formal terms, such as fragmentation of imagery and the disguise of appearances. Above all, he had to subject himself to the demands of narrative – something which the early Modernists had been most concerned to reject.

Rivera found ingenious ways of telling stories, taking hints from
Mexican popular engravers, such as José Guadalupe Posada (1852–1913), whom the Muralists turned into a revered ancestor figure, and also from the illustrated newspapers of the time, with their ingenious interlocking lay-outs. These borrowings cannot disguise the fact that his aims remained fundamentally opposed to basic Modernist concepts. It is easier to relate what he did in Mexico to the work of Piero della Francesca and Masaccio rather than to that of Picasso and Matisse. There is even a resemblance to Annibale Carracci, whose narrative systems for the mythologies in the Farnese Gallery in Rome bear a certain correspondence to Rivera's solutions.

Two other artists, José Clemente Orozco (1883–1949) and David Alfaro Siqueiros (1898–1974) are usually grouped with Rivera to form what Mexicans call the *tres grandes*, the great triumvirate of Muralists. Their historical and sometimes personal links were close, though in personal terms at least Rivera and Siqueiros were often violently opposed. It is a mistake, however, to insist that all three artists used what were simply variations of the same idiom. Orozco, for instance, may be thought to be cruder than Rivera and his pictorial language may seem less sophisticated, but he is also more directly moving.

Orozco's beginnings as an artist were tentative. His early childhood was spent in Guadalajara, Mexico's second city, where he was born and where he was later to do his best work. When he moved to Mexico City in 1890, he was immediately attracted by the work of Posada, whose humble printshop he passed every day on his way to school. Since his family did not want him to study art, he spent three years at agricultural college, where he learnt to draw maps. He owed

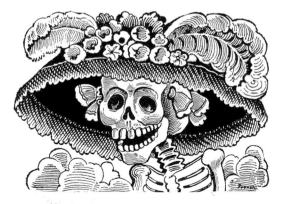

37 José Guadalupe Posada *Calavera catrina*

the final acknowledgment of his vocation to an accident – his left hand was blown off in an explosion.

The earliest independent work by Orozco shows the influence of the Symbolist Julio Ruelas; later, he fell under the spell of Dr Atl. By 1912 he had begun to make a series of drawings of pimps and prostitutes, not unlike Picasso's drawings of the same subjects made during his early years in Barcelona. Orozco also tried his hand as a caricaturist, making drawings for the partisan newspapers published during the civil wars. With typical irony, he denied taking sides: 'I played no part in the Revolution', he claimed. 'I came to no harm and I ran no danger at all. To me the Revolution was the gayest and most diverting of carnivals'. Diverting or not, it prevented him from earning a living, and he spent the last years of turmoil in the United States, working as a sign painter and later in a doll factory. He was back in Mexico in 1920, and was soon caught up in the burgeoning mural movement.

Vasconcelos put him to work, in the company of Rivera, in the Escuela Nacional Preparatoria. Here his early murals, which in their use of bold symbolic images reflected his experience as a caricaturist, soon aroused protest. In June 1924 groups of conservative students rioted. Orozco was dismissed and some of his paintings were defaced. Two years later, however, he was allowed to continue. Some notes made at this time seem to indicate his suspicion of the artistic

38–40 José Clemente Orozco
The Hour of the Gigolo 1913
(*opposite*); *Destruction of the Old
Order*, from the Escuela
Nacional Preparatoria murals,
Mexico City, 1926–7 (*right*); *The
Table of Brotherhood*, from the
New School for Social Research
murals, New York, 1930 (*below*)

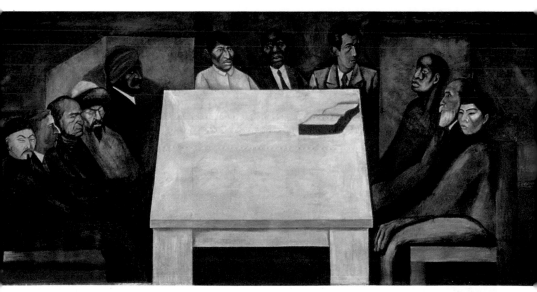

background from which Rivera came: 'Painting *that is not understood* is pseudo-cubist painting, that is, painting done with so called scientific *formulas*, imported from Paris. Such "painting" is not understood by anyone, even the one who does it.'

In Mexico City, Orozco was overwhelmed by Rivera's powerful personality, and also suffered in comparison because he did not have Rivera's experience of European art. In 1927 he once again left for the United States, and remained there until 1934. He painted murals at Pomona College, California, at the New School for Social Research in New York, and at Dartmouth College in New Hampshire. In 1932, in the middle of the Dartmouth commission, he broke off to make his first tour of Europe. This enabled him to see the great works of art which he had hitherto known only from descriptions and illustrations in books. In spite of his often-expressed suspicion of European influence, these made a great impression on him, especially the scale and power of Michelangelo's frescos in the Sistine Chapel and the intensity of El Greco's paintings in Toledo.

In 1936 Orozco returned to Mexico, at the invitation of Everado Topete, governor of the state of Jalisco, to paint murals in his native Guadalajara. After making paintings for the Assembly Hall of the University and the Government Palace, he embarked on a vast cycle of compositions for the deconsecrated church of the Hospicio Cabañas, once an orphanage. Painted at great speed, these occupied him during 1938 and 1939. The Hospicio Cabañas, designed by the Spanish-born architect and sculptor Manuel Tolsá (1757–1816), is one of the most important groups of neo-classical buildings in Mexico. The spaces in the church are austere, close to being pure geometric forms. As such, they are perfectly suited as a foil for Orozco's vehement art. The message of the murals is not a comforting one: the Indian world is perceived as cruel and savage, and the Spanish conquest as even more harsh. In one fresco a fierce El Greco-like Franciscan friar seems to threaten a kneeling Indian with a crucifix which looks more like a sword with the point held downwards. In another, the horse which carried the conquistadores to victory is transmuted into a magical but sinister machine, with a flowing tail made up of loops of chain. The colouring, mostly blacks and reds, is as harsh as the compositions.

Unlike Rivera, Orozco was not tempted to make claims that his murals were Pre-Columbian in inspiration. In fact, with his usual spirit of contradiction, he hastened to assert that the contrary was the case. In 1947 he wrote:

41–2 José Clemente Orozco, the Franciscan friar (*above*) and the horse (*below*) from the Hospicio Cabañas murals, Guadalajara, 1938–9

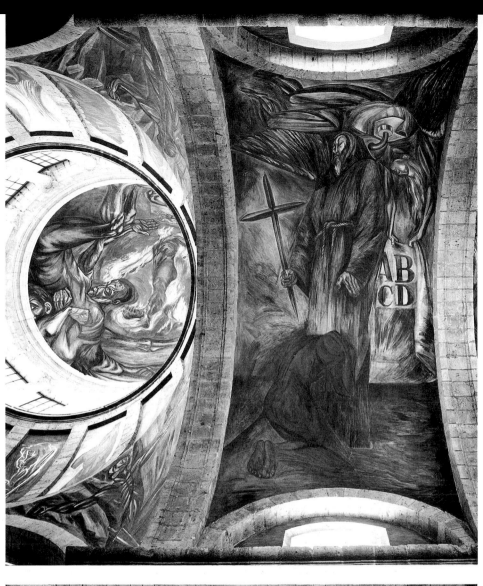

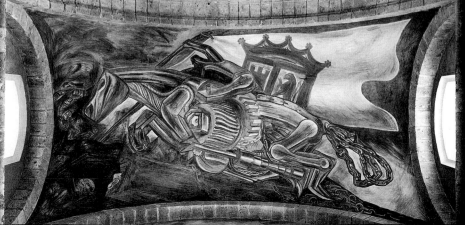

43–6 David Alfaro Siqueiros *Head of an Indian Woman* 1931 (*left*); *Untitled* 1947 (*below*); *Portrait of the Bourgeoisie*, from the Electricians' Union murals, Mexico City, 1936–7 (*right*); *The March of Humanity*, mural on the Polyforum Cultural Siqueiros, Mexico City, 1964 (*below right*)

Having studied the themes of modern Mexican mural painting, we find the following facts: all the painters begin with subjects derived from traditional iconography, either Christian or Frankish, and very often literally copied from them ... To all this outdated religious imagery very nineteenth-century liberal symbols are added. Freedom with its Phrygian cap and the indispensable broken chains ... very ancient symbols of the 'Bourgeois, enemy of progress' type still play a prominent part in murals, represented by pot-bellied toffs in top hats, or by pigs, jackals, dragons or other monsters, so well-known and familiar that they are as inoffensive as the plumed serpent.

The imagery which Orozco so contemptuously describes seems to indicate that he once again had Rivera specifically in mind.

Despite the importance of the mural commissions which Orozco received in the United States, it was Rivera who formed the image of the new Mexican art in the mind of North American critics, and it was inevitably he who was honoured with a retrospective exhibition at the new Museum of Modern Art in New York in 1931. (This was only the second retrospective show in the fledgling institution's history. The first had been devoted to the work of Matisse.) Within Latin America itself, however, Orozco seems to have had at least as much impact as Rivera on mural painting. Here his fiery pictorial rhetoric had enormous appeal.

Siqueiros, the third member of the triumvirate of Muralists, had a more erratic career, often distracted by politics from productive work as a painter. After studying art at the Academia de San Carlos in Mexico City, he fought in the civil wars and regarded himself as a battle-hardened veteran by 1919, when he went to Europe on a government grant. He made contact with Diego Rivera and in 1921 launched from Barcelona a *Manifesto to the Artists of America*. In some respects, its tone is like that of the Futurist manifestos of the pre-First World War period. 'Let us live our marvellous dynamic age!' Siqueiros exclaimed. 'Let us love the modern machine which provokes unexpected plastic emotions ...' These are phrases which might well have pleased the founder of Italian Futurism, F. T. Marinetti.

More significantly, Siqueiros recommended a return to indigenous sources, but only on terms which would be approved by Modernists:

Understanding the wonderful human resources in 'black art', or 'primitive art' in general, has given the visual arts a clarity and depth lost four centuries ago along the dark path of error. Let us, for our part, go back to the work of the ancient inhabitants of our valleys, the Indian painters and sculptors (*Mayas, Aztecs, Incas*, etc.). Our climatic proximity to them will help us to

assimilate the constructive vitality of their work. They demonstrate a fundamental knowledge of nature which can serve as a point of departure for us. Let us absorb their synthetic energy, but avoid those lamentable archaeological reconstructions ('*Indianism*', '*Primitivism*', '*Americanism*') which are so in vogue here today but which are only short-lived fashions.

Siqueiros returned to Mexico in 1922, in time to take part in the first mural campaign and, like Rivera and Orozco, worked at the Escuela Nacional Preparatoria at the invitation of Vasconcelos. Like Orozco's, his work there was interrupted by the student protests of 1924, but in his case the mural remained unfinished. His interests swung towards trade-union organization. He became the moving spirit in the Union of Technical Workers, Painters and Sculptors, and edited its journal *El Machete*. By the mid-1920s he was almost entirely absorbed in political and trade-union affairs, serving as secretary of the Communist Party of Mexico and as president of the National Federation of Mineworkers. Much of his activity was in the northern state of Jalisco, but in 1930 he participated in a banned May Day parade in Mexico City and as a result spent twelve months in prison. During this period he produced a series of small paintings which are 43 among his best works. Simple and monumental in design, they show the influence of Masaccio and other fresco painters whom Siqueiros had studied in Europe.

Having made Mexico too hot to hold him, Siqueiros left for the United States in 1932. He went to California, where he taught at the Chouinard School of Art. At this period he started to experiment with new techniques which were to be widely influential much later – spray painting and the use of photographic projectors to throw the image he wanted on the wall he planned to paint. After leaving California for Uruguay in 1933, he began to use pyroxylin paints ('Duco') of the kind used for painting automobiles – brilliantly coloured, transparent and quick drying. An interlude in Mexico from 1934 to 1936 was followed by a visit to New York, where he ran an experimental group for young painters (one of whose members was Jackson Pollock). He then left for Europe, to fight on the Republican side in the Spanish Civil War. After the war had reached its miserable conclusion, he returned to Mexico and was finally able to complete a mural in his own country. His *Portrait of the Bourgeoisie* in the 45 headquarters of the Electricians' Union in Mexico City shows the flamboyant qualities of Siqueiros's mural style, and the typical twisted perspectives which make his figures and groups seem about to detach themselves from the walls.

47 Pablo O'Higgins *Indian Wedding in San Lorenzo*, from the National Museum of Anthropology mural, Mexico City, 1964

Even at this point Siqueiros was not yet ready to retire from conspiracies and the excitements of revolutionary politics. He led an unsuccessful attempt to assassinate the exiled Trotsky, and had to flee the country. He returned in 1944, and this was the point at which he started to paint more regularly. Most of his major mural projects belong to the last thirty years of his life – to a period when, ironically, Muralism was being seriously challenged by other styles and other ways of thinking. His paintings and his personal legend remained intertwined, and the dramatic events of his life seemed to be echoed
44 by the flamboyantly dramatic, unrestrained nature of his art. His most
46 astounding creation, the Polyforum Cultural Siqueiros, was completed shortly after another, and final, period of imprisonment from 1962 to 1964. Siqueiros wanted to mould space by means of his art, and here the architecture and the painted design form a complete unity – no distinction is made between the paintings and the structure they cover. Siqueiros's brutal, over-lifesized designs give the outward-sloping surfaces of the exterior a disturbingly vertiginous character. The proclaimed subject, *The March of Humanity*, seems to

be irrelevant. This is essentially a monument to the artist himself, and an assertion of his importance within the framework of Mexican cultural and political life.

The *tres grandes* were not the only Mexican muralists. Other artists drifted into, and sometimes out of, Muralism's orbit. Some, such as the French-born Jean Charlot (1898–1979) and the San Franciscan Pablo (Paul) O'Higgins (1904–83), were foreigners lured by the spell of the Muralist movement. Charlot arrived in Mexico in 1921, more or less by accident. His grandfather had been an officer in Emperor Maximilian's army, and Charlot wanted to retrace his footsteps. Arriving at an opportune moment, he was promptly recruited for work in the Escuela Nacional Preparatoria, and was in fact the first artist to complete a mural there, as an inscription testifies. Not surprisingly, his early style was heavily dependent on Diego Rivera. Later he drifted into archaeological studies, and later still emigrated to the United States, where at one point he worked for Disney Studios in Los Angeles, and published a book with the title *Art from the Maya to Disney*. He continued to paint murals in Mexican style while living in the United States. Some of his most ambitious work was done in the 1940s at the University of Georgia. His murals in the 48–9 School of Journalism (1943–4) show a continuing interest in Pre-Columbian themes. The conquest of Mexico by Cortés is paired with the conquest of Europe by American paratroops. Although Rivera's influence was still strong in his work, it was academicized; the Spanish conquistadores on their horses, for example, are seen in terms of Uccello's *Rout of San Romano*.

Pablo O'Higgins arrived in Mexico in 1927, and worked as Rivera's assistant for some years before embarking on independent work. He is perhaps best known for a mural in the National Museum 47 of Anthropology in Mexico City, which he painted in the 1960s. This shows scenes of life in ancient western Mexico and the landscape setting owes something to Dr Atl.

The most interesting of the less acclaimed artists in the Mexican Muralist movement was Juan O'Gorman (1905–82), born in Mexico of Irish parents. He began his career as an architect, a disciple of Le Corbusier and the International Modern style. He started to paint seriously in 1935, and was for a while an admirer of the great nineteenth-century landscapist José María Velasco, who has been mentioned in Chapter One. His paintings of the 1940s, in tempera on 50 masonite, show an obsessive care for detail, and are reminiscent not 15 only of Velasco but of Mexican *retablos*, the small votive pictures

1520 · EMPEROR MONTEZUMA'S SCOUTS COVER AMERICA'S FIRST SCOOP · COR

ANNO DMI 1944 · PRESS AND CAMERAMEN FLASH ON THE SPOT NEWS · WORLD W

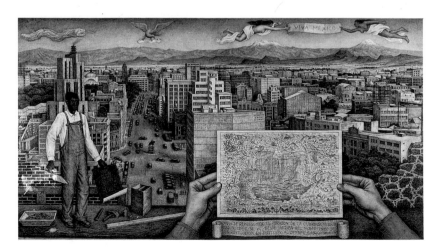

VIVA MEXICO

50–51 Juan O'Gorman *Mexico City* 1949 (*below left*); *The Colonial Past*, mosaic on the Central Library, Mexico University, Mexico City, 1952 (*above*)

made for Mexican churches. O'Gorman's fascination with intricate pattern and detail is also apparent in large-scale mural compositions which have no trace of the sweeping rhetoric typical of Orozco and Siqueiros.

O'Gorman's most remarkable achievement is the mosaic decoration he devised for the exterior of the Central Library of Mexico University. The flat, almost windowless surfaces of the library tower are covered in intricate designs made of native stones, producing an effect that is more like woven cloth than like painting. The designs are of Pre-Columbian inspiration. They certainly show no concern for narrative, and the contrast with Siqueiros's treatment of architecture in the Polyforum is very striking. The building and its decoration rightly became a symbol of the ability of Mexican artists to revive certain aspects of the Indian past without seeming sentimental or nostalgic.

51

46

48–9 Jean Charlot *Cortés lands in Mexico* (*above left*) and *Paratroopers land in Sicily* (*centre left*), from the University of Georgia murals, Athens, Georgia, 1944

52 Cândido Portinari *Economic Cycle*, from the Ministry of Education mural, Rio de Janeiro, 1937–47

Muralism Beyond Mexico

As has already been noted, Mexican Muralism had a major impact in the United States, influencing Thomas Hart Benton and the Regionalists. Not surprisingly, the movement also had great influence in Latin America itself, though here the results were (perhaps paradoxically) more dubious. Removed from its original Mexican context, Muralism rapidly became an official style. It checked rather than aided the development of Modernism. The reasons for its success are easily understood. It seemed to offer all Latin American artists, not only Mexican ones, a distinctive idiom of immediate relevance to their own experience. It also provided a vehicle for political, social and cultural concerns and ideas at a time when increasing agitation for social justice was, not surprisingly, almost automatically combined with a wish to return to indigenous roots.

Muralists appeared in almost all Latin American countries; predictably, they were especially successful in those whose culture still retained a strong Indian element. The precise moment of their emergence did, however, depend on prevailing political conditions. Thus, in the Andean countries, Muralism established itself earlier in Ecuador and Colombia than it did in Bolivia, where it did not flourish until the Socialist revolution of 1952. In Peru, the cradle of intellectual *indigenismo*, there were few opportunities to paint murals except in private houses, but a strong *indigenista* presence did nevertheless establish itself in Peruvian art.

Perhaps the most original mural work, deviating widely from the Mexican model, was done in Ecuador and Brazil. In Ecuador, the first important convert to Muralism was Eduardo Riofrío Kingman (1913–98). Like a number of other Latin American artists, his first opportunity to do important mural work came thanks to the New York World's Fair of 1939, where he provided paintings for Ecuador's national pavilion. His imagery, featuring scenes of Indian life, was 53 heavily influenced by Diego Rivera. Kingman returned to Quito in 1940 and founded the Caspicara Art Gallery, which became a focus for progressive artistic activity. After a stint on the staff of the San Francisco Museum of Art immediately after the Second World War,

53 Eduardo Riofrío Kingman
Boy with Flute 1941

he returned to his native country for a second time in 1947, and became director of the National Museum and the National Artistic Heritage.

By this time, however, his reputation was already beginning to be overtaken by that of his slightly younger fellow-countryman Oswaldo Guayasamín (1919–99). One of ten children from a poor mestizo family. Guayasamín began his career in traditional style by being expelled from the Quito School of Fine Arts. In 1941 he had a first, immensely successful show at the Caspicara Gallery in Quito, and attracted the attention of the American millionaire Nelson Rockefeller, a major collector of Latin American art, who purchased several paintings. Thanks to Rockefeller's patronage, Guayasamín was able to visit the United States and successfully exhibit there; the Museum of Modern Art in New York purchased a small painting of the head of a child, heavily dependent on Diego Rivera in style. In 1943 Guayasamín went to study with Orozco in Mexico and changed direction, starting to evolve towards a version of Expressionism. This was later combined with ideas borrowed from Cubism, especially the later figure paintings of Braque.

Guayasamín was a hugely prolific artist, making murals (the first, in 1948, were for the Casa de Cultura in Quito), easel paintings and prints. By the 1960s he had carried the rhetoric inherited from

54

55

70

54 Oswaldo Guayasamín
My Brother 1942

55 Oswaldo Guayasamín
Marimbas

Orozco to new extremes, and his work had become a disconcerting mixture of the frantic and the brutal, all gaping heads and enormous clutching hands. At the peak of his career he also became one of the best-known of all Latin American artists and very much an 'official' personality, serving as Ecuadorean cultural attaché in Peru, Chile, Argentina and Bolivia. To denigrate his work seemed to be almost equivalent to denigrating Latin American culture itself.

Cândido Portinari (1903–62), a Brazilian of Italian descent, was another very productive painter, usually cited in historics of Brazilian art as a home-grown equivalent of Diego Rivera. In fact this seems to show a misunderstanding of his gifts, which were very different from Rivera's. It is true that Portinari came early to mural painting. His first venture, a copy of a fresco by Fra Angelico, was painted in 1933. In 1937 he began an important series of paintings for the Brazilian Ministry of Education in Rio de Janeiro, which were not completed until 1947. In 1939 he, like Kingman, worked at the New York World's Fair, painting murals for Brazil's national pavilion. This was followed by a series of compositions for the Library of Congress in Washington D.C. and a final, major mural for the United Nations building in New York.

56–7 Cândido Portinari *Portrait of Paulo Osir* 1935 (*left*); the tile decoration designed by Portinari for the church of San Francisco, Pampulha, Belo Horizonte, 1944 (*opposite*)

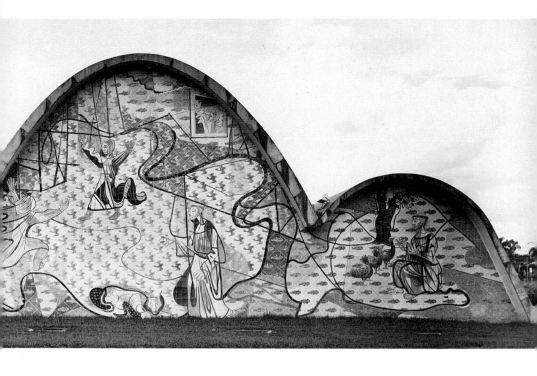

Portinari's style as a muralist initially owed much to Rivera and in this he resembled the mural painters from Andean countries who were his contemporaries. His mural work gradually became more personal, looser and more painterly. These later paintings have much closer links with his work as an easel-painter. His numerous paintings in smaller formats are often extremely Derainesque and, apart from their excursions into specifically local subject matter, are thus not immediately recognizable as Latin American. In these easel paintings, Portinari closely resembles his Brazilian colleague Di Cavalcanti. In fact, his whole development, even in the murals, seems to show that he became increasingly distanced from indigenous subject matter, rather than closer to it. It shows, too, that he was always more interested in obtaining a pleasing decorative effect than in putting across a political message. Some of his most original later work, done in collaboration with the great Brazilian Modernist architect Oscar Niemeyer, consists of wall decorations carried out in *azulejos*, the painted and glazed tiles traditional in Portugal and also used extensively in Brazilian colonial architecture. The tiled exterior walls which Portinari designed for Niemeyer's church of San Francisco at

56

57

58 Luis Acuña
1960s sculpture in the Museo
Luis Acuña, Villa de
Leyva, Colombia

59 (*below*) Alandia Pantoja
Bolivian Medicine, from the
Workers' Hospital mural, La
Paz, 1957

Pampulha, Belo Horizonte, show his considerable decorative abilities working at full stretch.

Another strongly decorative artist affiliated to the Muralist movement was the Colombian Luis Alberto Acuña (1904–94), who worked as a sculptor and mosaicist, as well as both a muralist and a painter of easel pictures. Acuña came into direct contact with the leading Mexican artists of the period when he served as Colombian cultural attaché in Mexico from 1939 to 1941. Even before this, however, he had been producing paintings illustrating Indian myths and legends, using ideas borrowed from European Symbolism and from Gauguin as well as from Rivera.

In recent years Acuña's reputation in Colombia has been somewhat eclipsed by the success of younger artists – for example, Fernando Botero and Alejandro Obregón – and he has been perceived as the symbol of everything against which Colombian art must rebel if it were to achieve its own identity. The small personal museum devoted 58 to his work in the colonial town of Villa de Leyva suggests that he deserves better than this. The ideas behind his art are naïve but his gift for handling colour, pattern and texture is undeniable.

The leading Bolivian muralist, Miguel Alandia Pantoja (d. 1975), is a less immediately attractive artist. His work is closely related to that of Orozco, but it is Orozco sweetened and simplified. His murals were executed for the headquarters of the Miners' Union in Catavi, in 1946–7, but his real opportunities arrived with the Socialist revolution of 1952, which created a demand for work with a strong propagandist content. Typical of this phase is Alandia Pantoja's mural of 1957, 59 *Bolivian Medicine*, in the auditorium of the Hospital Obrero (Workers' Hospital) in La Paz. The imagery, with native animals and flowers to the left and a dominant Indian medicine man conjuring an

enormous serpent in the centre, seems to suggest that modern science, symbolized by rather cowed-looking figures to the right, is inferior to inherited indigenous wisdom. Entering at the extreme right, a group of miners seems to threaten the representatives of Westernized modernity. Alandia Pantoja has one important rival, Walter Solón Romero, a Bolivian pupil of Siqueiros. His work is considered more 'historical' – that is, less politically committed – by Bolivian critics but he effectively dominated the small art scene that existed within Bolivia itself from the time of his emergence in the mid-1940s until his death in 1975. Any Bolivian artists who made reputations working in other, non-*indigenista* styles, made them outside their country of origin.

A more celebrated example of an artistic 'dictator' committed to the cause of *indigenismo* can be found in Peru. José Sabogal (1888–1956) belonged to an earlier generation than that of Guayasamín, Portinari or Acuña, all of whom were born after the beginning of the century. In terms of artistic background, he bridged two of the chief Latin American cultures, first studying art in Argentina, then spending six months in Mexico in the 1920s, just at the start of Vasconcelos's first mural project. This obviously made a strong impression on him, but an even more indelible one was made by the writings of his friend Mariátegui (discussed in the Introduction). Sabogal became director of the official School of Fine Arts in Lima in 1932, but lost the post just over a decade later and then founded a Free Institute for Peruvian Art based on the Museum of Anthropology. His influence over Peruvian painting and sculpture remained preponderant until his death.

Partisans of *indigenista* theories of Latin American art tend to find Sabogal a grave embarrassment: he contradicts the idea that *indigenismo* in Latin American art is indissolubly linked to Modernism. His most typical paintings are the Peruvian landscapes he produced in the 1930s. Placed in a European context (and they are in fact European in style though not in subject matter), their most obvious links are with the 'ethno-Symbolist' works being produced in Moscow and St Petersburg just at the turn of the century by artists such as Roerich, Andrei Ryabushkin (1861–1904) and Boris Kustodiev (1878–1927). All of these were affected by the Pan-Slavism characteristic of Russian culture at that time, and none were enthusiastic for the new avant-garde developments taking place in Paris. Sabogal similarly turned his back on developments such as Fauvism and Cubism, and persuaded Peruvian artists to do the same.

Despite Sabogal's keen consciousness of his messianic role in Peruvian art and his success in instilling this consciousness into those who surrounded him, his connection with Indian culture remained superficial. His pictures offer representations of Indian life without in any way participating in it.

60

60 José Sabogal *Young Girl from Ayacucho* 1937

The Exiles

While Muralism combined with the *indigenista* impulse produced major artists in Mexico, its effect in the rest of Latin America was largely to shut the door on Modernism, just as this had begun to open. The exceptions were artists who spent most of their time abroad. From the very beginning of the Independence period Latin American governments had regularly offered prizes and bursaries to enable young artists to study elsewhere. Those who came from prosperous families also often went to Europe unassisted. Most of these travellers eventually returned to live and work in their native countries, but a good proportion – like the Colombian Andrés de Santa María – spent the greater part of their lives away from Latin America.

The artistic, and sometimes too the political, situations which prevailed in Latin America in the period from 1930 to 1950 meant that the most important experimental artists, and certainly those with the closest links to mainstream Modernism, tended to be those who divided the bulk of their time between Europe and the United States. A partial exception to this, in the sense that his belated return home had a real and long-lasting impact on art in his native region, was the Uruguayan Joaquín Torres-García (1874–1949), who came back to live in his native country in 1934, at the age of fifty-nine, after an absence of more than forty years. During the time left to him Torres-García offered what was really the first serious challenge to the dominance of Muralism.

Torres-García was born in Montevideo, then a relatively small city of 135,000 inhabitants, of a Catalan father and a Uruguayan mother. He had known from early adolescence that he wanted to be an artist, but it was only in 1891, when he was seventeen and the family moved to Spain, that he began to study painting seriously. His first individual and independent works were in the *fin de siècle* style of Steinlen and Toulouse-Lautrec, then common currency in Barcelona, where Torres-García moved in the avant-garde circle which also included the young Picasso.

His first ambition was to be a muralist and painter of public art works rather in the style of the French academic Symbolist Puvis de

79

Chavannes. This was frustrated by Spanish cultural backwardness and by the deteriorating political situation in Spain. In 1920 he made the first of many moves, going to New York, where he met Marcel Duchamp, Joseph Stella, Max Weber and the composer Edgar Varèse. Although initially delighted with the openness and friendliness of American society, he failed to take root there and by 1924 was back in Europe. At first he lived in Italy, which was in the early stages of Mussolini's Fascism. Disliking this, he moved to France and in 1926 settled in Paris.

The move was to be decisive for his artistic development. Torres-García's painting had long shown a strong tendency towards simplification and compartmentalization. From 1918 onwards, this 62 was reinforced by his interest in making wooden toys. These, which sprang directly from his own childhood roots (his father had run a dry goods store and carpentry shop in Montevideo), consisted of simple elements which could be combined to make more complex shapes: buildings, animals in different postures, and automobiles.

Torres-García seems to have thought of the toys as a way of earning a better living than art alone could provide, and made repeated attempts, always unsuccessful, to manufacture them on a commercial basis. What they did, in fact, was to change his own approach to art, by demonstrating how intricate compositions could be built up from the simplest 'building blocks'. When he got to Paris he rapidly 4 became a member of the international Constructivist circle which had sprung up in opposition to the Surrealists. He met Theo van Doesburg, founder of the magazine *De Stijl*, and van Doesburg wrote an admiring article about him. He also met the young Belgian critic Michel Seuphor, who led him to Piet Mondrian. In 1929 Torres-

62 Joaquín Torres-García, a set of wooden toys, 1928–9

García and Seuphor were the moving spirits in the foundation of a new international Constructivist Group, Cercle et Carré. This expanded very rapidly and came to include many of the more distinguished foreign artists then living in Paris. However, when it was replaced in the following year by Abstraction-Création, a new grouping with many of the same participants, Torres-García found himself less sympathetic to the direction the Constructivist movement was taking, largely because of the renewed emphasis on absence of figuration.

Torres-García's own work, in his Paris period, was sometimes entirely abstract – for example, in some severe wooden constructions made under the direct influence of Mondrian. More often he painted complex works featuring grids, where figurative references, 61 especially to urban architecture, can still be seen clearly. The multiple compartments in these compositions are usually filled with symbolic objects: fish, clocks, anchors, keys, stars and ships, to which specific meanings can be attached so that the painting is also a kind of text. In Paris, as later in Montevideo, Torres-García also continued to produce some entirely figurative works, still lifes, heads, genre scenes and seascapes, though these seem to have been painted from memory. The paintings of this type have an engaging primitivism which distantly recalls the work of Torres-García's compatriot, Pedro Figari.

In 1932 Torres-García was forced to abandon Paris because of the world-wide economic depression, which was now having a marked effect on the Parisian art world. He went to Spain, discovered that things were if anything still worse in that country, and made the decision to return to Montevideo. He was the only major artist discussed in this chapter to achieve a full reintegration into Latin American society.

His return to Uruguay did not fundamentally alter his art, but there were changes in response to local conditions. For example, he was able to return to painting murals (very different from those in the Mexican tradition, since they were essentially enlargements of his more complex easel paintings). Murals had already been one of his preoccupations during his youth. Struck by the cultural dependence on Europe which he found in Montevideo, he began to look more closely at Pre-Columbian art. Allusions to this became part of his repertoire of symbols, though the personal alphabet which he invented at this time was based on Phoenician characters rather than on any Amerindian writing system.

63 Joaquín Torres-García *Cosmic Monument* 1939, Parque Rodó, Montevideo

63 The most obviously *indigenista* work produced by Torres-García during this final period in his career is three-dimensional – the *Cosmic Monument* in the Parque Rodó in Montevideo, completed in 1939. This was the practical outcome of the studies for monumental works he had been making for some time and resembles a miniature Aztec or Maya temple, its surfaces covered in glyphs.

 Once based in Uruguay, Torres-García became an active propagandist for the kind of art he supported. He founded the Asociación de Arte Constructivo in Uruguay, and began to issue a magazine called *Círculo y Cuadrado* (*Circle and Square*) which appeared, though only at irregular intervals, until the end of 1943. It contained articles by, among others, major international artists including van Doesburg, Mondrian and the former Futurist Gino Severini. In 1943 he opened the Taller Torres-García in Montevideo to instruct young artists in Constructivist ideas and technique. This was to have a direct influence on the development of Latin American art in the immediately post-Second World War period.

Because of his directly pedagogic activity in the final decade and a half of his life, Torres-García's influence on the development of Latin American art is in fact more directly quantifiable than that of two other Latin American exiles who are often mentioned in almost the same breath – the Cuban Wifredo Lam (1902–1982) and the Chilean Matta (1911–2002). Both were closely connected with the Surrealist movement, whereas Torres-García, as we have seen, was allied to Surrealism's chief opponent in the Parisian avant-garde, International Constructivism.

Lam came from a background which was exotic even by Latin American standards. His father, Lam Yam, who had emigrated to Cuba from Canton, via San Francisco and Mexico, was a Chinese shopkeeper in the small provincial town of Sagua la Grande. His mother, Lam Yam's second wife, was a mulatto with some American Indian blood. Lam was the last of eight children and his father was already eighty-four when he was born. During his childhood, Lam became familiar with the *candombe* rites inherited by black Cubans from their African forebears – his godmother was a *candombe* priestess.

His family were nevertheless sufficiently prosperous and middle class to be able to send him to Havana to be educated, and then to Spain. Having already had some training as an artist in Havana, he arrived in Spain at the end of 1923, and was to remain there for fifteen years. His work from this period (of which very little survives) seems 64 to have been relatively conservative, though showing some influence from early Cubism. He did, however, discover the paintings of Bosch in the Prado, and Palaeolithic, Neolithic and Iberian art in the Archaeological Museum in Madrid. His belated departure for Paris was the direct result of the Spanish Civil War, in which he fought on the Republican side, taking part in the defence of Madrid. While in hospital because of an intestinal infection contracted during the campaign, he met the sculptor Manolo (Manolo Huguë), an old friend of Picasso, and this, together with the fact that it was now impossible to make a living as an artist in Spain, supplied the impulse to depart. Lam arrived in France in 1938, presented a letter of introduction from Manolo, and immediately gained Picasso's friendship. He had much in his favour: the charm of his personality, his exotic origin and appearance, and above all his involvement with the Republican cause. Picasso introduced him to a number of major artists and dealers, made plans to exhibit with him (there was a shared exhibition at the Perls Gallery in New York in 1939) and, perhaps most importantly of all, presented him to André Breton and

64 Wifredo Lam
The Window 1936

Benjamin Péret, leaders of the Surrealist movement. It seems to have been Picasso and the Surrealists who between them introduced Lam to primitive art, Oceanic as well as African. In this sense, they imposed on him a vision of what they thought he ought to be like, because of his background and appearance. Circumstances, however, were soon to reinforce these influences, by taking him back to his native Cuba.

The paintings which Lam made immediately after his arrival in Paris, the earliest substantial group of his work to survive, show strong traces of Picasso's influence, although more that of the *Demoiselles d'Avignon* (1907) and the work of the so-called Negro Period than of what Picasso was doing in the late 1930s. In some cases they are almost direct transcriptions of African carvings. A rapid evolution, however, took place in the early 1940s, amid the tumult of world events. Lam, like many others, fled from Paris after the German invasion of 1940, and made his way to Bordeaux, mostly on foot. He

was later able to rejoin the leading members of the Surrealist group in Marseilles. His presence there seems to have cemented his relationship with them, despite the fact that his work, with its strongly Cubist element, deviated in many ways from orthodox Surrealism.

In 1941 he and three hundred other French and French-affiliated intellectuals made a slow, unpleasant and perilous voyage to the West Indies aboard the SS *Capitaine Paul-Lemerle*. Breton was one of their fellow-passengers, as was the anthropologist Claude Lévi-Strauss, who has left a vivid description of the journey in his book *Tristes Tropiques*. On arrival in Martinique most of the passengers were interned, among them Lam. Breton was treated more leniently, and it was through him that Lam was able to make the acquaintance of the Martiniquan poet Aimé Césaire, then a school-teacher on his native island. Césaire had just published fragments of his first masterpiece *Cahier d'un retour au pays natal*. His work was to become the touchstone of the new intellectual *négritude*, which manifested itself first in French literature:

To me my dances,
My bad-nigger dances;
To me my dances,
The choker-cracking dance,
The prison-break dance,
The-dance-that-says-it's-good-and-fine-and-right-to-be-a-nigger.

Even after reaching Martinique it took Lam seven more months to reach Cuba. On his eventual arrival there, his impressions, after his long absence, were not favourable. As he explained to the critic Max-Pol Fouchet:

Since I had left everything behind me in Paris, I had to start from scratch, as it were, and I no longer knew where my feelings lay. This filled me with anguish, because I found myself in much the same situation as before I left Cuba, when I had no great horizons before me. If you want to know my first impression when I returned to Havana, it was one of terrible sadness.

And he added:

Havana at that time was a land of pleasure, of sugary music, mambas, rumbas and so forth. The Negroes were considered *picturesque*. They themselves aped the whites and regretted that they did not have light skins. And they were divided – the blacks disdained the mulattos, and the mulattos detested their own skin because they were no longer like their fathers, but were not white either.

It was this negative reaction to the Cuban environment, as he re-encountered it after his long absence in Europe, which led him to resolve to 'thoroughly express the negro spirit'. The paintings in what is now Lam's most familiar style spring directly from this impulse. A celebrated example is *The Jungle*, painted in Cuba and first exhibited in 1944, at the Pierre Matisse Gallery in New York. It caused a scandal because of its supposed ferocity, but also because Lam had refused to participate in an exhibition of Cuban art which was taking place at the Museum of Modern Art at the same moment. This refusal was a mark of his disillusionment with the current Cuban régime.

The Jungle is typical of Lam's mature work in many respects. It makes use of a polymorphism which associates human, animal and vegetable life; it alludes to African art, and especially to African masks. A closely integrated, frieze-like composition binds four figures together and knits their bodies into a densely growing thicket of jointed stems. This thicket, in turn, helps to create a picture space which is simultaneously claustrophobic and disturbingly undefined. It is in fact a more ambitious variant of the original 'shallow space' of Synthetic Cubism (as, for example, in the two versions of Picasso's *Three Musicians*), where figures and objects seem to float in a narrow area just behind the picture-plane. Lam's figures are vertically elongated thanks to their ribbon-like arms and legs, which have scarcely any modelling. They have huge feet, vestigial torsos and bulging buttocks and breasts, swollen like ripe fruit. Lam described his intention in painting the picture as follows:

When I was painting it, the doors and windows of my studio were open and the passers-by could see it. They used to shout to each other: 'Don't look, it's the Devil!' And they were right. Indeed, a friend of mine says that in spirit it is very close to certain medieval representations of hell. In any case, the title has nothing to do with the real countryside in Cuba, where there is no jungle, but woods, hills and open country, and the background of the picture is a sugar-cane plantation. My intention was to communicate a psychic state.

I think that from my childhood there had been something in me that was leading me to this picture. Le Douanier Rousseau, you know, painted the jungle, in *The Dream*, *The Hungry Lion*, *The Apes*, with huge flowers and serpents. He was a magnificent painter, but not the same kind of painter as I am. He does not condemn what happens in the jungle. I do. Look at my monsters and the gestures they make. The one on the right proffering its rump, as obscene as a whore. Look, too, at the scissors in the upper right-hand corner. My idea was to represent the spirit of the negroes in the situation in which they were then. I have used poetry to show the reality of acceptance and protest.

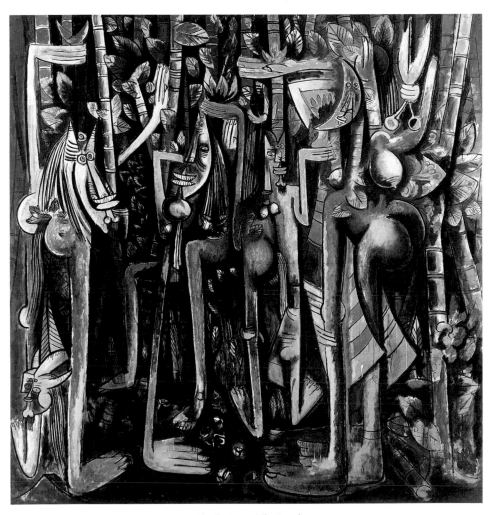

65　Wifredo Lam *The Jungle* 1943

One of the peculiarities of *The Jungle*, however, is that it was clearly not created for a Latin American audience (as the work of the Mexican Muralists was). Its job was to describe the reality of Latin America, or at any rate one aspect of that reality, to people outside the region.

66 Lam's mature style, once established, did not vary much, though he deepened his experience of inherited African customs by making a four-month visit to Haiti, where the voodoo ceremonies he attended sharpened his interest in Afro-Caribbean imagery. After dividing his time between Cuba, New York and Paris for ten years, he settled again in Paris in 1952. His implacable opposition to the Batista régime of the 1950s meant that he gave a warm welcome to Fidel Castro, who came to power in 1959. One of his functions thereafter was to recruit support for the new revolutionary government among the intellectuals of Western Europe. The culminating points of this process of courtship were the transfer to Havana of the complete Paris Salon de Mai in 1967 and the Havana Cultural Congress of 1968. After this the close relationship between the intellectual left in Europe and the Castro government gradually began to sour, though not through any fault of Lam's. However, he remained a cosmopolitan rather than a fully Latin American figure, married to a Swedish wife and dividing most of his time between Paris, where he was now a respected senior figure in the French art world, and Albisola Mare, near Genoa, where he kept his main studio.

Even more obviously a citizen of the world is the Chilean-born Matta, who spent none of his adult life in his native country, apart

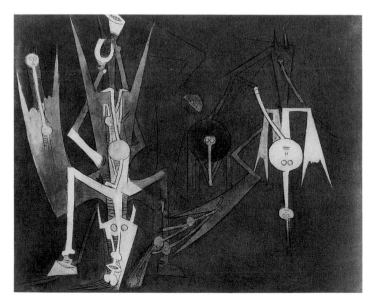

66 Wifredo Lam
The Entry 1969

from rare and fleeting visits, and who during the Pinochet régime in Chile sometimes insisted on being described as Cuban rather than Chilean. Matta's ancestors were Basque, Spanish and French. He came from a conventional upper-class background, and was educated by the Jesuits at Santiago's Catholic University. He soon rebelled against both his family and his education, and left Chile in 1932. One factor in this decision was the fact that Chile was experiencing a period of extreme political and economic instability: there were ten governments in eighteen months after the fall of the dictator Carlos Ibáñez del Campo in 1931.

Matta made his way to Paris, then as now a magnet for Latin Americans, and found a job in the office of the leading Modernist architect Le Corbusier. It was in a sense a false start. Le Corbusier was linked to the Cubists and the Constructivists and the kind of rationalism he represented was never likely to appeal to the young Chilean. Among the early friends he made in Europe were the Spanish poets Rafael Alberti and Federico García Lorca, and in general major influences on him at this period seem to have been literary rather than artistic ones. His compatriot, the Chilean poet Gabriela Mistral, introduced him to the writings of José Martí. This Cuban poet and patriot had died in 1895, but his work and the legend of his personality served to kindle liberationist movements throughout Latin America. In due course Fidel Castro was to make Martí the idealized hero-figure who presided over his own struggle against Batista. There was also the influence, via Alberti and Lorca, of the great Spanish hermetic poet Luís de Gongora y Argote (1561–1627).

In 1936 Lorca introduced Matta to his old friend Salvador Dalí. Through Dalí he met Breton and in 1937 some of his drawings appeared in a Surrealist exhibition; in 1938 he started to paint. Although he had come to Surrealism via Dalí, his drawings and paintings had none of the meticulous 'veristic' quality of the latter's work but had, instead, evolved from the long-established Surrealist practice of automatic writing.

As the political situation in Europe darkened, Matta became one of the first members of the Surrealist group to make his way to New York. Young (he was still only twenty-eight) and adaptable, he became an important emissary who brought the members of the nascent American avant-garde into contact with European ideas. The earliest paintings made in the United States offer imagery appropriate to the times, but also show very clearly their derivation from Surrealist automatic processes. They depict a turbulent universe

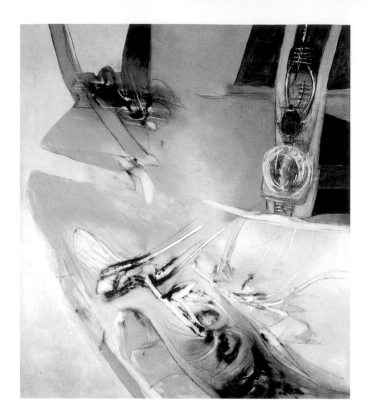

67 Matta
Composition 1945

which is being born out of chaos; much of the imagery has been
developed through a controlled use of accident, so that the work
seems still to be in the process of becoming. Matta's use of painterly
accident was to have a strong influence over the development of
67 American Abstract Expressionism. His employment of biomorphic
imagery, a function of his persistent interest in eroticism, was also to
be important for American painters, especially Arshile Gorky.

In 1941 Matta made a trip to Mexico in the company of Robert
Motherwell – his first direct contact with the Latin American milieu
since he had left Chile nearly a decade previously. The prestige of
Rivera and the other Muralists was then at its height, but Matta seems
to have paid no attention to their work. What interested him was
Aztec and Maya art. He was particularly fascinated by Pre-
Columbian astrological calendars, which seemed to offer the key to an
intricately structured universe governed by fantastic divine beings.

90

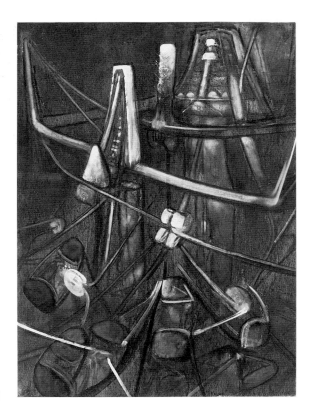

68 Matta
Tendre Mie 1955

Matta was able, in his own mind, to link these conceptions with the
energy and mystery of modern science. From the mid-1940s onwards
his work featured machines which were as much examples of fantasy 68
in their own way as the hierarchies of Pre-Columbian gods, and he
evolved a personal mythology reminiscent of Science Fiction (then
just starting to emerge in the United States as a grass-roots literary
form) and opposed to the nostalgic refinements of standard bourgeois
culture. Long before the emergence of Pop Art Matta, while
remaining in most respects a typical made-in-Paris intellectual,
showed an instinctive sympathy for forms of expression which were
rooted in the new urban mass.

It is no accident that much of his recent work, and in particular the
paintings and drawings made from the 1960s onwards, shows a 69
fascination with comic strips. Matta combines these with ideas taken
from Aztec, Mixtec and Maya codices, which also use a version of the

'strip' format, and from European sources such as the drawings of deluges made by Leonardo da Vinci and the paintings of Hieronymus Bosch. Matta's cultural polymorphism matches the actual polymorphism typical of much of his work. It was a characteristic that by the end of the 1950s was to become typical of twentieth-century Latin American art in general, and in this sense Matta can be thought of as a true precursor. Nevertheless, in the historical sense he was, and has remained, an isolated figure. In terms of direct influence, he had more impact on the first generation of New York Abstract Expressionists than on any Latin American artists. Without him, Abstract Expressionism would perhaps not have taken the form it did.

In 1948 Matta separated himself from the Surrealist movement, and left the United States in order to live in Europe, dividing his time between Italy, Paris and London. His interventions in the artistic affairs of Latin America were always those of a prestigious outsider, often taking the form of self-conscious expressions of 'solidarity' with left-wing causes, such as the murals, complete with revolutionary slogans, painted in Santiago de Chile for the Popular Unity Muralist Brigade during the short-lived régime of Salvador Allende (1970–3). These murals, enlargements and simplifications of Matta's easel paintings, have no stylistic link with the long-established Mexican tradition.

Between them, Lam and Matta played a major role in creating the idea that twentieth-century Latin American art was essentially Surrealist – a myth now firmly entrenched in most histories of Latin American culture. The other components were the International Surrealist Exhibition held at the Galería de Arte Mexicano in Mexico City in January and February 1940 and the Magic Realism practised by a number of leading Latin American novelists, among them the Colombian Nobel Prize-winner Gabriel García Márquez.

Something should perhaps be said about that Surrealist exhibition in Mexico, if only to dispel some of the misconceptions that have surrounded it. The chief organizer was the Czech painter Wolfgang Paalen (1905–59), assisted by Breton, who was then living in Mexico, and the Peruvian poet César Moro. Paalen, born in Vienna, had already had a varied career in European avant-garde circles before coming to Mexico in 1939, at the invitation of Frida Kahlo. In the early 1930s he had exhibited with the Abstraction-Création group in Paris before changing his allegiance and joining the Surrealist group. The exhibition he put together was divided into two parts – on the one hand an ecumenical selection of the work of Surrealists (most

69 Matta *The Shadow of the Moment* 1966

hailed from Europe, but both Kahlo herself and her husband Rivera were included), and on the other, a separate section entitled 'Painters of Mexico'. Among these were emphatically non-Surrealist artists such as the muralist and easel-painter Roberto Montenegro (1887– 70 1968), despised by Rivera for the decorative, non-political character of his art.

The exhibition was the fashionable event of the winter season in Mexico City, and the majority of the local critics wrote warmly about it. One, however, was more reserved, and perhaps more accurate. Writing of the extremely successful inaugural event, he said that it 'had the character of a very correct visit to Surrealism, not a deeply felt or fiery encounter'. Kahlo, from the beginning, felt uneasy about Breton's enthusiasm for her work. 'I never knew I was a Surrealist', she said, 'till André Breton came to Mexico and told me I was.' Very soon after the International Surrealist Exhibition, she and her husband

70 Roberto Montenegro
*Portrait of the Photographer
Hoyningen-Huene, c.* 1940

renounced any connection with the movement. Paalen was not long
in following their example. In 1942, while still resident in Mexico, he
founded a magazine called *Dyn*, supposedly as a vehicle for Surrealist
ideas. However, in its first issue he proceeded to publish a detailed
'Farewell to Surrealism'. His breach with Breton was only healed in
1950, when he returned temporarily to Europe.

The verdict on the early history of Surrealism in Latin America
must be that its adherents were of two kinds – either Latin American
exiles who had been recruited into the ranks of the Surrealist
movement in Paris, or else European émigrés who moved to Latin
American countries, chiefly Mexico, in the late 1930s and early 1940s,
impelled by political events.

It is, however, important to add a footnote about at least one
notable exception. This was the Guatemalan artist Carlos Mérida
(1891–1984) who had moved to Mexico and spent a period as Rivera's
chief assistant before going to Europe for a while where he met Paul
Klee and Joan Miró, among others. Though Mérida did not become
an orthodox Surrealist, his contact with the movement seems to have
been a kind of liberation for him, enabling him to move from
politically oriented figuration to a much more personal kind of
71 abstraction. After 1950, his work, often concerned with creating a
close, organic connection between abstract art and its architectural
setting, has a much more obvious link with Constructivist ideas than
with Surrealist ones.

94

71 Carlos Mérida *The Bird the Serpent* 1965

Mexico: Four Women and One Man

Women have played a more prominent role in the history of twentieth-century Latin American art than they have in that of either European or North American Modernism. This will already have become at least partly apparent from my account of the genesis of the Modernist movement in Brazil, in which Anita Malfatti and Tarsila do Amaral played such major parts. The prominence of women may spring, paradoxically, from the machismo long inherent in Latin American culture. This tends, at its most extreme, to categorize all the arts as belonging essentially to the feminine sphere, while the male arena is that of political and military action. There is also the idea that women have the right to make statements about private feelings, while men must confine themselves to public statements, since the admission of the power of personal emotions in them counts as a weakness. In essence this is the difference between the art of Diego Rivera and that of his wife Frida Kahlo (1907–54). Only rarely, as in 73 the deservedly famous *Dream of a Sunday Afternoon in the Central Alameda*, painted in 1947–8 for the Hotel del Prado in Mexico City, does Rivera allow a purely personal element to break through, and it is at these moments that his work is closest to that of his wife, which is 72 nearly always directly autobiographical.

During their own lifetimes there was always an element of rivalry in Diego and Frida's relationship, but Diego always seemed to have the upper hand, since Kahlo was perceived as worthy of consideration largely because of her position as Rivera's consort. Since the publication of Hayden Herrera's vivid and revealing biography of Kahlo in 1983, however, this perception has changed, and Frida's fame as a feminist heroine has increased so that it almost eclipses that of her husband. It seems likely that Kahlo would have found this development astonishing.

Kahlo's career as an artist was closely intertwined not only with her relationship with Rivera but also with her chronic ill-health and her fierce Mexican nationalism. Her ill-health was the result of a street accident during her late teens. A bus on which she was travelling was crushed by a tram; Frida never fully recovered from the injuries she

72 Frida Kahlo *Self-Portrait with Diego and My Dog*, c. 1953–4

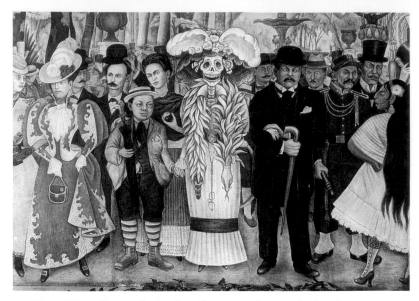

73 Diego Rivera *Dream of a Sunday Afternoon in the Central Alameda* 1947–8 (detail), Hotel del Prado, Mexico City

received, and underwent numerous operations as a result. She was frequently in severe pain and was unable to bear children. Her painting became a way of trying to deal with her misfortunes, by allegorizing and thus exteriorizing them. Though she took a few courses in drawing and modelling while she was at the Escuela Nacional Preparatoria, as a painter she was essentially untrained, and her husband encouraged her to preserve the 'naïve' quality of her work, in which (so he thought) there resided a fair part of its originality. Influenced first by Italian fifteenth- and sixteenth-century painters such as Botticelli and Bronzino (whose work she knew entirely from books), Kahlo was later influenced by Rivera himself, and then, much more profoundly, by Mexican folk art, and especially by *retablos*. These paintings, made by journeymen artists, belonged to a tradition dating back to the colonial period. They were small votive pictures showing some peril which the dedicator had survived, thanks to the intervention of some holy personage or saint (generally the Virgin). *Retablos* were essentially narrative, with long inscriptions as well as images, but it was narrative of a special sort. As Herrera remarks in her biography of Kahlo:

Both Frida's paintings and *retablos* record the facts of physical distress in detail, without squeamishness. Both evince a kind of deadpan reportorial directness; since salvation has already been granted, there is no need for the rhetoric of entreaty. The tale is told not to elicit pity but to settle accounts with God. The narrative must be accurate, legible and dramatic, for a *retablo* is both a visual receipt, a thank-you note, for the delivery of heavenly mercy, and a hedge against future dangers, an assurance of blessings.

Kahlo seems to have drawn on other Mexican sources as well, especially on the portraits and still-life paintings of the nineteenth-century semi-naïve artist Hermenegildo Bustos (1832–1907). Bustos 75 was a painter of *retablos*, but the greater part of his output consists of portraits, very direct paintings reminiscent of Holbein though in fact more likely to have been influenced by photography. He also painted a handful of still lifes whose impact is clearly evident in Frida's 76 ventures into this field. Bustos, like Rivera, was a native of Guanajuato, and this may have been one reason for Frida's interest in him and for her knowledge of his work.

74 Frida Kahlo
Self-Portrait 1940

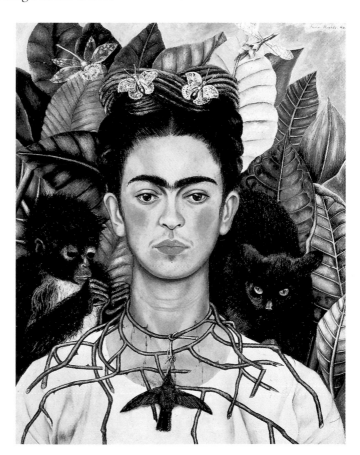

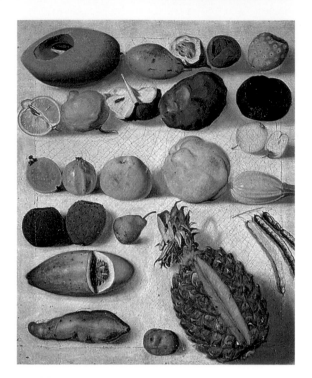

75 Hermenegildo Bustos
Still Life with Pineapple 1877

76 (*below*) Frida Kahlo
The Fruits of the Earth 1938

77 (*right*) Antonio Ruiz
The Dream of Malinche 1939

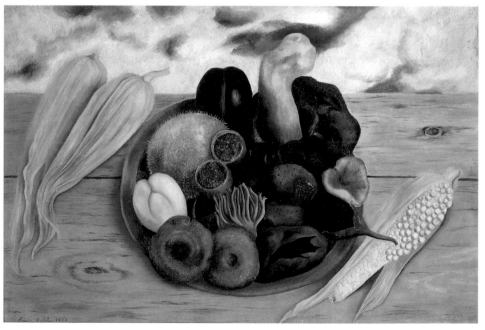

By turning to specifically Mexican sources, albeit ones which belonged to the 'non-heroic' colonial epoch and to the nineteenth century, Kahlo seemed, where her own immediate circle was concerned, to have accepted a hierarchy of values which categorized her work as 'minor' just as her husband's murals were categorized as 'major'. Her posthumous success is based in part on feminism's rise to articulacy and search for role-models, but also on the piercing emotion distilled by her work. Every painting confronts us with the 74 woman herself, her joy, her defiance and her pain, and this is true even of the paintings where self-portraiture is not involved. In addition to this, Kahlo prophesied the future preoccupations of Mexican art – the fact that it would turn away from Pre-Columbian themes and begin to look, instead, at the uniquely rich heritage of Mexican folk culture.

Kahlo was not the only Mexican artist of her generation to be influenced by *retablos*. That influence is also present in much of the work of Antonio Ruiz (1897–1964), called El corzo. After studying art 77 in Mexico, Ruiz spent part of the 1920s in Hollywood where he worked on film sets for Universal Studios. After he returned to

Mexico, he pursued a career as a teacher of art, but chose jobs which kept him on the margins of the official Mexican art world. Like Goitia before him, he worked as a teacher of drawing in elementary schools, then as a professor at the School of Engineering and Architecture in Mexico City, and later as a professor of perspective and scenography in the National School of Fine Art. When he did finally begin to teach fine art, in 1942, it was at an art school that he himself had founded.

The early work of Ruiz shows a mixture of influences, including that of the Art Deco caricaturist and occasional painter Miguel Covarrubias (1904–57), who enjoyed considerable success in New York, making drawings for periodicals like *Vanity Fair*. Ruiz also seems to have felt the attraction of Surrealism, and was included in the Mexican International Surrealist Exhibition of 1940 with more justification than either Rivera or Kahlo. For example, his *The Dream of Malinche* (1939), shown on that occasion, portrays a sleeping Indian girl (the title tells us that she is Cortés's mistress and guide, the betrayer of her people). The coverlet drawn up over her body is transformed into a Mexican landscape surmounted by a church built in colonial style. The implication is that Mexico's Indian past still slumbers beneath the trappings of the European present.

Ruiz was not often so directly allegorical. Many of his best paintings, such as *The Bicycle Race, Texcoco* (1938), are representations of everyday life, shown in a clear, dry style derived from the Mexican *retablos* already described. It would be no surprise to see the Virgin of Guadalupe appearing in one corner of the composition, ready to rescue one of the competitors from disaster.

A similar, though more sophisticated, handling of the painter's materials, and a more definite dedication to generically surrealist imagery can be found in the work of two women artists who lived in Mexico, but who were not Mexican by birth. One was Remedios Varo (1908–63), the other Leonora Carrington (b. 1917). Varo, born in Spain, came into contact with the Surrealist group through her lover, the poet Benjamin Péret, who came to Spain to fight in the Civil War on the Republican side. After the Republican defeat, she and Péret went to Paris, then fled to Mexico in 1942. Though Varo had participated in the International Surrealist Exhibition held in Paris in 1938, and (in absentia) in that staged in Mexico in 1940, she did not begin to paint full time until 1953. The meticulous paintings she produced during the last ten years of her life demonstrate her interest in the occult and in alchemy, and often contain hints of the alienation she felt as a woman trying to make a place for herself in a man's world.

78 Antonio Ruiz *The Bicycle Race, Texcoco* 1938

79 Remedios Varo *Magic Flight* 1956

80 Remedios Varo
The Encounter 1962

Among her sources were the traditional designs on tarot cards, and the work of El Greco and (inevitably) Bosch. Once she actually began to exhibit her work she was rapidly accepted as a leading figure in the Mexican art world yet, as her biographer Janet A. Kaplan notes, Mexico itself seems to have had little impact on what she did:

80　Transformations of layered memories, her paintings become palimpsests, traces of visual resources drawn from the past. While Varo did not intentionally avoid engagement with Mexican art, her work done in Mexico records the release of pent up ideas that had been fermenting during previous

years. Her work was already so filled with images drawn from previous experiences that it seems as though she had little room for Mexican culture and given the brevity of her mature career, little time to assimilate it as a significant source for the work she was able to produce.

Carrington also came into contact with Surrealism through a lover, in her case the leading Surrealist painter Max Ernst. It was not until after Ernst had abandoned her that she arrived in Mexico, in the company of her husband, the Mexican diplomat Raymond Leduc. She was to remain in the country from 1942 until 1985, when she moved to the United States. During this long period of residence she, like Varo (who became a close friend) was regarded as an integral part of the Mexican art scene. Also like Varo, Carrington had a passionate interest in the occult; many allusions to Gnostic doctrines appear in her work, as do references to techniques of divination and prognostication and to ancient Celtic mythology. She was, for example, greatly impressed by Robert Graves's book *The White Goddess* when this was first published in 1949. References to Mexican myths and legends are entirely absent but for one totally uncharacteristic exception: the mural she was commissioned to do for the Museum of Anthropology

81, 82

81 Leonora Carrington *The Distractions of Dagobert* 1945

82 Leonora Carrington *The Old Maids* 1947

in Mexico City, in the room dedicated to the state of Chiapas. What seems to have interested her most vitally about the commission was the use of ritual magic by the primitive Chamula Indians. Even then, as her friend and patron, the eccentric English millionaire Edward James commented, the end result remained 'a lot more Irish than Mexican, a lot more Celtic than Amerindian'.

A woman painter more deep-rootedly Mexican than either of these two was María Izquierdo (1902–55). In a sense her life offers a paradigm of the position of the woman artist in Mexican society during the first half of the twentieth century. Izquierdo was born in San Juan de los Lagos, an old colonial town in Jalisco with a shrine to the Virgin almost as famous as the shrine to the Virgin of Guadalupe on the outskirts of Mexico City. She lost her father while she was very young, and was brought up by her grandparents in a conservative and

83

83 María Izquierdo *Poor Mother* 1944

Catholic ambience. In 1917, at the age of fourteen, she made an arranged marriage to an army colonel, and rapidly bore him three children. The couple moved to Mexico City in 1923.

In 1927 Izquierdo left her husband, and a year later she began to study at the Escuela Nacional de Bellas Artes. She seems, however, to have been suspicious of professional training as something which might blunt her inspiration, and left after only a year. The most important results of her period there were a four-year relationship with Rufino Tamayo, then an instructor at the Escuela Nacional, and the friendship of Rivera, who was its director. Rivera was responsible for organizing her first solo exhibition, in 1929, and wrote the preface to the catalogue. This was the first of numerous shows, as Izquierdo was a prolific artist. However, she, like Frida Kahlo, often suffered from being thought of as a mere appendage to the men with whom

she was associated. In 1938, after her relationship with Tamayo had ended, she began to live with the Mexican painter and diplomat Raúl Uribe Castille, whom she married in 1944 and divorced in 1953. There was a particularly painful incident in 1945, when she was deprived of a large mural commission for the Palacio Nacional in Mexico City, already agreed, because Rivera and Siqueiros considered that she was too inexperienced to handle it.

Izquierdo was aware of the 'primitivism' of Gauguin and Picasso – sources which she and Tamayo seem to have explored simultaneously but independently. It is also clear, from some of her compositions, that she had examined the work of Matisse. She was, however, always very insistent on her own 'Mexicanness', and her primary sources of inspiration were Mexican. In 1947 she wrote:

I try to make my work reflect the true Mexico, which I feel and love. I avoid anecdotal, folkloric and political themes because they do not have expressive or poetic strength, and I think that, in the world of art, a painting is an open window to human imagination.

It is noticeable that, like Kahlo, Izquierdo often draws directly on her own experiences, painting the circuses which were among the few amusements of her colonial childhood and creating still lifes which are also portraits because they show her own possessions. She also, again like Kahlo, drew inspiration from Mexican colonial art, and from the naïve art of the nineteenth and early twentieth centuries in Mexico. She made robust images of the Virgin and Child, basing them on primitive ex-votos, and pictures of *alacenas* (open cupboards) which repeat a pictorial formula used in the eighteenth century. There is a famous *alacena* by the Mexican artist Antonio Pérez de Aguilar (active 1749–69) in the Pinacoteca Virreinal in Mexico City, which Izquierdo must have known.

It has been remarked that Izquierdo's cupboard still lifes reflect a feeling of confinement which often occurs elsewhere in her work. Not surprisingly, critics have speculated that these images are metaphors for the constrictions of her own life in Mexico – as a child, as a young married woman, and later. It is also noticeable that Izquierdo, like Kahlo, accepts a hierarchy of inspiration based on difference in gender. Where the men who surrounded her turned to Pre-Columbian art, she went instead to colonial works and to contemporary or near-contemporary Mexican artifacts with a popular accent. In this respect she seems both to offer and to accept a judgment on the essential limitations of her own position as a woman artist working in a man's world.

85

84

84–5 María Izquierdo
The Open Cupboard 1946; *The
Circus Riders Lolita and Juanita*
1945

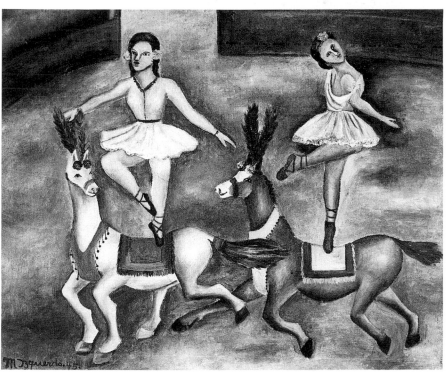

A Climate of Change

The 1950s and 1960s witnessed a radical change in the climate in which Latin American art developed. Established hierarchies were challenged; Modernist ideas, which had been partially suppressed by the triumph of Mexican Muralism during the inter-war period, recovered their prestige. It was a period of violent polemics but one which also saw a renewal of creativity.

The chief agents of change were as follows. First, there was the simple passage of time. All over Latin America a new generation of artists had grown up, impatient with the ideas of their elders. Within Mexico, artists increasingly resented the monopoly over the market, and over opportunities to exhibit, exercised by the leading mural painters and a few allies. Outside Mexico, there was resentment of what seemed excessive Mexican predominance. Secondly, Latin American artists were increasingly better informed about developments in other major artistic centres, especially Paris and New York. The age of lavishly illustrated art books and of glossy magazines devoted to contemporary art had begun. This printed material circulated widely in Latin America and became perhaps the chief source of information about new artistic developments. Museums of contemporary art were created – the first were in São Paulo and Rio de Janeiro, both founded in 1948 – and national museums added contemporary work to their collections. In most cases, however, the bias of acquisitions was national rather than international: each country collected its own art. This bias was to some extent compensated for by ambitious temporary exhibitions, and especially by the regular return of the São Paulo Bienal, founded in 1957, which made a wide range of contemporary art available to Latin American audiences. The Bienal became a major source of information for Latin American artists and critics. When an artist appeared at São Paulo who particularly appealed to the Latin American temperament, the reaction was immediate. A case in point was Francis Bacon, whose work was shown in 1959. Bacon's emotional extremism attracted disciples throughout the region – many more than he had at home, indeed.

The main agents for change in the visual arts, however, were new political and economic circumstances. During the 1950s many Latin American countries experienced a period of prosperity unmatched since the earliest years of the century. Like the United States, they were beneficiaries of the Second World War. First they expanded their economies to meet a world-wide demand for food and raw materials while the war was being fought. Then, after it was over, they continued to supply a battered and debilitated Europe. They also participated, as important though secondary partners, in the booming North American economy of the period. Success in exporting raw materials encouraged many Latin American governments to try to build up a new industrial base which would, so they believed, lead to economic self-sufficiency. New industries, in turn, encouraged the growth of a new middle class, who provided artists with a wider, less ideologically inclined market for their work. In Mexico, for example, the tone was set by the administration of President Miguel Alemán (1946–52), which tried to steer a middle course between the free-market capitalism of the United States and the socialistic nationalism of the National Revolutionary Party which had ruled Mexico since the election of President Plutarco Elías Calles in 1924.

During the 1960s the climate darkened. In Cuba, Fidel Castro had toppled Fulgencio Batista in the revolution of 1959. Faced with the implacable hostility of the United States, he threw himself into the arms of the Soviet Union. The presence of an openly Communist state in the western hemisphere, and its successful defiance of the USA, provided a focus for radicals throughout Latin America. In political terms, the influence of the left reached a high-water mark with the election of Salvador Allende as president of Chile in 1970, even though he received less than 37 per cent of the total vote. However, his régime was soon brought down by a violent military coup.

By this time, other Latin American countries – including Brazil in 1964 and Argentina in 1966 – had already come under military rule. Dictatorial régimes inevitably polarize political sympathies, and Marxist guerilla groups, looking to Cuba for support, sprang up in opposition to the military rulers. The new generation of Latin American artists was disenchanted, and for the most part out of step, with what was happening politically. Some emigrated, others incorporated political references into their work, though these often had to be covert. In countries where more open forms of expression were forbidden, these coded references gave artists a special, but of course wholly unofficial, kind of cultural importance.

The best publicized debate about the future of the visual arts took place in Mexico, for two reasons. One was that the régime had remained stable, and open expression of dissent was possible, no matter how much heat it generated. The other was that Mexico was the home of Muralism, and there was thus something tangible against which to react.

Central to the debate about Muralism was the personality of Rufino Tamayo (1899–1991). Tamayo belonged to the same generation as the three major Muralists Rivera, Orozco and Siqueiros (he was a year younger than Siqueiros) and enjoyed a curiously ambiguous relationship with them. He was born in Oaxaca, of Zapotec Indian parents, and having been orphaned, came to Mexico City in 1911 to live with an aunt and uncle. For a while he sold fruit in one of the city markets. After attending drawing classes at the Academia de San Carlos, he began his career as chief of the drawing section of the Archaeological and Ethnographical Museum in Mexico City, a post to which he was appointed in 1921. This brought him into intimate contact not only with Pre-Columbian art but also with the rich folk culture of Mexico. From 1928 to 1930 he taught, under Diego Rivera, at the National School of Fine Arts. Tamayo, nevertheless, was not fully convinced of the value of Mexican Muralism. Later he was to say: 'Although the painting of that period revealed some distinguished qualities, the preoccupation of its authors to produce, above all, art that was Mexican, led them to fall into the picturesque, and be careless of the really plastic problems.'

Tamayo's response was to distance himself from the Mexican milieu. He visited New York for two years, from 1926 to 1928, going there in the company of the composer Carlos Chávez. He returned to settle there in 1936 and remained until 1950. During this period he returned to Mexico every summer but exhibited very little in his native country. In the 1930s, for instance, he had just two gallery shows in Mexico, in 1930 and 1938, but numerous exhibitions in the United States. In New York he was in contact with a wide spectrum of artists, including, for example, the American Cubist Stuart Davis. He was also able to see a number of important exhibitions. The Picasso retrospective of 1939–40, at the Museum of Modern Art, made a particularly strong impression on him, and he was to borrow many ideas from Picasso's work of the inter-war period.

Tamayo has often been described as an artist who is essentially a synthetist, who brings together ideas taken from a variety of sources –

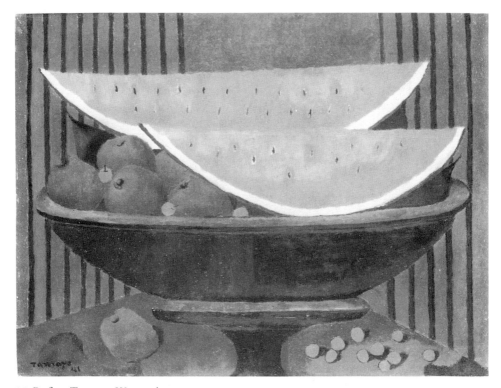

86 Rufino Tamayo *Watermelons* 1941

Gauguin, Cézanne, Picasso, Matisse, Stuart Davis, Miró. He also 86
owed something, certainly in his earlier work, to María Izquierdo; the
two artists lived together from 1929 to 1933. Despite his evident
eclecticism, he is also powerfully individual, and much of this
individuality comes from his treatment of colour. It is always very
subtle, even when the paintings are almost in monochrome, and
frequently rich, saturated and full of sonorous harmonies. It is
Tamayo's colour which makes him instantly recognizable as
Mexican. His own observations on this theme were extremely clear:

Mexicans are not a gay race but a tragic one, among other reasons on account
of their long history of foreign domination ... [the Mexican artist's]
colouring arises as a reflection and comes from his observation of the
economic conditions of Mexico, a poor country where people generally use
cheap colours, mixed with earth and lime, to paint their houses and objects.

Linked to Tamayo's colour is his feeling for texture. His picture surfaces are tactile and richly worked, making the painting visibly a work of craft as well as a work of art. This aspect, in turn, was emphasized by Tamayo's frequent use of folk motifs and by his references to Mexican life in the present rather than in the past. His still 86 lifes of fruit, for example, allude to the richness of form and hue to be 87 found in Mexican markets, and to his own direct experience of these as an adolescent.

By the 1940s, Tamayo's careful career strategy was beginning to pay off. He had a major official retrospective in Mexico City in 1948, was the Mexican representative at the Venice Biennale of 1950, and was asked to paint two murals in the Palacio de Bellas Artes (the ultimate consecration in terms of the politics of Mexican art) in 1952. He was also loaded with international honours; he was a prize-winner at the Carnegie International Exhibition in Pittsburgh in 1953 and again in 1955, and joint winner of the Grand Prix at the second São Paulo Bienal of 1953. By the mid-1950s (when he was living mostly in Paris), Tamayo provided a convincing point of reference for all the younger artists who were discontented with the dominance which the Muralists still exercised at home. He did not have to ally himself with them; it was enough that he existed.

The standard-bearer of the revolt against Muralism was a much 88 younger artist, José Luis Cuevas (b. 1934), initiator of the so-called 'Ruptura' which changed the history of Mexican art.

87 Rufino Tamayo *Women of Tehuantepec* 1939

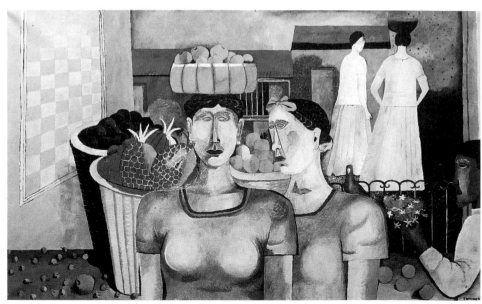

88 José Luis Cuevas
Man on a Seat 1961

Though Cuevas found allies among the Mexican artists of his own generation anxious for change and also for the artistic (and financial) recognition that the Muralists seemed set on denying them, it is significant that his chief supporter among Latin American critics was not Mexican. Marta Traba, founder (1962) and first president of the Museo de Arte Moderno in Bogotá, was of Argentinian origin, and began her career as a disciple of Jorge Romero Brest, for many years the virtual dictator of Argentinian art as director of the Museo de Bellas Artes in Buenos Aires. Traba left Argentina for Colombia in order to escape the régime of Juan Perón. A powerful taste-maker throughout Latin America, she had conceived a boundless contempt for the Mexican mural style, on one occasion describing it as 'an enormous abcess which has affected all our countries'. Her argument – more shocking then than it is now – was that the makers of the revolution in Mexico, because of their wish to democratize the visual arts and put them into the service of politics, were no better than

89 José Luis Cuevas *The Ugly of this World I*, from the *Homage to Quevedo* suite, 1969

political reactionaries. Cuevas agreed. In his view the Muralists had rejected art and replaced it with 'cheap journalism and harangue'. Since Rivera, Orozco and Siqueiros even at this point remained national idols, an enormous controversy broke out. Its final result was not to displace the *tres grandes* (which would have been impossible, given their genuinely central position in the history of Mexican culture), but to call attention to the work of Cuevas and his allies. There was another consequence as well. Latin American artists once again became aware that Modernism offered a plurality of choices.

The choice Cuevas made for himself was an interesting one. Primarily a draughtsman rather than a painter, he was precociously talented, and first exhibited his work in 1953, at the age of nineteen. Critics immediately recognized the affinity between his work and the early drawings of prostitutes and brothel scenes made by Orozco. In fact, rather than being influenced by the Mexican past, Cuevas was enthralled by the present, and in particular by what he saw around

him in the rapidly growing metropolis – the poor, homeless, diseased
and disfigured inhabitants of Mexico City. What he actually saw in
the streets around him led him to other, non-Mexican sources which
fed his imagination – for example to the novels of Dostoyevsky and
Kafka and the prints of Goya. Another important influence was films
– both the plump figure and rubbery features of the comedian Fatty
Arbuckle and images from classic horror films such as *Frankenstein*
and *Dracula*. All these related in one way or another to Cuevas's own
feelings of alienation, and this personal alienation was in turn linked to
that of the whole Mexican middle class. Newly created by Alemán's
economic reforms, this remained on the margins of Mexican political
life, which continued to be dominated by the professional politicians,
their wealthy cronies, their attendant bureaucrats and the trade
unions. Cuevas's bitter attack on the muralists thus has a logical, even
if subterranean, connection with the horrific images of 'monsters'
which he was producing at the same time. To complete the circle, the
images validated his own claim to be an *enfant terrible*.

In her book *Los cuatro monstruos cardinales* (Mexico City, 1965) – the
other three 'monsters' were de Kooning, Bacon and Dubuffet – Traba
suggests that art associated in any way with politics must now be
considered devalued and limited, and that the four artists she studies
owe their importance to the fact that they have transcended normal
political limits. That is, they have pushed matters much further
towards nihilism than genuine political commitment allows, and
depict evils but refuse to suggest cures. For Traba, Cuevas's 'monsters'
belong to a new moral order and another, more truthful reality.

Cuevas was associated with, but not intimately part of, Nueva
Presencia, the group which took its name from a luxurious illustrated
broadsheet of that title five issues of which appeared between August
1961 and September 1963. This group has often been put forward as
the catalyst that brought about the break between two generations of
Latin American artists – those associated with *indigenismo*, and their
more internationally inclined, stylistically freer successors. This view,
however, is one which focuses too narrowly on the history of
Mexican art, rather than more widely on that of Latin American art
viewed as a totality.

Nueva Presencia now seems in many ways to have brought a
change for the worse, a loss of originality and vitality. The lessons
Tamayo had to offer were not immediately understood though, in the
long run, his was to be an immensely important example. Yet the
'Ruptura' in Mexico had a distinctly conservative element. Nueva

90 Rafael Coronel *All Together* 1965

Presencia represented a scaling down of Muralism's ambitions rather than a total abandonment of them. Artists now no longer addressed themselves to the masses, as the *tres grandes* had done: they addressed themselves instead to the new professional class, making easel paintings and drawings rather than murals, and offering ambiguous meanings rather than direct and certain statements of truth. Like Cuevas, the artists of the group increasingly saw humanity as helpless, powerless to change its own fate. The result was an introverted, rather depressive kind of art, shocking only because it came after so many years of noisy public statements. Perhaps the best painter associated with the group – and then only briefly – was Rafael Coronel (b. 1932), the son-in-law of Diego Rivera. Coronel's work, like that of Cuevas, shows an eclectic mixture of influences. Some were native to Mexico, such as the early drawings of Orozco and the prints of José Guadalupe Posada; others were more widespread in origin, such as the 'black'

91 Coronel *Titian* 1969

paintings of Goya and images borrowed from films. Coronel's earlier paintings are Expressionist; there is, for instance, a forceful series of single figures – portraits of imaginary beings who belong to a world of nightmare. Later ones are more subdued and now seem more typical: we are shown strangely dressed figures of old men and women, seen in a dim light and drifting in a Kafkaesque limbo. They radiate a kind of numb despair; the vigorous social concern of the Muralists is very far away. 90

One reason for thinking that Coronel is an artist of significance is the way in which these later paintings reject many of Modernism's tenets and attach themselves to the long-neglected Old Master tradition. The reassessment of the pre-Modernist heritage, especially that part of it handed down from the great Spanish painters of the seventeenth century, was to preoccupy a number of gifted Latin American painters in the 1960s, 1970s and 1980s. 91

92 Gyula Kosice *MADI Neon No. 3* 1946

Geometric Abstraction

The real break, or 'Ruptura', in Latin American art had in fact begun to show itself long before the controversy about Muralism and the appearance of Cuevas and the Nueva Presencia group in Mexico. It has been customary to connect it with a process of political liberalization, but this hypothesis is contradicted by the facts. In Argentina, for instance, it began before the end of the Second World War, at a time when the country was ruled by a military junta, and it continued under Perón. Venezuela, with a very active artistic avant-garde during the 1950s, spent nearly the whole of the decade under the Pérez Jiménez dictatorship. The radicalization of Latin American politics did not come till much later, after Castro overthrew the Batista regime (1959), then began to export Communist doctrines to the rest of Latin America (1963), nearly twenty years after the first stirrings of a new radicalism in art.

One reason why a new experimental art was able to flourish in often repressive political circumstances was that it was usually abstract and therefore not a vehicle for political messages, or not unless these were of an intricately coded kind. In this respect the contrast with Muralism, which was figurative, and from its beginnings overtly political, could not have been more marked. The absence of violent public debate about the appearance of these new styles, such as marked the emergence of Cuevas and the Nueva Presencia artists in Mexico, was also a function of the political situation. It was possible to create avant-garde artworks; it was less possible if these aroused agitated public debate in societies where debate of most kinds was discouraged by the authorities.

The earliest renewal of avant-garde activity within Latin America took place in 1944, in Buenos Aires, with the publication of a review called *Arturo*. Though it lasted for only one number, this brought together the poets and artists who were shortly to form two rival movements, Madí and Arte Concreto-Invención, both founded in 1945.

In recent years Madí has been accorded legendary status. It is seen as 92 the forerunner of avant-garde groups like Fluxus in Europe, and

93 Juan Bay
MADI Composition 1950

indeed as the beginning of a whole reaction against art which is too solid, too pompous, too anxious to carve out a historical position. Madí's ideas were, however, usually more interesting than the objects it produced. The ambiguity of Madí attitudes is to some extent summed up in the name itself. A number of attempts have been made to find a derivation for it. One suggestion is that it represents a contraction of the phrase 'MAtérielisme DIalectique'. However, all this seems to be deliberate mystification. It is likely that Madí is a made-up word, like Dada.

The wilfulness of this gesture is the more surprising since the general orientation of the group was anti-Surrealist and pro-Constructivist, taking its lead from the work done by the Abstraction-Création group in Paris between the wars. The Madí manifesto, published in 1946 and written by the artist Gyula Kosice (b. 1924), a Hungarian immigrant who had arrived in Argentina with his parents at the age of four, makes this aspect plain:

Madi [it states] . . . confirms man's constant all-absorbing desire to invent and construct objects within absolute central human values, in his struggle to construct a new classless society, which liberates energy, masters time and space in all senses, and dominates matter to the limit.

Yet, compared with the typical products of European Constructivism, Madí art did stress capricious elements. Paintings, according to its manifesto, were to have 'uneven and irregular frames' and 'articulated surfaces with lineal, rotating and changing movements'. Sculptures, too, were to rotate and change. Experimentation was pursued for its own sake. In 1946 Kosice made what was probably the first work of art to incorporate neon tubing. Paintings by other members of the group such as Juan Bay (b. 1892) or Diyi Laañ (b. 1927), were eccentrically shaped or had moveable elements.

Madí's rival, Arte Concreto-Invención, was more orthodox in its exploration of Constructivism. The leaders were Tomás Maldonado (b. 1922) and Alfredo Hlito (1923–93) and the presiding influence was that of Max Bill. Maldonado met Bill on a trip to Europe in 1949, and in 1950 Bill had a retrospective exhibition in São Paulo, which made him influential throughout South America.

Paintings by Maldonado and Hlito use more conventional formats than those associated with the Madí artists, and concentrate on serial progressions of forms and colours. Maldonado, who was a gifted graphic designer as well as a painter, soon left Argentina to work

92

93

94

94 Tomás Maldonado
Development of the Triangle 1951

95 Alfredo Hlito
Chromatic Rhythm 1945

under Bill, who was then director of the Hochschüle für Gestaltung at Ulm, in Germany. His influence over European industrial design, exercised through the Hochschüle, was to be very great – Maldonado can be regarded as the main progenitor of the Minimalist 'black box' designs for electronic and other equipment which set the tone for up-
95 market manufacturers in the 1960s and 1970s. Hlito remained in Buenos Aires until 1963, then spent a decade in Mexico before returning to Argentina.

 If the energy of Madí and Arte Concreto-Invención had died down by the mid-1950s, they found a successor in the Grupo Generativo, founded in 1959. Here the leading figures were the painters Eduardo Mac Entyre (b. 1929) and Miguel Angel Vidal (b. 1928). They were not only somewhat younger than the Madí artists, but slower to develop. In the early 1950s both were producing skilled pastiches of Seurat and Signac. Later work of the 1960s and 1970s, when both artists were
96 fully mature, shows a liking for intricate curving patterns, of the type which can be produced mechanically by using an oscillating pendulum. Vidal, though often almost indistinguishable from

124

96 Eduardo Mac Entyre
Montage 1969–70

97 Miguel Angel
Vidal *Reversible
Topological Module
with Concave and
Convex Space* 1974

Mac Entyre in style, also has a liking for compositions made up of
97 rectangular shapes, sometimes put together like building blocks, so
that the painting becomes a kind of façade or wall. These 'façade'
paintings, though very different in hue, have a distinct resemblance, in
terms of composition and concept, to certain late works by Torres-
García. The latter was one of the contributors to *Arturo*, and his work
had continued to be well known in Argentina as well as in Uruguay.

The post-war Constructivist revival in Latin America soon
manifested itself in countries other than Argentina. One of the places
where Constructivism was most influential was Venezuela. This was
easily understandable. Venezuela, like Argentina, was at this period a
country which was looking to the future rather than to the past.
Under the dictatorship of Marcos Pérez Jiménez (1952–8), its oil
revenues had made it extremely rich. There was a construction boom
in Caracas, and new buildings included a number with important
symbolic as well as purely practical functions – in particular, the new
98 University City designed by Carlos Raúl Villanueva. In addition to
being a gifted architect, Villanueva was a connoisseur and patron of
art, and the university complex included important works com-
missioned from artists with major international reputations, among
them Hans Arp, Alexander Calder and Victor Vasarély. There was
also patronage for a new generation of Venezuelan Abstractionists.

The leading Venezuelan artists of the immediately post-Second
World War period can be divided into two groups: the more
traditional (though never completely conventional) Constructivists,
working largely in Venezuela, though also sometimes abroad; and
the artists connected with the Kinetic Art movement of the 1960s,
who tended to base themselves in Paris. Among the former the
chief figures were Alejandro Otero (1921–90) and Gego (Gertrude
Goldschmidt, 1912–94).

Otero's is the more various of the two artists' work, and also the
better known outside his own country. His range includes the long
series of *Colour-Rhythms*, with patterns of vertical or horizontal
stripes, which he began to make in the 1950s, a series of delicate
99 collages, and some ambitious public sculptures. The *Colour-Rhythms*
are strongly optical, and derive their effect from the kind of
interference patterns also found in the work of Vasarély and Bridget
Riley. They would not have seemed out of place in the 'Lumière et
Mouvement' show held in Paris in 1967, which gave the Kinetic Art
movement its public identity, though they were not in fact included.
The collages, using scraps of newsprint and other written materials,

98 (*above*) Carlos Raúl Villanueva, the Great Hall, University City, Caracas, 1954. Alexander Calder's 'Acoustic Clouds' hang from the ceiling and the walls.

99 (*below right*) Alejandro Otero *Delta Solar* 1977

are quite closely related to Schwitters. The public monuments are classically Constructivist, with a strong emphasis on the play of light. A good example is Otero's *Delta Solar* of 1977, which stands outside the Air and Space Museum in Washington D.C.

99

Gego was of German origin. She was born in Hamburg and arrived in Venezuela in 1939, when she was already an adult. Her whole career as an artist was, however, made in that country. She was a sculptor, and from the 1950s onwards her work developed in an especially individual way – away from objects simply placed in a space and towards reticulated, network-like constructions of cords, wires and rods which create a complete environment. One of the most ambitious of these is the *Reticularea* of 1969 made for the Galería de Arte Nacional in Caracas. The widespread, irregular network of wires and rings fills a whole room and cannot be seen in its entirety from any one position within it. The effect is like a three-dimensional version of one of Miró's *Constellations*, but there is no specific figuration and the actual technique, which remains classically Constructivist, can be referred back to artists like Naum Gabo.

100

The best-known of the Venezuelan Kineticists are Jesús Rafael Soto (b. 1923) and Carlos Cruz-Díez (b. 1923). Soto has spent most of his career in Paris, having arrived there in 1950. Nevertheless, when his work is relocated in a Venezuelan context, affinities with both Otero and Gego become apparent. Some early sculptures, with a pattern of

100 Gego *Reticularea* 1969

101 Jesús Rafael Soto *Mural Signals* 1965

parallel lines placed slightly askew over another group of parallel
lines, are obviously related to Otero's *Colour-Rhythms*. Soto was
already producing works of this type in the late 1940s, before he left
Venezuela for Europe. Some of his most ambitious later sculptures are
environmental but transparent, not unlike Gego's *Reticularea*. Cur-
tains and clusters of hanging strings, wires and rods modify the 101
spectator's perception of space and create vibrating optical patterns. In
his book *Kinetic Art* (1968), still the best text on its subject, the English
critic Guy Brett remarks that Soto 'has worked always with elements
which are of no interest in themselves and looked for mobility by
trying to find some sort of mobility *between* them' (the italics are his).
He also comments on the way in which the elements Soto uses seem to
lose their precise location in space and 'create their own fluid unstable
space'. This is a characteristic of Kinetic Art as a whole.

One of the things which Soto's works have in common with the
103 *Physichromies* of his compatriot Cruz-Díez is a kind of dematerializa-
tion of the object. In his catalogue statement for the 'Lumière et
Mouvement' exhibition, Cruz-Díez defined these works as 'changing
structures which project colour into space'. The formats he uses,
however, are more conventional than those adopted by Soto; in terms
of design, his work remains indebted to Max Bill, who had as strong
an impact on Venezuelan artists as he did on Argentinian ones. Cruz-
Díez's work is, however, stronger and more complex than that of
other Latin American Kineticists, for example the Argentinian Julio
102 Le Parc (b. 1928). Le Parc's pieces, using light and reflections of light,
are nevertheless of interest because they too stress the twin themes of
instability and dematerialization.

Since Constructivism was, in origin at least, an artistic language
which was intended to be totally trans-national, it is interesting to
note wide variations of style, approach and artistic intention among
its adherents in Latin America. There is, for example, a considerable
difference between Colombian Constructivism and the Brazilian
variety.

Colombia did not enjoy the economic good fortune of Argentina
and Venezuela in the immediate post-war years. The country was
torn apart by the bloody civil war called 'La Violencia', which lasted
from 1949 to 1958 and cost at least 250,000 lives. In spite of this it
managed to nurture two major abstract sculptors, Edgar Negret (b.
1920) and Eduardo Ramírez Villamizar (b. 1923).

Monumental sculpture plays a special role in the Latin American
urban scene. Nearly every city or town possesses one or more
monuments dedicated to some national or local hero or commemor-
ating some event of importance. Mexico, for example, is extraordi-
narily rich in figurative public sculptures, often bizarre in style. The
Muralist ethos (and most were produced when Muralism was still
dominant) seldom translated happily into three-dimensional terms.
Like abstract art in general, abstract sculpture on the grand scale only
began to be made after the Second World War. Negret and Ramírez
Villamizar were beneficiaries of the opportunities then offered, which
came after the Colombian civil war had been brought to an end. By
this time, both were well prepared for the task.

Negret's work evolved comparatively slowly, partly in response to
his travels in Europe and the United States. In the 1940s he was
producing semi-abstract sculptures in stone, related to the biomor-
phic carvings produced in Europe by Arp and others. The impulse to

130

102 Julio Le Parc *Series 29D, No. 11–9, 9–11, 9–11, 11–9*

103 Carlos Cruz-Díez *Physichromie 198* 1965

104 Edgar Negret *The Bridge (Homage to Paul Foster)* 1968

Constructivism first showed itself in the early 1950s, when Negret started to make sculptures from metal parts which were bolted together. These anticipated the sculptures by David Smith made from industrial elements, which date from nearly a decade later. Smith's work of the early 1950s owes more to the artisan tradition of Julio González than it does to the industrial forms already being used by Negret.

Having reached this point, Negret began to move towards a way of thinking which was linked to the established Constructivist tradition. His work continued to be made of metal plates, bolted together and usually painted a uniform colour, but now became less capricious in shape. What is especially typical of Negret's mature work is the stress put on hollow forms; a sculpture will often consist of a series of conjoined, tubular sections like an insect's exoskeleton.

104

105 Eduardo Ramírez Villamizar *Temple 1* 1988

Compared with Ramírez Villamizar, Negret remains on the fringes of the Constructivist movement, as his work continues to have strong, if elusive, figurative overtones. It is the former artist who is generally thought of as Colombia's earliest practitioner of pure abstraction. Like many members of the artistic avant-garde in Latin America, Ramírez Villamizar began his career as a student of architecture, the reason being that these schools used to be much more liberal in their attitudes to Modernism than schools of fine art. He then embarked on a career as a painter. His earliest work was figurative and expressionistic, strongly influenced by Rouault. By 1950 he had started to experiment with abstraction and by the end of the decade he had shifted to making reliefs rather than paintings. He showed his first fully three-dimensional works in 1963. Ramírez Villamizar's sculptures are in general less complex than Negret's, and more regular and

105

rational in their approach to form. They are often characterized by powerful, repeated diagonal rhythms. Their simplicity and use of repeated units bring them close to American Minimal Art but they avoid all trace of minimalist passivity.

Brazilian Constructivism, unlike the Colombian variety, avoids the monumental. Sometimes this avoidance is carried so far that it seems designed to make a polemical point. The most interesting and radical Brazilian artists involved with Constructivism belonged to a deliberately dissident subsection of the movement which announced itself with the 'Neo-Concrete Manifesto' published in the *Jornal do Brasil*, a Rio de Janeiro newspaper, in March 1959. Written by the poet Ferreira Gullar, it reads in part:

We do not conceive of a work of art as a 'machine' or as an 'object', but as a 'quasi-corpus' (quasi-body), that is to say, something which amounts to more than the sum of its constituent elements; something which analysis may break down into various elements which can only be understood phenomenologically. We believe that a work of art represents more than the material from which it is made and not because of any extra-territorial quality it might have: it represents more because it transcends mechanical relationships (sought for by the Gestalt) to become something tacitly significant (Merleau-Ponty), something new and unique. If we needed a simile for the work of art, we would not find one, therefore, either in the machine or in any objectively perceived object, but in living beings ...

Among the leading Brazilian artists associated with this tendency were Lygia Clark (1921–88) and Hélio Oiticica (1937–80).

106 Characteristic of Lygia Clark's approach are three inter-related series of sculptures, generally fairly small – the *Bichos* (*Machine Animals*), the *Repantes* (*Climbing Grubs*) and the *Borrachas* (*Rubber Grubs*). The essential idea in all of these is more or less the same. The sculpture, though completely abstract, is conceived of as a small beast, a quasi-independent being:

The Bicho [Clark said] has his own well-defined cluster of movements which react to the promptings of the spectator. He is not made of isolated static forms which can be manipulated at random, as in a game; no, his parts are functionally related to each other, as if he were a living organism; and the movement of these parts are [*sic*] interlinked.

It was part of the anti-monumental character of the *Bichos* that they could be presented on any surface and that their appearance was essentially provisional, part of a collaboration with the spectator.

107 Hélio Oiticica
Glass Bolide 4, 'Earth' 1964

Hélio Oiticica professed a rather similar attitude. He progressed from Constructivist painting to reliefs suspended in space (1959–60), then to what he called *Bolides (Fireballs* or *Nuclei)*. These were at first objects containing colour as a mass, in the form of pigment, earth, dust, liquid or even cloth, and thought of as forming a kind of energy centre. There is an obvious parallel with Joseph Beuys's use of blocks of fat presented in a similarly conceptual way. Later, *Bolide* became for Oticica a generic term for a container in a very broad sense: it could be a garment or a cabin as well as a bottle or a box. These containers were thought of as a means of focussing perceptions when looked at, entered, occupied or worn.

Oiticica's use of 'poor' materials in work made in the mid-1960s anticipated the Italian Arte Povera of the following decade (the Italian movement was named after an exhibition organized by the critic

107

Germano Celant at the Museo Civico, Turin, in 1970). It has, especially in the pieces he called *Penetrables* or 'Penetratables', a close relationship with the improvised architecture of the *favelas* or shanty towns in which the poorest Brazilians live. Oiticica often emphasized the tropical aspect of these deliberately flimsy walk-through environments by the use of potted plants. The *Bolides* which are also costumes – items to be put on and worn like fancy dress – recall the atmosphere of the famous Rio carnival, but it is a carnival stripped of any connotation of luxury. His insistence on the Brazilian roots of his work, on its 'tropicalism', links him to the first generation of Brazilian avant-gardists led by Tarsila do Amaral and Osvaldo de Andrade (*see* pp. 40–44).

The abstruse metaphysics of Brazilian Neo-Concretism also makes it a forerunner of the Conceptual Art movement in the United States and in Europe. The connection is reinforced by the fact that it was closely linked to the Concrete Poetry movement which flourished in Brazil at the same time, and whose products achieved a much wider international dissemination. Concrete poetry, with its progressive, Structuralist and Minimalist use of words and brief phrases was a powerful though still not fully recognized influence on Conceptual Art, not least because it created a situation where there was no real frontier between what was verbal and what was visual.

A more 'traditional' Brazilian artist – using the adjective to imply attitudes to materials rather than attitudes to art itself – was Sérgio Camargo (b. 1930). Camargo's artistic pedigree is a distinguished one. He began to study art at the age of sixteen, not in Brazil itself but at the Altamira Academy in Buenos Aires, where he came into contact with Emilio Pettoruti and Lucio Fontana. He went to Paris in 1948, to study philosophy at the Sorbonne, and began to make sculpture. There he visited Brancusi's studio and made contact with Arp and the then almost forgotten Vantongerloo. In 1953 he returned to Brazil, but went back to Europe in 1961, settling permanently in Paris.

Camargo first became known for reliefs made of wood – surfaces covered with cylinders set at different angles, and painted a dazzling white. The cylinders might be large or small, but the most typical reliefs are those with many small cylinders forming complex surfaces 108 which react to every variation in the angle or intensity of light. Later, in the mid-1960s, Camargo began to carve geometrical shapes in Carrara marble.

Compared with the work of the Neo-Concretists, his is a slower, much more meditative, even ruminative kind of art. The spectator is

110 Gonzalo Fonseca *Katabasis II* 1975

invited to gaze at the sculptures for a long time, watching them change as the light itself changes. A number of Camargo's more recent sculptures, made in the late 1970s and early 1980s, are particularly fascinating because they seem to carry the development of Latin American Constructivism almost full circle: they are façades or 'walls' of angled blocks which are strongly reminiscent of certain paintings by Torres-García. They also have an even closer affinity with the sculpture of Torres-García's most distinguished direct disciple, the Uruguayan sculptor Gonzalo Fonseca (1922–97). However, Fonseca's sculptures are figurative, not abstract – they are specifically architecture in miniature, inhabitable by the imagination. And unlike Camargo's work, there is an element of direct interaction with the spectator, since Fonseca often adds small objects, cubes and little pyramids, which can be moved from place to place, and put in various compartments or openings.

The same motif, that of a façade concealing something, recurs in the work of the expatriate Argentinian artist Marcelo Bonevardi

109
61

110

139

108–09 *(left)* Sérgio Camargo, white cylinders, 1973; Carrara marble, 1979

111 Marcelo Bonevardi *Red Compass* 1979

112 Gunther Gerzso *Blue-Red Landscape* 1964

(1929–94), who made his career in the USA. Bonevardi is as close to
Fonseca as he is distant from the Argentinian Constructivists discussed
at the beginning of this chapter but, because he worked with wood
and canvas, he is usually classified as a painter rather than a sculptor.
However, the materials he painted on are stretched over wooden 111
frames so as to form angled surfaces; there are further additions in
wood, and sometimes compartments or pigeon-holes within the
composition. Bonevardi's occasional use of numerals and letters
further reinforces his link with Torres-García.

 Constructivism, so successful throughout Latin America, managed
to find a foothold in Mexico, even though this was the country where
the art world was instinctively most hostile to it. The two leading
exponents of Constructivism were powerful personalities, the one
very different from the other. Gunther Gerzso was born in Mexico in 112
1915, but trained in Germany. Before setting up as an independent
artist, he had a long connection with the theatre, having worked as a

draughtsman and stage designer at the Cleveland Playhouse in the United States. He began to paint when he returned to live in Mexico in 1942, but even then continued to support himself by working as an art director in films. Among the directors for whom he worked were Luis Buñuel and John Ford.

112 Gerzso's powerful compositions, based on overlapping planes, are generally classified by critics as abstract Constructivist works, but he himself denied the connection, saying: 'I do not consider myself an abstract painter. I see my paintings as realistic, based on Mexican landscape and pre-Hispanic culture. Friends of mine who drive through Chiapas tell me they see what I paint.' It is in fact easy to accept the claim of pre-Hispanic influence, as Gerzso's paintings often look like stylized versions of cyclopean walls, and thus recall Torres-García. Yet there may also have been an element of prudence in his denial, given the fiercely controversial nature of the Mexican art scene.

One artist who was never afraid of controversy was Mathias Goeritz (1915–90), German-born but Mexican by adoption. Goeritz did not settle in Mexico until 1949, by which time he was already in his thirties. He soon managed to tangle with the Mexican artistic establishment of the time. Rivera and Siqueiros described him in an open letter as 'a faker without the slightest talent or preparation for being an artist, which he professes to be'. Goeritz's base was in the Mexican educational system and among architects. In 1957 he was appointed director of Visual Design at the National School of Architecture, and in the same year was commissioned by Mexico's greatest Modernist architect, Luis Barragán, to design the entrance to Satellite City, then being built to the north of Mexico City. Goeritz's

113 solution was simple and dramatic – five concrete pylons, triangular in section and between 36 and 58 metres high. These immense towers are still his most conspicuous work in Mexico.

What interested Goeritz was the synthesis between art and architecture. His *Five Towers* have some of the qualities of both. Although completely different in scale from that of the Brazilian Neo-Concretists, his work expresses a rather similar kind of sensibility. Like them, he anticipated some of the ideas which American Minimal and Conceptual artists were to adopt in the late 1960s.

113 Mathias Goeritz *Five Towers* 1957–8, Satellite City, Mexico City

Informal Abstraction

The upsurge of interest in Constructivism which took place in Latin America after the Second World War was not imitative. Latin American artists were out of step with what was happening in Europe and the United States, where the Constructivist movement had fallen from favour after the war. Through their participation in the Kinetic Art movement, Latin Americans triggered a partial revival of Constructivist principles in Europe. More importantly, some of the experiments conducted under the aegis of Constructivism, within Latin America itself, were forerunners of tendencies which did not appear in New York, the supposed focus of avant-garde experimentation, until the late 1960s.

Yet interest in Constructivism, though widespread in Latin America, did not exclude other post-war tendencies. Latin American artists were attracted by most of the main international art movements of the time. Some of these imported styles enjoyed greater success in Latin America than others. This depended on the political at least as much as on the artistic climate. One tendency which encountered a surprisingly lukewarm reception was informal abstraction.

In one sense this was surprising, since Abstract Expressionism and its European equivalents received much support from the critical establishment, and were repeatedly displayed in the showcase of the São Paulo Bienal as well as in lesser and shorter-lived biennial exhibitions in Argentina (at Córdoba) and in Mexico City (the controversial Inter-American Biennial of American Painting). Also at least potentially supportive were the Esso Salons staged in 1965 – competitive exhibitions open to artists under forty held in eighteen Latin American countries (only Cuba was excluded). These efforts were perceived, however, especially in Mexico, as an attempt to extend an already much-disliked North American imperialism by cultural means. The Esso Salon in Mexico, for example, met with a vitriolic response. A typical reaction appeared in the journal *Política*: 'Since the Mexican School of painting is a nationalist and progressive manifestation it is in the interest of imperialism to combat it with all

methods possible, because the abolition of nationalism is favorable to the penetration of Latin America.'

The stronger schools of informal abstraction in Latin America nearly always owed their strength to particular historical causes. The two countries where it is easiest to demonstrate this are Peru and Brazil. Although Peru, like Mexico, had once been the seat of a great Pre-Columbian civilization, its artistic development in the years after independence in 1821 followed a different and ultimately less vital course. In the colonial period, Peru had possessed a distinctive school of religious painters, the School of Cuzco, who grafted indigenous ways of seeing and thinking on to the standard Baroque idiom imported from Spain. Their work can in certain respects be compared with that of traditional Russian icon painters: they were simultaneously journeymen and mystics, producing paintings which conformed to a narrow range of increasingly stereotyped formulae.

The major painter of the Independence period, José Gil de Castro (1785–1841), still belonged in large part to this world. His portraits of the leaders of the Independence movement, such as the celebrated and much-reproduced full-length *The Martyr Olaya* painted in 1823, can 114 be compared with the court portraits of the English Elizabethan epoch. The resemblance extends to many points of detail – the flatness of the figure, the lack of weight and absence of any form of chiaroscuro, the obsessional emphasis on the minutiae of dress and the use of long inscriptions to reinforce the effect of the visual image – all of which make *The Martyr Olaya* a kind of pendant to Marcus Gheeraerts' 'Ditchley' portrait of Queen Elizabeth I, painted nearly 250 years previously.

The comparison is not as wilful as it might at first seem. Both portraits are patriotic images, produced in countries thrust into cultural isolation by a political upheaval of the first magnitude. England's break with Rome in the sixteenth century was the equivalent of Peru's break with Spain at the beginning of the nineteenth. In the case of Peru, this isolation was emphasized by two factors – first that the country faced the Pacific, not the Atlantic, and secondly that it suffered from perpetual political instability. Whereas other Latin American countries absorbed a belated version of Neo-Classicism, along with other aspects of the European Enlightenment, Peru tended to stagnate culturally and intellectually. One minor symptom of this was the absence of an academy of fine arts to teach painting according to approved European methods. Not until 1860 did Peru possess a teaching institution where students could study art

on academic lines (that is, according to the method approved by the great Neo-Classicist Jacques-Louis David and bequeathed by him to his pupils) and even then it was open only three days a week. The Peruvian National School of Fine Arts was set up as late as 1918.

This had two long-term consequences. If there was no academy, there could be no real revolt against the academy: the necessary polarity for a genuine modern movement was missing. José Sabogal's artistic *indigenismo* was in fact a continuation, not a rebellion. The first experiments with indigenous subject matter, treated seriously rather than merely picturesquely, had been made by Francisco Laso (1823–69), who had studied in Paris with Delaroche and Gleyre. The rebellion, when it came, was not against an entrenched academic attitude to art but against the nationalist *indigenismo* of Sabogal and his followers. The first exhibition of abstract art in Peru did not take place until after 1945.

In the circumstances, the Constructivism which attracted other younger Latin American painters at this time cannot have seemed an desirable option. Within it were the seeds of the rationalism which had fuelled nineteenth-century Neo-Classicism. Peruvian artists, as

114 José Gil de Castro
The Martyr Olaya 1823

115 Fernando de Szyszlo *Abolition of Death*

we have just seen, had no tradition of this sort. They wanted to explore a wider world and in particular wanted to catch up with what was happening in Paris and New York.

The leader of the new Peruvian school was Fernando de Szyszlo (b. 115 1925). Like many progressive Latin American artists of his generation, he began as a student of architecture and later attended the art school forming part of the Catholic University of Lima. By 1946 he was already making his first experiments with abstract art, and in 1949 he set off for Paris. One of his first productions there was a portfolio of lithographs entitled *Homage to Vallejo*. The tragic César Vallejo (1893–1938) is Peru's greatest Modernist poet and, many would claim, the greatest poet produced by twentieth-century Latin America. His extraordinary first collection, *Los heraldos negros (The Dark Messengers,* 1918), was as far in advance of its time as the *indigenista* painters – his contemporaries – were behind theirs. The poems in this collection, even more so those in his second collection

147

Trilce (1922), combine apparent obliqueness with utter directness in matters of the spirit, which make them a bridge between Rimbaud's *Les Illuminations* on the one hand, and the work of the great German-speaking Rumanian poet Paul Celan (1920–70) on the other.

Szyszlo's work is similarly oblique and 'coded' in its use of Informalist techniques. Buried in the paint are traces of pre-Columbian imagery. Some forms, for example, have been suggested by the complex knottings of Inca textiles, while other references are to sacrificial knives and ceremonial altars. Szyszlo's colours are influenced by the range of hues found in ancient Indian weavings.

Cultural conditions in the smaller Andean republics were similar to those in Peru. In landlocked Bolivia, the major Modernist artist of the period just after the Second World War was María Luisa Pacheco (1919–82). Like Szyszlo, her talent flowered when she was able to leave Bolivia and experience a wider artistic world in Europe. In 1951 she travelled to Spain, with the assistance of the Spanish government. At this time she was making figurative paintings in the socially concerned tradition then completely dominant in Bolivia. After her return to La Paz in the following year, she continued to work in this style, but during the rest of the decade her work gradually became

116 María Luisa Pacheco *Cosmos* 1968

more abstract. The process was accelerated when she settled in New York in 1956. By 1959 figuration had been totally eliminated from her paintings. Even so, her work can still perhaps be seen as a subliminal reflection of the austere forms and colours of the Bolivian landscape, and Latin American critics have continued to interpret it in this sense. 116

Basing herself in New York from 1956 until her death, Pacheco was thus more isolated from her Latin American roots than was Szyzlo, who continued to spend considerable periods of time in Lima. Nevertheless, through exhibitions in Lima (at the Instituto de Arte Contemporáneo in 1960 and 1966) and eventually in La Paz (a major retrospective at the Museo Nacional de Arte in 1975), Pacheco exercised considerable influence over the Bolivian art scene, demonstrating that there was a valid alternative to *indigenista* figuration.

The career of the Ecuadorean artist Enrique Tábara (b. 1930) owes something very specific to the geography of Ecuador. The country is divided into highland and lowland zones, which are culturally at odds with one another. Guayasamín, the dominant force in Ecuadorean art when Tábara was a young man, came from the capital, Quito, which lies high in the Andes. Tábara came from the port city of Guayaquil. For him the switch to Informalism, when he was in his early twenties, was a sign of rebellion against Guayasamín (who was eleven years his senior) and his followers. Tábara made his first fully abstract paintings in 1954, the year before he moved to Spain, on a scholarship from the Ecuadorean government.

Once in Spain he showed his work in Barcelona and Madrid, and made contact with the group of Informalist painters just emerging on the Spanish art scene. These painters, of whom Tàpies is the best-known, differed from their Parisian counterparts chiefly through their liking for richly worked, heavily textured surfaces. Tábara learned much from their example. He lived in Europe until the early 1960s, but then decided to settle permanently in Ecuador. One motive behind his decision to return home was the feeling that, for him at least, there was something lacking in contemporary Spanish art. He now complained of its 'dryness', by which he meant its obsession with purely formal issues.

Tábara's work at this period had started to incorporate recognizable pre-Hispanic motifs — pyramids, snakes, mirrors and plumes — and it was to become even more specifically figurative in the early 1970s. These motifs and symbols, however, continued to be embedded in the rich, painterly textures he had learned to use in 117

117 Enrique Tábara
Superstition 1963

Barcelona. Despite his partial return to figuration, Tábara remained opposed to almost everything represented by the work of Guayasamín. In 1964, soon after his return from Europe, he went so far as to found VAN, which was an Ecuadorean artists' movement specifically directed against *indigenismo*.

Because he comes from a small country and has spent most of his career there, Tábara's art is still not as well known as it deserves to be. Like that of Szyszlo, it represents a remarkable and original effort to fuse Pre-Columbian influences with aspects of the new post-war sensibility.

If Informalism became a typically 'Andean' style in Latin America, it was certainly not the exclusive property of Andean artists. Another very different group was involved with informal abstraction – the Japanese painters living and working in São Paulo. These, even more than the Andean Informalists just discussed, were the product of a special set of cultural circumstances. Almost all came to Brazil as young adults, arriving between the 1930s and the 1960s. In the space of four decades, São Paulo became one of the greatest Japanese cities in the world. Once arrived, the Japanese did not disperse into the mass of other Brazilians, but remained a community within a community,

117

retaining all their national characteristics. Artists of Japanese origin, such as Tomie Ohtake (b. 1913), Manabu Mabe (1924–97) and Tikashi Fukushima (1920–2001), have therefore tended to form a group quite separate in most respects from other Brazilian painters and sculptors. As if to mark this separateness, nearly all were members of the Seibi Group, the Japanese artists' association in São Paulo. Nevertheless non-Japanese critics naturally tended to compare their work with what was most accessible and familiar – that is, primarily with American Abstract Expressionism and French *art informel*. A more enlightening comparison can be made with the abstract painting being produced in Japan itself during the 1950s and 1960s, by members of the Gutai Group, founded in 1954.

118, 119

118 Tomie Ohtake, untitled

119 Manabu Mabe *Ecuador No. 2* 1973

Expressionist Tendencies

Beyond the confines of the Expressionist movement in Germany, Expressionism during the years preceding the First World War was often less a style than an anti-style: it was effectively a rebellion against formulaic ways of seeing, combined with an attempt to make the work of art the true mirror of the self. In the Introduction I noted the deep-rooted Expressionist tradition in Latin American art which reflects both what might be thought of as the passionate nature of the Latin American psyche, which may sometimes erupt in violence, and the equal violence of external events. Even the basically anti-Modernist tendencies of Mexican Muralism did not entirely stamp out such an essentially Expressionist impulse. Orozco's affinities with the style have long been recognized.

It is therefore understandable that Expressionism, in the looser sense of the term, should have enjoyed a resurgence in the years following the Second World War. However, it did not manifest itself immediately; it belongs to the 1960s rather than the 1950s. The latter decade was distinguished by the prevalence of authoritarian régimes. Perón ruled Argentina from 1946 to 1955. In Venezuela, the sinister dictatorship of Pérez Jiménez lasted until 1958. In these circumstances, as has already been said, abstraction was often the safer option. Thus, in a number of countries the reasons behind the re-emergence of Expressionism were political, and Expressionist figuration almost inevitably became a vehicle for political and social messages as the situation became more open and the politics of the region more radical.

Some established artists became Expressionists only as they grew older. An example is the Argentinian painter Raquel Forner (1902–87). She began her career as a disciple of Lino Spilimbergo, and was thus essentially under the spell of the later Derain and the Italian Novecento. Obsessed by the tragic events of the Spanish Civil War, she painted political pictures using that fairly conservative idiom. Then, in the 1950s, she began to absorb the lesson of Picasso – many elements in her late style come from what Picasso was doing in the 1930s and 1940s. The transition to a new way of working was not,

120 Raquel Forner *Conquest of the Moon Rock* 1968

however, complete until the early 1960s, when Forner embarked on a
long series of canvases devoted to a new theme: man's conquest of
space. Her roly-poly figures – part child, part robot, part mutant or 120
monster – are derived from the images of television and from
photographs showing astronauts. While the work still owes much to
Picasso (the frequent twinning of figures and images is especially
Picassian), there is now also a resemblance to the work of Karel Appel,
one of the leaders of the COBRA group in Europe. Though eclectic,
Forner's work is also personal: a half-joyful, half-fearful hymn to the
future, totally appropriate to the Latin American context.

In the work of the Argentinian group *Otra figuración*, named after
an exhibition held in Buenos Aires in 1961, there is an even more
eclectic mixture of elements. The *Otra figuración* style owes something
to classic Expressionism, something to Dubuffet, perhaps also

something to de Kooning's figurative pictures, and to Rauschenberg. The group consisted of four artists, all much younger than Forner, who shared a studio and criticized one another's work. In 1962–3 they were all briefly in Paris together, and in 1966 the group formally disbanded, though the participants retained much of their energy. From 1965 to 1970 they owed much to the support of the Centro di Tella, a lavishly financed avant-garde art centre run by the leading Argentinian critic and curator Jorge Romero Brest, already cited (p. 115) as the mentor of Marta Traba and the inspiration for her attack on the Mexican Muralists.

123, 122 The members of *Otra figuración* were Jorge de la Vega (1930–71),
124 Luis Felipe Noé (b. 1933), Ernesto Deira (1928–86) and Rómulo Macció (b. 1931). The most gifted, as well as the most experimental and extreme, was the short-lived de la Vega, whose experiments led in two directions. On the one hand he made much use of collage, bringing together unexpected and disparate elements in a way reminiscent of Rauschenberg's combine-paintings. On the other, he practised radical distortion, so that the imagery is often only barely
121 legible at first glance. One series of paintings is entitled *Anamorphosis*, an anamorphosis being an image which is only recognizable when it is viewed from a particular angle. The great virtue of de la Vega's work

121 Jorge de la Vega *And Even in the Office*, from the *Anamorphosis* series, 1965

122 Ernesto Deira *S/T* 1965

is its huge vitality. Its surfaces are always alive, and it is this which invites the spectator to overcome the obstacles to comprehension which the artist deliberately puts in the way.

In his late teens, Noé studied with the well-known Argentinian painter Horacio Butler (1897–1983), a rather cautious disciple of Cézanne and the more academic French Cubists. But, largely through his activities as a journalist (he wrote for the Buenos Aires newspaper *El Mundo*), he seems to have become involved with the new Argentinian avant-garde of the 1960s. His attitude was more intellectual than that of de la Vega and was affected by contact with what was happening in intellectual circles in Paris. There is an echo of Sartre in his pronouncement: 'The man of today finds no shelter in his image. He is in a permanent existential relationship with other men and with things.' A gifted draughtsman, Noé was more interested in pictorial narrative than were the other members of the group, and he had a

123 Luis Felipe Noé *Introduction to Hope* 1963

123 more developed concern with history and politics – all of which make him in some ways more typically Latin American than the other *Otra figuración* artists. One of his best-known early paintings, *Introduction to Hope* (1963), is a paraphrase of James Ensor's celebrated *The Entry of Christ into Brussels*. Interestingly enough, this is not the only instance of Ensor's influence in Latin America. Another artist who owes something to him is the leading Venezuelan, Jacobo Borges (*see* p. 162).

156

124 Rómulo Macció *Politics* 1986

Deira and Macció, especially when compared to de la Vega and 122
Noé, are only on the fringes of Expressionism. In both there are traces
of Francis Bacon – a pervasive influence throughout Latin America –
while Macció offers occasional hints that he is familiar with the work 124
of Richard Lindner. His description of his own procedure is
interesting, however. He speaks of 'an attempt to disarticulate
pictorial space, counterpointing plane versus volume, perspective
versus indeterminate space, or making two themes participate in the

125 Alberto Heredia, three *Camembert Boxes* from the series, 1961–3

same picture'. This accurately describes a set of effects which appear repeatedly in Latin American figurative painting of the second half of the twentieth century, whether Expressionist or not. The liking for this kind of fluidity and pictorial instability seems to be another mark of the Latin American temperament.

In addition to Expressionist painters, Argentina has produced one extraordinary Expressionist sculptor. This is Alberto Heredia (1924–2000). Heredia is usually described by Argentinian critics as a Surrealist rather than an Expressionist, and he has participated in group exhibitions under that label. Because he was an assemblage artist who made use of 'poor' rather than 'noble' materials, he also has a link with Pop Art. His work prompts a comparison with that of Ed Kienholz, with whom he shares the same sense of horror, the same fascination with kitsch and the same irrepressible black humour. Nevertheless Heredia seems to me to be very close to some of the *Otra figuración* artists. What de la Vega does in two dimensions, though sometimes using relief elements, Heredia develops in three. His 125 earliest mature works, *Camembert Boxes*, are in fact collage reliefs on a modest scale. Heredia started to make them in 1961, when temporarily crippled after a riding accident. The phantasmagorically large figures which eventually developed out of these small assemblages are among the most unsettling images in modern Latin American art.

Expressionist figuration after the Second World War was not confined to Argentina, though in all of Latin America it became most deeply rooted in Buenos Aires. There were also major Expressionist

painters in Colombia and in Venezuela. Both in Colombia and in the
United States, Alejandro Obregón (1920–92) built himself a brilliant 126, 128
early reputation, though it has now been somewhat compromised by
two factors – his own propensity for pictorial rhetoric, and the inter-
national success of his compatriot Botero. Admired by the writer
Gabriel García Márquez, and passionately supported by Marta Traba,
his work deserves to be reconsidered.

Obregón, perhaps even more than most Latin American painters,
wears his influences on his sleeve. Over five years between the late
1940s and early 1950s he lived and worked in France. Inevitably, he
was fascinated by Picasso, and he also knew the work of lesser artists,
such as Anthoni Clavé (b. 1913), who were fashionable in Paris at that
time. He became aware of the work of Tamayo, a sumptuous
colourist like himself. The impact these artists made on him remains
visible yet still only partly absorbed, even in his comparatively recent
work.

An outsize personality, the creator of a personal myth, Obregón is,
however, the kind of artist whom formal art criticism finds difficult to
deal with. It is this quality which attracts García Márquez. The latter
tells a wonderful story about the night Obregón, who then lived in
Barranquilla, went in search of a drowned fisherman:

Suddenly Obregón saw him: he was submerged up to his crown, almost
sitting in the water, and the only things floating on the surface were the errant
strands of his hair. 'He looked like a jelly-fish', Obregón told me. He grasped
the bundle of hair with two hands and with the colossal strength of a painter

126 (*above*) Alejandro
Obregón *Dead Student*
1956

127 (*left*) Jacobo
Borges *The Betrothed*
1975

128 (*right*) Alejandro
Obregón *Shipwreck*
1960

of bulls and storms drew the drowned man up, eyes open, huge, dripping with the slime of sea-anemones and manta rays, and flung him like a dead shad into the bottom of the boat.

That episode, which Obregón recounts yet again because I ask him to do so every time we get drunk together – and it also gave me the idea for a story about drowned men – is perhaps the instant in his life which most resembles his art. That is the way he paints – as if he were fishing drowned men up out of the darkness.

In its own way this anecdote, plus the comment García Márquez attaches to it, gives a good impression of the virtues of Obregón's best work. He paints extrovert semi-abstract landscapes, inspired by Colombia's Caribbean coast (in the 1960s he moved from the coastal town of Barranquilla to the beautiful colonial port-city of Cartagena), heraldic representations of animals, and figurative scenes, usually with either an erotic or a political message. The landscapes are the most consistent in quality; the seascapes, in particular, are the work of a \quad 128 convinced if belated romantic, and sometimes may even prompt a comparison to Turner. Rhetoric and sentiment often get the better of the figure paintings, but one or two, such as the powerful *Dead Student* \quad 126 (1956), have an emblematic force in the way they both lament and commemorate the endless cycle of political violence in Colombia. Only cynics can be totally unmoved by them, and the Picassian

mannerisms to be found in some of the details matter much less than the total effect.

The Venezuelan painter Jacobo Borges (b. 1931) is equally prolific, but his work is much more even in quality. He is in fact one of the most impressive figurative painters modern Latin America has produced. Where nearly the entire first generation of Latin American Modernists came from prosperous backgrounds, Borges came from a poor family. As a student at the Escuela de Artes Plásticas y Artes Aplicadas in Caracas he had to support himself by doing odd jobs. In 1951, having rebelled against the academic nature of the instruction at the school, he was expelled. At the same time, however, he won a prize offered by the film company Metro-Goldwyn-Mayer, which enabled him to make his way to Paris, where he spent four years, returning to Venezuela in 1956.

It was only then that he became a mature artist. An important influence was *The Lost Steps*, the celebrated novel by the Cuban writer Alejo Carpentier, which had been published in 1953. *The Lost Steps* is one of the chief documents of the so-called 'magic realist' tendency in Latin American literature, together with the later *One Hundred Years of Solitude* (1967) by Gabriel García Márquez. *The Lost Steps* tells of a musician who goes to the remote jungle near the mouth of the

129 Jacobo Borges *The Show Begins* 1964

Orinoco river to look for primitive musical instruments. He and his companions are also in search of 'primitive' wisdom, but the musician, when the moment of decision comes, opts to return to civilization – but cannot find his way back. Borges undertook a similar journey to a remote fishing village (inspired not merely by Carpentier's mix of fact and fiction but by an actual visit made to Reverón in Macuto in 1949). Like Carpentier's protagonist, he found it was largely a journey into himself.

His paintings of the early and mid-1960s, often very large-scale, feature grotesque figures which bear a resemblance to some of Cuevas's drawings of 'monsters', and a still closer one to Ensor's pictures showing grotesque masks and masked figures. As with Ensor's work, the emotional mainspring is self-lacerating black humour. Borges hated the complacent capitalism of the Betancourt régime which had succeeded the Pérez Jiménez dictatorship. He was concerned with what he called 'the tropical problem' – the temptation to self-indulgent lushness. He was also worried by what he saw as the essential isolation of Latin American art. 'The decisions of history', he said later, 'don't arrive in undeveloped countries – we are behind history, behind a mirror . . .' Borges's paintings of the 1960s can be regarded as a ferocious attempt both to show the situation for what it was and to break out of it.

In the 1970s Borges began to abandon Expressionism, and to develop in a fascinating and unexpected way. After going through a brief phase where he was in step with certain aspects of European Pop Art (there are some paintings from this time which have a resemblance to work by the American-born but British-domiciled R. B. Kitaj), he started to re-examine the heritage of the Old Masters and in particular the legacy of Velázquez and Goya. Some of the most striking works of the mid-1970s feature shadowy interiors, where mysterious, often sinister, events are taking place. Unlike the work of the previous decade, which has a strong element of protest, these paintings are essentially meditations; their subject is the passage of time and the persistence of memory. Often one has the impression that two different sets of events have been allowed to occupy the same physical space.

Borges's reversion to the Old Masters was a significant event in the history of Latin American art. It found parallels in the work of other important artists of the same generation, who now began to flout both North American and European value-systems by calling into question the whole basis of Modernism.

130 Fernando Botero *Prelate, c.* 1959

Realism, Pop Art and Surrealism

To raise the question of the way in which leading Latin American artists absorb, paraphrase and reinterpret the art of the past involves immediate contact with the work of the Colombian artist Fernando Botero (b. 1932). Botero is both fortunate and unfortunate in his 130 reputation. Of all living Latin American artists he is perhaps the most popular with the international public. In general, however, critics – recently, at least – have had little good to say about him. Yet there must be an explanation for the tenacious hold he has established over the public imagination, and this, in turn, may imply that he is in fact a highly original creator – something which a mass audience somehow senses but which critics have ignored or failed to interpret correctly.

Like his contemporary Jacobo Borges, Botero comes from a humble background. His father was a travelling salesman, who died when Botero was very young. His first real contact with any kind of avant-garde activity came in 1952, when he moved from Medellín, his native city, to Bogotá. He stayed only six months in the Colombian capital before making the obligatory journey to Europe. One of his first actions, after landing in Barcelona, was to visit the local Museum of Modern Art. He was gravely disappointed by what he found. In fact, what Botero did in Europe was immerse himself in the Old Masters, particularly the great fresco painters of the Renaissance – Giotto, Piero della Francesca, Masaccio – rather than in the latest 'isms' of Modernism. He was aware that, in doing this, he was following in the footsteps of Diego Rivera, who had made a trip to Italy to study Renaissance fresco painting shortly before his return to Mexico in 1921. 'For me,' Botero has said, 'a personality such as Rivera was of the greatest significance. He showed us young Central American painters the possibility of creating an art that did not have to be colonized by Europe. I was attracted by its *mestizo* character, the mixture of old, indigenous and Spanish culture.'

Nevertheless, it was some time before Botero evolved what was to be his characteristic manner. He returned to Colombia in 1955 but soon began travelling restlessly; he went to Mexico in 1956 and to the United States in 1957 before finally evolving his typical 'fat' figures,

131 Fernando Botero
*Princess Margarita after
Velázquez* 1978

131 now the hallmark of his art. The earliest of these are paraphrases of
Old Master paintings – works by Velázquez and Leonardo da Vinci
which are cultural clichés as well as cultural icons. The technique was
rougher and more painterly than it later became. It was only in the
1960s that Botero finally evolved the smoothly meticulous manner,
firmly based on traditional methods, which is a major cause of offence
to Modernist critics.

The main issue in his work is not technique, however, but the actual
morphology – Botero's deliberate exaggeration of forms, and the
significance to be attached to this. Botero has always denied that his
intention is satirical: 'No, I'm no caricaturist. Like almost every artist,
I employ deformation. Natural phenomena are deformed to a greater
or lesser extent, corrected in accordance with the composition.' Or
again:

The deformation you see is the result of my involvement with painting. The
monumental and, in my eyes, sensually provocative volumes stem from this.
Whether they appear fat or not does not interest me. It has hardly any
meaning for my painting. My concern is with formal fullness, abundance.
And that is something entirely different.

The German critic Werner Spies has suggested that fatness, for
Botero, is simply an artistic 'language', just as thinness was for

Giacometti. This, however, fails to take into account other aspects of Botero's art, and in particular one of the most obvious: his subject matter. The artist has, in the course of his career, tackled a variety of themes – versions of the Old Masters, tropical still lifes, nudes. There are a substantial number of anti-clerical paintings (a common theme in Latin American art, found also in the work of Jacobo Borges), and even more which are concerned with aspects of contemporary Colombian life, or of Latin American life in general. Some pictures condemn militarists and people in power; others take a sardonic view of the morals and manners of the bourgeoisie.

Among Botero's best compositions is a series of monumental figure paintings showing riotous brothel scenes. These seem to allude directly to the Medellín of his youth, and the comedy of the presentation hardly hides Botero's contempt for the participants, specifically, the male participants (Botero looks more kindly at the women). If Botero is a sort of anti-Giacometti, he can also be seen as a Latin American Manet, or a Latin American Magritte. The brothel

132

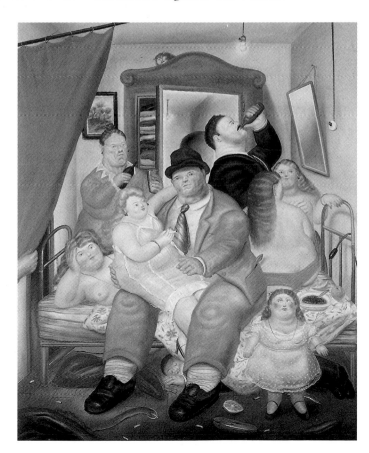

132 Botero
The House of the Arias Sisters 1973

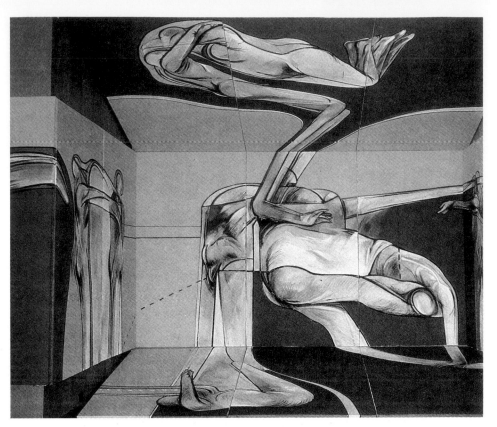

133 Luis Caballero, untitled, 1968

scenes combine aspects of both these artists. One of Botero's preferred personages is in fact a version of Magritte's bowler-hatted man – the individual bourgeois who is also the whole bourgeoisie incarnate. At the same time, these paintings have the apparent innocence, but also the delayed power to shock, of Manet's *Le déjeuner sur l'herbe*. Manet almost protested that he did not know why paintings like *Le déjeuner* or *Olympia* upset people; Botero's protestations that he is not a satirist take on something of the same tone when one looks at the brothel scenes and other similar compositions.

Colombia has an especially strong tradition of figurative art, based in part on the fact that art-teaching continued to follow a sternly

traditionalist nineteenth-century model well into the 1980s. The
strength of this inheritance shows itself clearly in the work of Luis
Caballero (b. 1943). Like many Latin American artists, Caballero
began as an ardent admirer of Francis Bacon, and the early works 133
which made his reputation, produced in the 1960s, are heavily
indebted to Bacon. In the 1970s Caballero's style changed, becoming
superficially more academic, but also more personal. His subject is the
nude male body, and he uses it to express three different things: his
own homosexuality, his residual religious feelings, and his horror at
the political violence which continues to afflict his country. These
subjects are never separated – the paintings and large drawings are
deliberately ambiguous, so that, for example, it is impossible to tell
whether two figures are attacking one another or making love. 134
Caballero is a gifted draughtsman from the life, but his source
materials also include Spanish religious paintings and carvings of the

134 Caballero, untitled, 1991

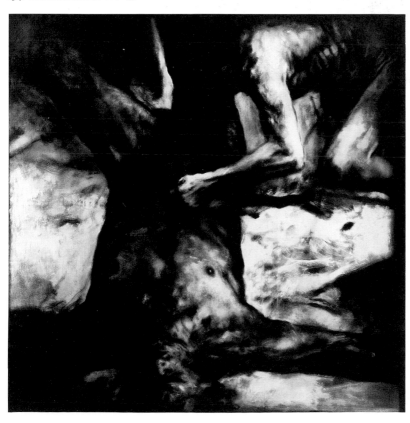

seventeenth century (crucifixions, depositions and martyrdoms), the blood-spattered news photographs which appear in Colombian popular newspapers, and images taken from homosexual pornography. He says his aim is to 'show but not relate' ('*mostrar sin "relatar"* '). Though his work is much more openly confessional than Botero's (it is a form of continuous confession, in fact), it too has a public, moralistic aspect. Some of Caballero's larger compositions echo the combination of horror, indignation and romantic excess to be found in Géricault's *Raft of the Medusa*. Not surprisingly, this is a work he greatly admires.

In addition to Caballero, Colombia has a strong school of contemporary Realist artists. Among them are Enrique Grau (b. 1920), and the brothers Santiago Cárdenas Arroyo (b. 1937) and Juan

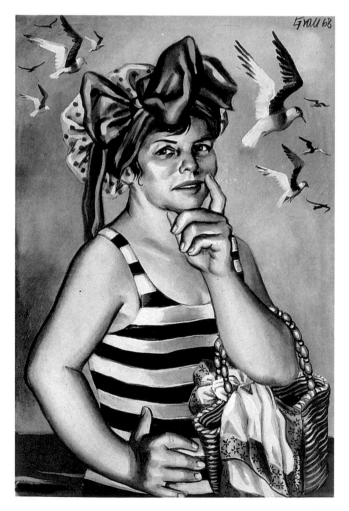

135 Enrique Grau
Bather at Cartagena 1968

Cárdenas Arroyo (b. 1939). Grau is an artist who has passed through a number of phases. His early work was heavily influenced by Picasso, and also by the Italian painter Massimo Campigli. In the 1960s it became much more distinctively his own. His favourite subjects are plump young women, often in a state of déshabille, frequently wearing elaborate hats (even when they are clad in little else). Though he puts a lot of emphasis on the rotundity and weightiness of the human body, like his compatriot Botero, the paintings are in general much more naturalistic. Their cheerful sensuality makes them reminiscent of the work of a number of Italian artists of the inter-war and immediately post-war epochs – Mario Marfai and Fausto Pirandello, for example. Like them, he seems to have deliberately eluded the more rigorous demands of Modernism.

135

The Cárdenas brothers, though both Realists, are very different from one another in style. Santiago Cárdenas produces meticulously observed canvases which combine Super Realism and Minimalism. A typical subject is a trompe l'oeil version of a blackboard from which the chalk marks have been almost, but not quite, effaced. Juan Cárdenas is obsessively fascinated with autobiography. His paintings are almost invariably self-portraits, painted on a smallish scale and with great elegance and lightness of touch. With an irony typical of much Latin American art, they chronicle the episodes of the painter's daily life.

136

Another Realist – one with a strong academic bias and a taste for seventeenth-century Spanish art – is the Chilean-born Claudio Bravo (b. 1936). Like his compatriot Matta, Bravo has long been away from Chile, which he left in 1961. Unlike Matta, he firmly rejects all connection with the Latin American art scene. His early work does in fact attach itself quite easily to the Realist art of the closing Franco years in Spain, where Bravo lived for a period.

In 1972 he left Spain to live and work in Morocco, and has remained there ever since. During the 1970s a gradual change came over his work. In addition to making paintings and pastels of still lifes and landscapes in traditional style – some of the pastels of flowers are dazzling feats of virtuosity – Bravo started to produce a number of ambitious figure paintings, among them paraphrases of the Old Masters, based on artists such as Bellini, Caravaggio and, perhaps with most success, Zurbarán. It was helpful to him here that traditional Moroccan dress, the *djellaba*, resembles the habits of the monks who so often feature in Zurbarán's work. These paraphrases, for example a *vanitas* with two figures and a table loaded with symbolic objects,

137

136 Juan Cárdenas *Studio with Mirrors* 1985

137 Claudio Bravo *Vanitas* 1981

convey an overwhelming sense of the way the past overlaps and intermingles with the present – something I have already cited as being typical of one variety of recent Latin American painting. Despite himself, Bravo has thus retained some aspects of the Latin American artist.

Similar effects, more consistently pursued, can be found in the panoramic landscapes painted by the Uruguayan artist José Gamarra (b. 1934), who has lived in Paris since 1963. Gamarra's career has gone through three stages: childhood and youth in his native Uruguay, then four years in Brazil before he settled in Europe. The landscapes obviously owe much to the time he spent in Brazil. It would be

unwise, however, to interpret them too literally. As a Uruguayan artist Gamarra regards himself as a child of Figari and Torres-García, especially the latter. Before he went to Brazil he had already evolved a vocabulary of signs, which he used in his graphic work. The landscapes are essentially a naturalistic matrix for these signs; they are not the result of direct observation but are essentially visionary. Gamarra did not start to paint them till he went to live in Paris. For the landscapes themselves, his references include the work of the Dutch painter Frans Post (c. 1612–80), who travelled to Brazil in the seventeenth century, and that of Le Douanier Rousseau. Figures and other details come from many sources, ranging from old photographs to children's toys, which are paraphrased and transformed so as to suit the purpose the artist has in mind.

This purpose is usually to disturb. Sometimes figures from two different worlds confront one another: a European explorer, shown as a translucent, rainbow-hued figure in a shaft of light (a visual trope which may be borrowed from holography), surveys an Indian hunter
138 who is unaware of his presence; or a helicopter (painted from a toy) hovers over the equally oblivious figure of a Spanish conquistador. The clues are seldom obvious – often they are much subtler than the examples cited here – but the general tendency is always the same. Gamarra constantly questions the facts of Latin American history.

A similar inclination to question is present in the more recent work of the Nicaraguan-born Armando Morales (b. 1927), who started his career as a disciple of Abstract Expressionism. As is the case with so many Latin American artists, especially those from smaller and poorer countries, he has led a peripatetic life, with only a brief period in Nicaragua itself after 1965. Subsequently he worked in Costa Rica, the United States of America and Paris, and now lives in London. He turned from abstract to figurative work in the 1970s, and about 1983
139 began his best-known series of paintings, which are based on memories of his birthplace, the Nicaraguan port-city of Granada. He once described Granada thus: 'A little city, completely surrealistic, with a nineteenth century railway station, which does not cease to haunt me. There is in it a little bit of the South of Tennessee Williams ... an inertia, an immobility. A completely anachronistic passivity.' These figurative compositions are deliberately fragmentary. They show not the reality of Nicaragua but what the memory of an exile preserves, with the gaps which the process of recollection inevitably entails.

138 José Gamarra
Encounter with Conquistadores
1989–90

139 Armando Morales
Family Reunion 1983

Most of the Realists so far discussed in this chapter are presently resident outside Latin America. Botero is based in Paris, though he has a farm near Bogotá and visits Colombia frequently. Caballero and Gamarra live in Paris, and Claudio Bravo, as has already been said, resides in Morocco. Morales, after spending time in the United States and in France, has now settled in London. Their work is necessarily distanced from Latin America. Indeed, perhaps it is distance which permits them to be Realists, in the sense that it allows them to deal with difficult and painful topics. Caballero, for example, who exhibits frequently in Bogotá, and who is completely candid about his sexual orientation in interviews with the Colombian press, nevertheless feels that his homosexuality, quite apart from political and economic factors, makes permanent residence in Colombia impossible.

Antonio Berni (1905–81) has a very different biography and is a very different case artistically. Berni was thoroughly Argentinian, and his work is a close observation of the society in which he lived. A great artist, though his work is of uneven quality, he is now mostly valued for the work he produced from the 1960s onwards. The material from this period largely belongs to two great narrative series of large-scale works which combine painting with collage, in which Berni expressed his feelings about his country. Each series has a protagonist – the urchin Juanito Laguna from the slums of Buenos Aires, and the prostitute Ramona Montiel from Berni's birthplace, Rosario.

Before this stage, Berni's development had followed a somewhat tortuous course. He studied in Paris for five years on a government scholarship, leaving Argentina in 1925 and returning in 1930. His teachers were the minor but fashionable Cubists of the day, André Lhôte and Othon Friesz, but he also came into contact with the Surrealist movement through the poet Louis Aragon. After his return to Argentina, however, he became a Social Realist. Politically aware and socially committed, he was influenced first by the Mexican Muralists (he worked with Siqueiros on a mural in a private house when the latter visited Buenos Aires in 1933) and then, after the Second World War, by Picasso in his most Communist phase (*Massacre in Korea*, 1951), and by the Social Realist artists identified with the French Communist Party, such as André Fougeron (1913–98) and Boris Taslitzky (b. 1911). There is also a residual touch of the Novecento elegance of Spilimbergo.

In an interview for *Le Monde* in 1967, Berni explained the genesis of his new style as follows:

140 Antonio Berni *Juanito in La Laguna* 1974

One cold, cloudy night, while passing through the miserable city of Juanito, a radical change in my vision of reality and its interpretation occurred . . . I had just discovered, in the unpaved streets and on the waste ground, scattered discarded materials which made up the authentic surroundings of Juanito Laguna – old wood, empty bottles, iron, cardboard boxes, metal sheets etc., which were the materials used for constructing shacks in towns such as this, sunk in poverty.

It was now he began to add elaborately worked collage elements to his paintings: Junanito and, later, Ramona, inhabited settings made from the materials which would have been familiar to them. Because many of these materials are industrial detritus, there is a temptation to think of Berni, in this late phase, as a Latin American convert to Pop Art. If he is, this is true only in an ironic sense – the use of these materials, the discards of industry, symbolizes the subservient position occupied by Latin America in relation to the developed world.

Pop Art itself never stood much chance of taking root in Latin America because it essentially reflects, and usually celebrates, the material superabundance in an industrial society, especially an American one. Inevitably, however, since Latin American culture is

141 Raúl Martínez *Always Che* 1970 (detail)

142 Antonio Caro *Colombia* 1976

nothing if not absorbent, certain Pop Art devices were adapted for local use. They were generally employed in what may seem a rather crude way, showing how very little their true meaning had been understood. For instance, in Cuba Raúl Martínez made multiple portraits of Che Guevara, on the model of Andy Warhol's multiple likenesses of Marily Monroe and others. It is a telling point of difference, however, that Martínez's images are not silk-screened but laboriously hand-painted, which immediately removes all but the most superficial resemblance to Warhol's. In Colombia, Antonio Caro made a print which adapted the instantly recognizable script of the Coca-Cola logo to read 'Colombia' instead. In these cases, what is being satirized generally finishes by getting the better of the satirist. The imitative image simply reinforces the strength of the original, and imprints it yet more firmly on the viewer's consciousness.

The artist who most successfully took over some of the devices of Pop Art was the Brazilian Antonio Henrique Amaral (b. 1935), a collateral descendant of Tarsila do Amaral. He did so because he found himself in a special situation. In 1964 the government of Brazil was replaced by a military junta headed by General Humberto Castello Branco. Thanks to the new government's economic policies, designed to check run-away inflation, the Brazilian economy entered a phase of severe recession. By 1968 the phenomenon of urban guerilla warfare had appeared in Brazil, as it also did at the same moment in Argentina and Uruguay. The guerillas, in turn, provoked the formation of paramilitary death squads, the imposition of censorship, and a general climate of severe political repression.

141

142

146

179

143 Tilsa Tsuchiya
Moment in Red

144 Mario Carreño
Light of the South 1967

145 Alberto Gironella
La Beauté convulsive: Homage to André Breton
1991

Amaral's coded commentary on these events was embodied in a series of paintings of bananas produced between 1968 and 1975. The banana was an appropriate symbol for several reasons. Brazil is the largest exporter of bananas, producing 23 per cent of the world's consumption. In addition, the trade in bananas is largely controlled from the United States and, by association, the image of the banana therefore conjured up the idea of continuing dependency on more prosperous and developed countries. Amaral spelt most of this out in the first painting in the series, where the image of the banana is combined with those of the Stars and Stripes and the Brazilian flag. The latter bears the motto 'Ordem & Progresso', which was punningly altered to read 'Prog(Esso).'

146 Painting huge bananas in close-up and from unexpected angles, Amaral produced images which appeared to have some of the iconic authority of Pop Art, but this was associated with a sharply political content normally alien to the Pop ethos, which generally implies acceptance of things as they are. One reason for the success of the paintings was that they combined undoubted Pop Art influence with genuinely Brazilian roots. They could be seen as a revival of the *tropicalismo* of Tarsila do Amaral's generation.

Another artist whose work contains Pop Art elements, though mixed with other things, is the Mexican Alberto Gironella (b. 1929). Gironella has attracted attention from critics chiefly through his sharp-edged parodies of Velázquez and Goya. His work is in fact much more various than these might suggest: it also features images which are specifically Mexican, such as the figure of Zapata, and others of purely contemporary significance – badges, small items of packaging, labels. In his witty use of these Gironella resembles both the American Joseph Cornell and the Englishman Peter Blake, though his range of reference is probably wider than either of theirs and his work has a pervasive 'black' humour which seems typically Latin American. Gironella is also interested in the history of Surrealism, and his titles often refer to this. A series featuring strippers,
145 for example, has the ironic title *La Beauté convulsive: Homage to André Breton*. Gironella is not in any sense a fully Surrealist artist, but in some ways he can be thought of as a transitional figure who demonstrates what Pop Art owed to the earlier movement.

In the 1960s and 1970s Latin American artists, in addition to exploring the boundaries of Realism and flirting with Pop Art (in, as we have just seen, a generally unconvinced and unconvincing way), finally embraced Surrealism. This was no longer the property of Latin

182

146 Antonio Henrique
Amaral *Banana 164* 1971

American artists (such as Lam and Matta) who chose to pursue their careers largely outside Latin America, or of immigrants (such as Wolfgang Paalen, Varo and Carrington), but became a genuinely Latin American idiom, albeit of a somewhat conservative kind. Most of the Surrealists, or neo-Surrealists, of this new generation were associated with countries on the Pacific, not the Atlantic, seaboard. Perhaps the most striking talent among them was Tilsa Tsuchiya (1932–84), a Peruvian of Chinese descent. Tsuchiya began her career under the joint influences of Sabogal's *indigenismo* and Szyszlo's Peruvianized version of Abstract Expressionism. Her work only reached maturity after she went to Paris to study in 1960. Despite the fact that Surrealism was by that time very much in decline in Europe,

143

this was the influence she brought back with her. Like Varo and
Carrington, Tsuchiya was an extremely refined technician: her
paintings are exquisite luxury objects. What is unique about them is
the way in which they combine European Surrealism with *indigenista*
(Pre-Columbian) and Chinese motifs. They also look back to the
European Symbolism of the 1880s and 1890s.

Tsuchiya found a link between the Chinese and the American-
Indian sensibility in the concept of the *huaca*. A *huaca* is a sacred object
– tree or rock – or simply a sacred place. It can also be a portable
object, such as a strangely shaped stone. *Huacas* serve as residences for
malevolent spirits, who need to be placated. The Chinese liking for
the strange and grotesque in nature finds a ready counterpart in this

147 Nemesio Antúñez *New York, New York 10008* 1967

system of mythology, and Tsuchiya's most typical paintings are often representations of invented spirit beings, where Pre-Columbian elements are seen through the lens of a basically Oriental sensibility. 143

In Chile, there were two neo-Surrealist painters of quality – Mario Carreño (1913–99) and Nemesio Antúñez (1918–93). Carreño was born in Cuba and worked in Paris, Italy and New York before settling in Chile in 1957. Influenced initially by Picasso and de Chirico, he later came under the influence of the Afro-Cuban imagery used by his compatriot Wifredo Lam. It was not, however, until he reached Chile that he became fully Surrealist, and even then the tight, rather 144 mechanistic rendering of forms in his work suggests the influence of painters who were distinctly anti-Surrealist, such as Léger.

Antúñez also spent a period in the United States, and then in Paris. He started his career as a graphic artist, working with William Hayter, then served as Director of the Contemporary Art Museum of the University of Chile before returning to the USA as cultural attaché at the Chilean embassy in Washington. This combination of administrative and artistic functions is typical of a certain kind of Latin American career, in both art and literature. Immediately after the fall of Allende in 1973, Antúñez, who had been the director of the Museo de Bellas Artes in Santiago, resigned his post and went to Barcelona, then to London and Rome before finally returning to Chile in 1984. Antúñez's work reflects this peripatetic, cosmopolitan lifestyle – his paintings have a kind of detached elegance. The most typical are representations of vast landscapes, simplified and geometricized, 147 populated by swarming crowds of tiny figures. The remote ancestors of these compositions are Pieter Brueghel the Elder's representations of the Tower of Babel.

These distanced landscapes find a counterpart in the paintings showing gigantic towers produced by the Argentinian Surrealist Roberto Aizenberg (1928–96). Argentina, because of its commitment 148 to Europe and to European culture, was in fact more open to Surrealist influence in the inter-war period than was Mexico. Antonio Berni, as we have already seen, came into direct contact with the Surrealist movement during his period in Paris, though he rapidly renounced any connection with it after his return home. Another Argentinian artist who dabbled in Surrealism, though without real conviction, was Juan Battle Planas (1911–66). Battle Planas, in turn, was Aizenberg's teacher (1950–3). Unlike Carreño and Antúñez, Aizenberg spent his youth at home. He went to Paris only in 1977, when he was already nearly fifty, and settled in Tarquinia, Italy,

148 Roberto Aizenberg
Atmospheric Personage . . . 1963

ten years later. His work nevertheless has the same rather reserved cosmopolitanism as that of Antúñez. The most frequent motifs in his paintings are tall, deliberately featureless towers, or headless figures. He depicts a world in which identity is always kept secret.

Like that of the other Latin American Surrealists discussed in this chapter Aizenberg's technique is notably tight – one might almost call it 'academic'. And this points to a paradox: the leading Latin American Surrealists in fact give away much less of themselves than the so-called Realists who are their contemporaries and rivals. This in turn seems to say something about the true position of Surrealism in the history of Latin American art. Far from being a pioneering force, as is so often suggested by historians of the subject, it has very often been a conservative one: a way of embracing Modernism without risking too much.

The Present Day

Like the rest of late modern art, art in Latin America is currently split into conflicting genres. Basically, three main tendencies exist. The first is the continuation of the very specific Mexican tradition founded by Tamayo, which has now produced several generations of artists. The second is a Latin American version of European tendencies such as Neo-Expressionism and Post-Modernism, mostly associated with Argentina. The third is conceptual and site-specific work, prevalent everywhere except perhaps in Mexico, and particularly closely associated with Brazil.

Mexican painting has demonstrated remarkable continuity, fusing folk and Pre-Columbian elements to create a unique and instantly recognizable flavour. Tamayo's achievement was to have demonstrated how many Pre-Columbian ideas and images had been preserved in folk art. That is, instead of approaching these images archaeologically, with a kind of intellectual detachment, artists now looked for them not in ruins and excavations but in the living folk culture of Mexico, the most vigorous phenomenon of its kind in the hemisphere.

One direct heir of Tamayo is the incredibly prolific Francisco Toledo (b. 1940). Like Tamayo, Toledo is not innocent of European influences. He studied in Europe from 1960 to 1965, absorbing lessons from Dubuffet and Klee in particular. Nevertheless, the impact made by these artists seems to have been largely superficial. What matters most to Toledo is the rich Indian culture of his native Oaxaca. To 149 material gathered from this source he has added Mayan myths and legends found in seventeenth- and eighteenth-century Spanish records. The result is a richly decorative art which could not be anything other than Mexican. Toledo's work, however, is to some extent devalued by its relentless fluency. It has an artisan quality, and this is something which tends to keep all his production more or less on the same level. Rich in colour and sumptuous in texture, it is curiously unmemorable in terms of individual images.

This comment could never be made about the work of Toledo's near-contemporary, Alfredo Castañeda (b. 1938). Castañeda, like

149 Francisco Toledo
The Lazy Dog 1972

150 Alfredo Castañeda
The Great Birth 1983

Magritte, whom in some ways he resembles, is a master of visual paradox. His paintings are often representations of 'impossible' events, presented in a completely dead-pan way. In one work, for example, a bearded figure – a self-portrait, like many of the personages in Castañeda's paintings – is giving birth to himself. The painting eschews the sumptuous textures of a Tamayo or a Toledo. It looks like an inn sign, a rather battered one, and the title *El Gran Parto* (*The Great Birth*) is written in fancy nineteenth-century lettering above the figure. In the picture Castañeda offers a threefold link with the Mexican past. A figure giving birth is a common subject in Pre-Columbian pottery; the meticulous but rather naïve technique recalls the work of Hermenegildo Bustos; and the autobiographical element is reminiscent of Frida Kahlo.

Even though Castañeda's subject matter is often violent – the self-portrait or alter ego is sometimes depicted being stabbed or shot – his art is not, as Kahlo's is, a dramatization of personal suffering. Rather, the visual paradoxes found in his paintings are a commentary on the essential topsy-turviness of Mexican life.

The work of a new generation of Mexican artists is remarkable for its powerful sense of fantasy. Among the most striking artists are Nahum B. Zenil (b. 1947), Alejandro Colunga (b. 1948), Germán Venegas (b. 1959), Roberto Márquez (b. 1959) and Julio Galán (b. 1959). Zenil seems in many ways to be Castañeda's direct successor.

150

151

151 Nahum B. Zenil
Bloodiest Heart 1990

His work, too, is autobiographical, and the artist's own image appears again and again in his paintings and drawings (which are always modest in scale). Zenil makes use of a number of devices already associated with Castañeda: for example, doubling of images and ironic quotations from Mexican popular art. However, Zenil is, like Kahlo (whom he greatly admires), more propagandistic than Castañeda, and more fixated on the theme of personal suffering. His theme is the disadvantaged situation of the homosexual in Mexican society. Like Kahlo, he uses the traditional format of the *retablo* to confront the spectator with subversive ideas.

Colunga cites Tamayo among the artists who have influenced him, and his work has a tremendous exuberance of colour and form which makes the connection self-evident. Born and brought up in Guadalajara, Colunga bases his imagery on a world of childhood fantasy, which he traces back to the stories told to him and his numerous siblings by a nurse. His paintings often feature characters like La Llorona, the weeping woman who has lost her child, and wanders the streets in the company of Chamuco, the devil, looking for other children to kill. A typical device in Colunga's work is to paint an enormous single figure which fills the whole of a large canvas

151

152

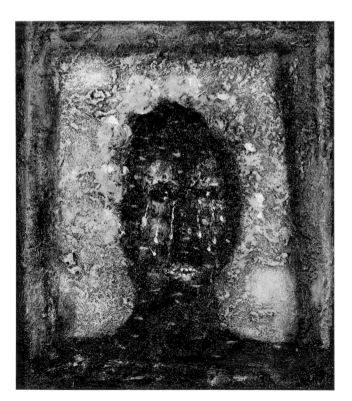

152 Alejandro Colunga
The Weeping Woman 1989

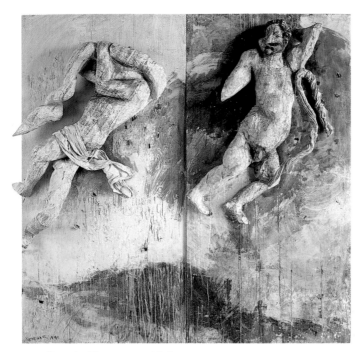

153 Germán Venegas, untitled, 1990

– but this figure is equipped with a disproportionately small head, so that it seems to loom above the spectator as an adult would over an infant.

Colunga shows remarkable dexterity in marrying elements which are purely Mexican to others borrowed from different cultures. His paintings testify to his admiration for El Greco and also show his acquaintanceship with the multi-headed and multi-armed deities of Indian art.

The career of Germán Venegas shows a development away from the saturated hues generally typical of Mexican art. His earliest works could be categorized as paintings, though they generally have relief elements. The more recent works are reliefs roughly carved in wood, 153 touched with subdued colour and mounted upon large wooden boards. Venegas thinks of his figures as natural presences, beings latent within the substance of the wood itself. This feeling is strengthened by the fact that the whole series of reliefs has been carved from a single, gigantic dead tree, given to the artist by neighbours in the state of

Puebla, on the condition that he also made some new reliefs of saints from the same wood for the local church. The images used in the reliefs seem like ghosts from the Christian and colonial past, though the artist deliberately leaves the subjects unspecific and the reliefs themselves untitled.

Like Venegas, Roberto Márquez has made reliefs which refer to Mexican colonial art. His major works, however, are large figurative canvases, very precisely painted, which incorporate a wide range of cultural references. *El Sueño de Brunelleschi*, for instance, shows a male figure (a self-portrait) surrounded by models of 'ideal' buildings.

154

154 Roberto Márquez *The Dream of Brunelleschi* 1991

155 Roberto Márquez *The Lost Dream of Shoël, Painter of Tigers* 1992

From the pyramidal roof of the model which the figure holds springs a sparkling firework display. *El Sueño Perdido de Shoël, Pintor de Tigres* 155 shows a nude figure, and the tiger of the title, against a Japanese screen. These images have the 'fantastic realism' of a novel by the artist's namesake, Gabriel García Márquez. Yet they are also very resistant to cultural stereotyping. In the imagery he chooses, Márquez consciously lays claim to the full range of civilizations invented by humankind.

Julio Galán's paintings, like those of Castaneda and Zenil, are rooted in the ex-votes and *retablos* of the colonial period and the nineteenth century. Yet here the overlapping images, and references 156 to photographs, old postcards and film posters also link the work to the world of the fashionable New York avant-garde, where Galán enjoyed a striking success in the late 1980s. In particular, there are references to the 'bad painting' of artists like David Salle. Mexican art, still rather enclosed and self-sufficient, is here in the throes of trying to come to terms with the current international art scene, while still struggling, at the same time, to remain both essentially and visibly Mexican.

156 Julio Galán *How Much is Missing?* 1990

157 Alfredo Prior *Paradise* 1988

158 Guillermo Kuitca *Triptych of Mattresses* 1989

In June 1990 Galán shared an exhibition in Rotterdam with the young meteor of Argentinian art, Guillermo Kuitca (b. 1961). The work of the two artists made a fascinating comparison. Kuitca is the son of Jewish immigrants to Argentina. It is not only that his own background and culture are cosmopolitan; there is also the fact that Argentine painting, taken as a whole, has never established an instantly recognizable national idiom, something either to rebel against or to accept, as has been the case with painting in Mexico. This, as the show demonstrated, gave Kuitca an extraordinary feeling of liberty; being Argentinian, even being Latin American, was not an issue in the sense that it clearly was with Galán. Yet it was also significant that most of the paintings Kuitca showed seemed to be about loneliness and urban isolation. His earliest mature paintings
159 were depictions of large theatrical spaces, slightly reminiscent of some of the etchings of fantastic prisons by Piranesi. They were in fact connected with work Kuitca was then doing in the theatre.
158 Later works have been more conceptual – images of maps and plans of middle-class urban apartments. Kuitca has said that one major

196

influence on his work is the novel *The Lost Language of Cranes* by David Leavitt, published in 1986. This is about a family called the Benjamins – father, mother and son – living in a middle-class New York apartment. The apartment is a womb, but also a prison, since both father and son are homosexual. The son, unaware of his father's orientation, grows up in a private world of solitude; the crisis comes when he struggles to get away and make a new life. By admitting his own sexual feelings, he brings those of his father into the open. One significant detail is that the son has a fascination with maps, and spends many hours in his room making maps of imaginary cities.

Kuitca's slightly older contemporary, Alfredo Prior (b. 1952) is similarly unhampered by nationalist preconceptions. He switches restlessly from style to style, sometimes making works which are Minimalist and influenced by Oriental art (his wife is Peruvian-Japanese), sometimes creating large canvases full of iridescent 157 Turneresque colour, and often depicting forest scenes peopled by fantastic characters.

Argentina is also producing a talented new generation of expatriate artists, among them Octavio Blasi (b. 1960), whose work is marked 160 by irreverent humour and an imaginative use of mixed-media techniques. One series of works, with fragmented images and thick pieces of wood collaged to canvas, is in step with the European Neo-Expressionism of the 1970s and 1980s. In another, later series, the

159 (*left*) Kuitca *Vague Idea of a Passion* 1985

160 (*right*) Octavio Blasi *Landscape* 1989

163 Ofelia Rodríguez *Dying Landscape in Midair* 1989

imagery is more specific, and the humour much blacker. In one work
a green Mickey Mouse is nailed to a cross bearing the label 'Christie's' 161
where one expects to see the letters INRI. On either side of the crucified
figure are enormous dollar signs. The message is hardly very subtle,
but it is somehow very Latin American for an artist to use Pop Art
techniques to criticize the materialism of American mass culture. The
piece is also technically interesting: it is made from colour-
impregnated paper pulp, using the method familiar from David
Hockney's *Paper Pools* of the late 1970s.

The British-domiciled Argentinian artist Ricardo Cinalli (b. 1948) 162
also uses an unconventional technique involving paper. He creates
ambitious compositions, often of very large size, using semi-
transparent layers of tissue paper, drawing on these with pastel. His
style is a Post-Modern variant of Neo-Classicism, and he imbues his

161 (*above left*) Octavio Blasi *Christie's* 1990

162 (*below left*) Ricardo Cinalli *The Blue Box* 1990

162 compositions with a very personal kind of unease. In *The Blue Box* (1990) the figures appear to be confined to a windowless room, where they enact a bacchanalian dance which brings them up short against the walls. De Chirico uses a similar device in his 'gladiator' series in the late 1920s. In another work, *Premonition I* (1989), Cinalli's figures are not confined, but one of them pushes frantically against an enormous naked foot, which implies the presence of a giant many times larger than himself. The Neo-Classical heritage has always been important in Latin American art for two reasons: first that, as has already been said, instruction in the fine arts has continued to have an academic, therefore classical basis; second that, particularly in the immediately post-Independence period, Neo-Classicism seemed to supply a kind of universal language, through which the artists of the New World could make themselves known to their fellow-artists in the Old. By using Neo-Classical forms to create dislocated and disturbing work, Cinalli questions whether there is any universal language of art.

A similar irony, directed against established European values, can be found in the work of the Colombian artist Ramiro Arango (b. 1946). Arango's method is to make parodies of familiar Old Master compositions by finding humble still-life equivalents for the figures.
164 Velázquez's *Las Meninas* becomes a gathering of coffee-pots, jugs and pears of various sizes. Arango here seems to be telling the spectator that for him the great European art of the past is fascinating yet also alien and distanced. It has lost its traditional meanings and is in the process of acquiring others, originally unintended.

Colombian art nevertheless, continues to reflect the divided nature of Colombian geography which in turn has led to a divided Colombian culture. Ofelia Rodríguez, from Barranquilla on the Colombian coast, has worked with Santiago Cárdenas Arroyo and Luis Caballero, but in a style quite different from either of them. She
163 uses flat semi-abstract shapes and bold tropical colours. In addition to painting, she also makes small, brightly painted boxes with found objects, which are often discarded toys found in street markets. These boxes are 'magical objects' which refer obliquely to surviving African cults in the Caribbean coastal region of Colombia, where a good proportion of the inhabitants are black.

Rodríguez's boxes make a bridge between the paintings and related work described above and the conceptual and environmental art which have recently become very important in Latin America. Their success can be explained – in part at least – by a pair of paradoxes: they are public yet private, accessible to everyone yet carefully coded. In

164 Ramiro Arango *Las Meninas* 1989

165 Víctor Grippo *Analogy IV* 1972

Argentina, during the worst days of the recent military junta, a lively art scene survived under the aegis of CAYC (Centre de Arte y Comunicación), founded in 1971 by the critic and impresario of the arts Jorge Glusberg. The metaphysics of an artist like Víctor Grippo (b. 1936), who specializes in what he describes as 'parallels', escape from the confines of any possible censorship, certainly in a state where Socialist Realism remained a wholly alien concept, at least to the men in power. This is Glusberg's description of a work made by Grippo in 1972, a year of 60 per cent inflation and escalating terrorism, when the ephemeral military ruler of the day, General Alejandro Lanusse, was just about to step down and recall the exiled Perón:

165 *Analogía IV* involves a table, divided into two sections. Each section contains a plate and real potatoes. Cutlery made of transparent acrylic is on one section; metal and china are used on the other section.

Apart from demonstrating the contrast between what is natural and what is artificial, the work also refers to ostentation and modesty and to the basic and the luxurious. The emphasis on potatoes suggests the awakening of consciousness; the cutlery and the plates introduce the concept of *homo faber*.

There was a similar upsurge in conceptual and site-specific work in Chile, under General Pinochet. The market for conventional art works was at that moment almost dead because of the severe deflation imposed by the government's economic policies, and most of the established artists, such as Antúñez, had left the country. What remained was a small 'scene' of artists making works for themselves, practically without hope of patronage. There was an interest in 'body art', some of it masochistic and self-mutilating. Raúl Zurita, better known as a writer, one of the leading Chilean avant-gardists of the late 1970s, performed 'actions' in which he burned his face (1975) or attempted to blind himself (1980).

As the political situation eased, with a partial return to democracy, and the economic situation improved, artists like Gonzalo Díaz (b. 1947), another avant-gardist under Pinochet, were able to make more ambitious environmental works. *Banco/Marco de Pruebas* (1988) shows 166 signs of the influence of Rauschenberg, who had a large touring show in Latin America in the 1980s. Díaz's title may contain a pun. Literally it means 'Test Bench'. However, 'banco' is also slang for 'prison', which, if such is intended, would give the piece a political meaning.

166 Gonzalo Díaz
Test Bench 1988

The complex imagery includes references to measurement and violence but the symbolism remains obscure – much more obscure than that of a mural by Rivera, Orozco or Siqueiros – and the piece is clearly addressed to an elite, not the mass public.

Installation art has also made an appearance in Cuba. During the later Castro years, it seems to have become one of the few officially tolerated ways of expressing dissidence with the régime and has made its appearance in contributions of younger Cuban artists to the Havana Bienal. An example is an untitled installation by Lázaro Saavedra (b. 1964), a participant in the third Havana Bienal of 1989. This makes ironic reference to revolutionary slogan-mongering, but also to the surviving influence of the Catholic Church in Cuba, to the worship of consumer goods, to 'tropicalism' and to the cult of technology. It appears to be the product of a by-now thoroughly cynical society.

Perhaps the richest, liveliest and most varied range of Conceptual and site-specific work has been produced in Brazil. In its disregard of conventional formats, its liking for the temporary and often the insubstantial, and its frequent polemical reliance on humble materials, the new Brazilian art has much in common with the Neo-Concretism of the 1960s. The wilful and fanciful element already present in the work of Lygia Clark and Hélio Oiticica is, however, now deliberately stressed, and the remnants of Constructivist logic have been abandoned. In recent years Brazil has produced a unique blend of the Conceptual and the Surrealist: for the first time one is confronted with a kind of Surrealism which seems genuinely rooted in Latin American culture, rather than being an imposed commentary.

The link between Neo-Concretism and Brazilian neo-Surrealism is particularly apparent in the work of Hilton Berredo (b. 1954), who makes wall-objects and sometimes whole installations out of cut and folded sheets of rubber, brightly painted with acrylic. These have an obvious kinship to the 'Grubs' of Lygia Clark. More typical of the new ethos, however, are artists like Waltercio Caldas Jr (b. 1946), Cildo Meireles (b. 1948) and Tunga (Antonio José de Mello Mourão, b. 1952). Caldas is a maker of inexplicable and disturbing objects – for example, a tortoise shell enclosing a steel tube, entitled *Object for Contemplation* (1978), or a toy cannon perched on a large egg (*The Origin of the Future*, 1974). Meireles, too, is a specialist in disturbing normal perceptions and expectations, using minimal means. *Rodos* (1974) consists of a series of four mysterious wooden rods, with attachments in wood and rubber. They look like implements whose

167 Lázaro Saavedra,
untitled installation, 1989.
The slogan reads 'Artists of
all sects, unite!'

168 Hilton Berredo,
untitled, 1988

169 Waltercio Caldas Jr *The Next* 1990

170 Cildo Meireles *Rods* 1978

171 Tunga *Lizart* 5 1989

meaning would become clear if one knew what task they were intended to perform – but this information is withheld.

Tunga is more extrovert. His obsession is hair. He makes 171
gargantuan braids by plaiting hanks of lead wire. He throws heaps of tresses on the floor, sometimes caught in a Brobdignagian comb. In his more ambitious installations, this hair invades the whole space, pushing its way up through the floorboards. The reference is to the kind of sexual fetishism which lies only half-concealed in the drawings of Henry Fuseli and the children's stories of Lewis Carroll. Tunga occupies a territory halfway between the two. Yet there is a significant difference: his work is entirely knowing, fully conscious of what is being disclosed, while theirs is not.

If Tunga's work is personally symbolic, in a disturbingly Freudian way, it also has another aspect, less likely to have been intended by the artist. It provides a fitting image with which to symbolize the mysterious labyrinths of modern Latin American culture.

In the concluding years of the 1990s, three things had a powerful effect on the development of Latin American art. One was the impact made by successive Havana Bienals. One was the continuing attraction of the United States. The third was increasing access to technology.

The Havana Bienals, with the aid of finance from Europe – the German-based Ludwig Foundation, in particular – offered a different model from that provided by the long-established Bienal of São Paulo. In Havana, the emphasis was not so much on the idea of competition between nations, but on the Third World as a cultural entity with its own ideas and standards. Latin American countries found themselves aligned with emerging nations in Asia and Africa. In addition, there was the impact made by Cuban society and Cuban art on visiting artists participating in the Bienals.

Cuban art under Castro had, from the beginning, been an art of public statement – there was no place in a Communist society for the private collector. The poster art of the earlier years of the régime mutated into an art chiefly based on installation. The reasons were obvious: materials for making more conventional artworks were in short supply, and installations could be created from scavenged and recycled materials; in addition, these installations were pre-eminently public and democratic. Cuban policy allowed the visual arts to be more outspoken than text statements. Hence Cuban installations could deal movingly with topics such as the fate of the *balsaleros* – those who tried to escape from the island using fragile, improvised rafts. Cuban pieces sparked a new wave of installation work throughout Latin America.

However, those Cuban artists who attracted international attention tended to leave their country – in this case with the blessing of the government – in order to earn money to support themselves, as well as their families back home. There was thus a steady trickle of emigration. Artists such as José Bedia (b. 1959) established themselves either in Miami (Bedia's own choice) or in Mexico, and became part of a wider international art world. In doing so, they became less distinctively Cuban. Their fate was similar to that of the Russian avant-garde artists of the last years of the Soviet epoch. These, too, left home in search of better things as soon as it was possible to do so, and as a result cut themselves off from the new post-Communist society that was developing in Russia.

Meanwhile the cultural influence of the United States remained powerful in Latin America, despite the dislike felt by many Latin American artists for North American culture. This influence operated

172

172 José Bedia *Untrappable* 1998

173 Doris Salcedo *Untitled* 1995

in two ways. There were the artists who became popular in New York because they seemed to hold a mirror up to aspects of Latin American society that Americans immediately recognized. This was the case with the Colombian Doris Salcedo (b. 1958), whose sculptures and installations, made from old pieces of furniture, were powerful indictments of the cruelty of the continuing civil war in her country. There were also the artists whose work combined aspects of gringo and Latin

173

174 Rubén Ortiz Torres *California Taco, Santa Barbara, California* 1995

American popular culture. An example is the Mexican Rubén Ortiz 174
Torres (b. 1964), who now lives and works in Los Angeles. His photo-
graphic 'House of Mirrors' series documents the intermingling of
two apparently antagonistic realms.

Ortiz Torres's use of photography represents a major growth area
in Latin American art. Though Latin America had produced distin-
guished photographers, notably Manuel Alvarez Bravo (1902–2002),
photography was not, till recently, part of the artistic mainstream. In
terms of artistic attitude, Miguel Calderón (b. 1971), perhaps the most
discussed of all the younger Mexican artists, represents an entirely fresh
departure. His work has been well described by Elizabeth Armstrong
and Victor Zamudio-Taylor:

Calderón belongs to the first generation of Mexicans who had wider access
to mall and global cultures. His work draws on a mixture of forms and
sources, bridging Mexico and the United States: the *telenovela* (soap opera),
mass tabloid imagery, international music video and Mexican punk cartoons,
diverse cinematic genres, and stereotyped notions of the 'bad taste' of
Mexico's working and middle classes.

He uses a wide range of different technical means, employing
them to make ironic points about the state of Mexican society.
'Evolution of Man' (1995) is a series of six photographic self-portraits: 175

175 Miguel Calderón *Evolution of Man* 1995

Calderón begins as a nude, squatting primate without a weapon, and acquires clothes and accoutrements as he stands more and more upright. In the final image of the sequence he is a strutting *vato loco* – a Mexican 'home boy', armed with a sub-machine-gun and a heavy-calibre pistol.

The most complex society in Latin America, and the fastest moving, is undoubtedly Brazil, and it is new Brazilian art which has tended to be at the forefront of Latin American innovation during the 1990s, and in the earliest years of the present decade.

Contemporary Brazilian art is enormously various. There is a long tradition of installation in Brazil, and the tendency is increasingly towards interactivity. There are interactive installations of a non-technological sort, such as those of Ernesto Neto (b. 1964), who fills rooms with tubes of stretched, white, semi-translucent cloth, through which the spectator/participant is invited to move. The form shifts and changes with the intervention of each new person who enters the maze.

176

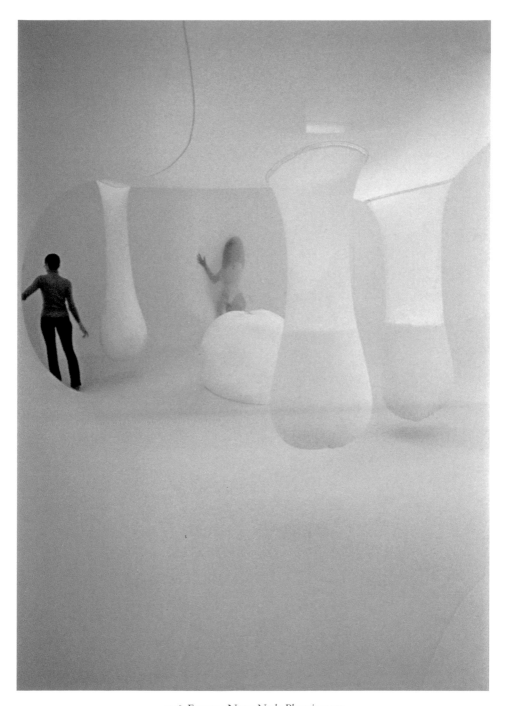

176 Ernesto Neto *Nude Plasmic* 1999

177 Diana Domingues *TRANS-E, My Body, My Blood* 1997

There is also a more and more imaginative use made of advanced technology. Another Brazilian artist, Diana Domingues (b. 1947), creates interactive video environments that simulate trance states. 177 In her *TRANS-E, My Body, My Blood*, digital technologies, in the artist's own words, provide 'an electronic ritual'. She compares the experience offered by the piece to that of entering a shamanic trance. 'A drum sound repeats an insistent rhythm and the sound of heart-beats is altered by the actions of the bodies. Simultaneously, a red liquid within a bowl moves according to the infra-red wave effects from the heat of bodies. To Afro-Brazilian popular religions, the blood is an *offerenda* to life.'

Yet painting also survives in Brazil. Recently a great deal of inter-national exposure has been given to the brilliant, explosive canvases of 178 Beatriz Milhazes (b. 1960), whose technique is an unusual marriage of

214

178 Beatriz Milhazes *The Carnation and the Rose* 2000

painting and collage. On a sheet of plastic, placed on the floor, she paints elaborate and colourful patterns. These, when dry, are peeled off the plastic and applied to the canvas. Her references are to traditionally female activities, such as sewing and embroidery, but these remain sub-liminal. While her paintings are also clearly indebted to some of the late work of Kandinsky, the explosive force of the designs seems to carry the long-established Latin American Constructivist tradition into a whole new realm.

Select Bibliography

Dawn Ades et al, Art in Latin America: The Modern Era, 1820–1980 (exh. cat.). Hayward Gallery, London, 1989
Josefina Alonso de Rodriguez, Arte Contemporáneo, Occidente-Guatemala. Guatemala City, 1966
Aracy Amaral, Perfil de UM Acervo (exh. cat.). Museu de Arte Contemporânea da Universidade de São Paulo, São Paulo, 1986
Silvia de Ambrosini and Alina Molinari, Los 80 en el MAM: Instalaciónes de 27 Artistas (exh. cat.). Museo de Arte Moderno, Buenos Aires, 1991
Nemesio Artúñez (exh. cat.). Praxis Galeria de Arte, Santiago, Chile, 1988
Elizabeth Armstrong and Victor Zamudio-Taylor, Ultra Baroque: Aspects of Post Latin American Art (exh. cat.). Museum of Contemporary Art, San Diego, 2000
Antonio Luna Arroyo, Francisco Goitia, Total. Mexico City, 1987
Arte Colombiano del Siglo XX. Bogotá, 1981–2
Dore Ashton, Jacobo Borges. Caracas, 1982
Enrique Azcoaga, Lino Eneas Spilimbergo. Buenos Aires, 1963
Ricardo Ulloa Barrenchea, Pintores de Costa Rica. Costa Rica, 1974
Damian Bayon, Artistas Contemporáneos de America Latina. Paris, 1981
— (ed.), America Latina en sus Artes. Paris and Mexico City, 1980 (3rd edn)
— and Roberto Pontual, La Peinture de l'Amérique latine du xxᵉ siècle: Identité et modernité. Paris, 1990
Evelyn Berg et al, Ibere Camargo. Rio de Janeiro, 1985
Antonio Berni: Obra pictorica 1922–1981 (exh. cat.). Museo Nacional de Buenos Aires, 1984
Juan Gustavo Cobo Borda, Obregón. Bogotá, 1985
Jacobo Borges (exh. cat.). Museo de Monterrey, Mexico, 1987
Jacobo Borges (exh. cat.). Staatliche Kunsthalle, Berlin, 1987
Jacobo Borges. Buenos Aires, 1990
Jacobo Borges: Itinerario de Viaje 1987–91. Caracas, 1991
Alfredo Boulton, Historia de la pintura en Venezuela. Caracas, 1968
Brasil Já (exh. cat.). Museum Morsbroich, Leverkusen, Germany, 1988
Guy Brett, Kinetic Art: The Language of Movement. London and New York, 1968
Ronaldo Brito, Waltercio Caldas Jr 'Aparalhos'. São Paulo, 1979
—, Camargo. São Paulo, 1990
German Rubiano Caballero, La escultura en America Latina (Siglo XX). Bogotá, 1986
—, Enrique Grau. Bogotá, 1983
Luis Caballero (exh. cat.). Galeria Garces Velázquez, Bogotá, 1990
Luis Caballero: Retrospectiva de una confesión. Bogotá, 1991
Luis Caballero: Large-Scale Drawings (exh. cat.). Nohra Haime Gallery and Grey Art Gallery and Study Center, New York, 1991
Juan Calzadilla, Armando Reverón. Caracas, 1979
Galaor Carbonell, Negret: Las Etapas Creativas. Medellín, Colombia, 1973

Stanton Loomis Catlin and Terence Grieder, Art of Latin America since Independence (exh. cat.). Yale University Art Gallery and University of Texas at Austin Art Museum, New Haven and Austin, TX, 1966
CAYC Group at the Bank of Ireland (exh. cat.). Dublin, 1980
Jean Charlot: Murals in Georgia. Athens, GA, 1945
Chilean Contemporary Art (exh. cat.). Toledo Museum of Art, OH [1946]
Teresa del Conde, Julio Ruelas. Mexico City, 1976
Contemporary Art from Chile / Arte Contemporáneo desde Chile (exh. cat.). Americas Society, New York, 1991
J. Corredor-Matheos, Tamayo. Barcelona, 1987
Lucien Curzi, Wifredo Lam. Bologna, 1978
Holliday T. Day and Hollister Sturges, Art of the Fantastic: Latin America, 1920–1987 (exh. cat.). Indianapolis Museum of Art, 1987
Conrad Detrez, Caballero: ou l'irrésistible corps de l'homme-dieu (exh. cat.). Galerie Jade, Colmar, France, 1980
Frank Elgar, Poleo. Caracas, 1970
Helen Escobedo (ed.), Mexican Monuments: Strange Encounters. New York, 1989
Escultores Argentinos del siglo xx. Buenos Aires, 1982
José Fernandez, Luis Caballero: Me tocó ser así. Bogotá, 1986
Miguel Angel Fernandez, Art in Latin America Today: Paraguay. Washington, D.C., 1969
Max-Pol Fouchet, Wifredo Lam. Barcelona, 1976
Juan Fride, Luis Alberto Acuña: pintor colombiano. Bogotá, 1946
Carlos Fuentes, Jacobo Borges. Buenos Aires, 1976
Ileana Fuentres-Perez, Graciella Cruz-Taura and Ricardo Pau-Llosa (eds), Outside of Cuba / Fuera de Cuba. New Brunswick, NJ, and Miami, FL, 1988
Julio Galán (exh. cat.). Annina Nosei Gallery, New York, 1989
Gaspar Galaz and Milan Ivelic, La Pintura en Chile desde la Colonia. Valparaiso, 1981
José Gamarra (exh. cat.). Donald Morris Gallery, Birmingham, MI, 1987
José Gamarra (exh. cat.). Galerie Albert Loeb, Paris, 1992
Emily Genauer, Rufino Tamayo. New York, 1974
Guillermo Gersio, Arte Argentina en Japón 1980–1985 (exh. cat.). Museo Nacional de Bellas Artes, Buenos Aires, 1988
Edouard Glissant, José Gamarra (exh. cat.). Galerie Albert Loeb, Paris, 1985
Jorge Glusberg, Del Pop Art a la Nueva Imagen. Buenos Aires, 1985
—, Art in Argentina. Milan, 1986
Shifra M. Goldman, Contemporary Mexican Painting in a Time of Change. Austin, TX, and London, 1981
Mario H. Gradowczyk, Joaquín Torres-García. Buenos Aires, 1985
Ferreira Gullar, Donato Mello Jr, Noemi Ribeiro and Rogerio Fari, 150 anos de pitura brasileira, 1820–1970. Rio de Janeiro, 1979
Hayden Herrera, Frida: A Biography of Frida Kahlo. New York, 1983, and London, 1989
Victor Carvacho Herrera, Veinte Pintores Contemporáneos de Chile. Santiago [1979]

Intimate Recollections of the Río de la Plata: Paintings by Pedro Figari (exh. cat.). Center for Inter-American Relations, New York, 1986

Cordova Iturburu, *80 años de pintura argentina*. Buenos Aires, 1981 (2nd edn)

María Izquierdo: monografía. Guadalajara, Mexico, 1985

Edouard Jaguer, *Remedios Varo*. Paris, 1980

Adelaide de Juan, *Pintura Cubana: temas y variaciones*. Mexico City, 1980

Angel Kalenberg, *Arte contemporáneo en el Uruguay* (exh. cat.). Museo Nacional de Artes Plásticas y Visuales de Montevideo for circulation in Germany [1983]

Janet A. Kaplan, *Unexpected Journeys: The Art and Life of Remedios Varo*. New York and London, 1988

Pál Kelemén, *Peruvian Colonial Painting* (exh. cat.). Brooklyn Museum, New York, 1971

Lincoln Kirstein, *The Latin-American Collection of the Museum of Modern Art*. New York, 1943

Gyula Kosice, *Arte Madí*. Buenos Aires, 1982

Kuitca. Buenos Aires, 1989

Guillermo Kuitca (exh. cat.). Witte de With Centre for Contemporary Art, Rotterdam, 1990

Wifredo Lam (exh. cat.). Ordrupsgaardsamlingen, Copenhagen, 1978

The Latin American Spirit: Art and Artists in the United States, 1920–1970 (exh. cat.). Bronx Museum of Art, New York, 1988

José Antonio de Lavalle and Werner Lang, *Arte y Tesoros de Perú: Pintura Contemporánea Segunda Parte, 1920–1960*. Lima, 1976

Carlos Lemos, Jose Roberto Texeira and Pedro Manual Gismonti (eds), *The Art of Brazil*. New York, 1983

José Alfredo Llerena, *La Pintura Ecuatoriana del siglo xx*. Quito, 1942

Ramon Lopez Velarde, *Saturnino Herrán*. Mexico City, 1988

Edward Lucie-Smith, *Luis Caballero: Paintings and Drawings* Editions Aubrey Walter, 1992

Lumière et mouvement (exh. cat.). Musée d'Art Moderne de la Ville de Paris, 1967

Rómulo Macció: Selección de pinturas/Selected Painting, 1963/1980. Buenos Aires, 1980

Matta (exh. cat.). Centre Georges Pompidou, Paris, 1985

Carlos Mérida, *Modern Mexican Artists*. Freeport, NY, 1968 (2nd edn)

Thomas M. Messer and Cornell Capa, *The Emergent Decade: Latin American Painters and Painting in the 1960s* (exh. cat.). The Solomon R. Guggenheim Museum, New York, 1966

Thomas M. Messer et al, *Alejandro Obregón* (exh. cat.). Galeria Quintana, Bogotá, 1983

Mexico: The New Generations (exh. cat.). San Antonio Museum of Art, TX, 1985

Mexico: Splendors of Thirty Centuries (exh. cat.). The Metropolitan Museum of Art, New York, 1990

Mexique: peintres contemporains (exh. cat.). Musée Picasso, Château d'Antibes, Antibes, 1980

Modernidade: art brésilien du 20° siècle (exh. cat.). Museé d'Art Moderne de la Ville de Paris, 1987

Armando Morales (interview with Jean Piaget). Paris, 1986

Humberto More, *Actualidad Pictorica Ecuatoriana*. Guayaquil [1970s], (2nd edn)

Carlos Salazar Mostajo, *La Pintura Contemporánea de Bolivia*. La Paz, 1988

Museum of Modern Art of Latin America. Selections from the Permanent Collection. Washington, D.C., 1985

The National Museum of Cuba: Painting. Havana and Leningrad, 1978

Nuevos Momentos del Arte Mexicano/New Moments in Mexican Art (exh. cat.). Parallel Project, New York, 1990

Alejandro Obregón: Pintor colombiano/Peintre colombien (exh. cat.). Museo Nacional, Bogotá, and Maison de l'Amérique Latine, Paris, 1985

Hélio Oiticica (exh. cat.). Witte de With Centre for Contemporary Art, Rotterdam, 1992

Orozco, 1883–1949 (exh. cat.). Museum of Modern Art, Oxford, 1980

Orozco: Una Reflectura. Mexico City, 1983

Carmen Ortega Ricuarte, *Diccionario de Artistas en Colombia*. Bogotá, 1979

Hanni Ossoff, *Gego* (exh. cat.). Museo de Arte Contemporáneo, Caracas, 1977

Alejandro Otero (exh. cat.). Museo de Arte Contemporáneo, Caracas, 1985

Amelia Peláez, exposición retrospectiva 1924–1967 (exh. cat.). Museo de Bellas Artes, Caracas, 1991

Nelly Perazzo, *El Arte Concreto en La Argentina*. Buenos Aires, 1983

Pettoruti: Un recorrido de la mirada (exh. cat.). Museo Nacional de Bellas Artes, Buenos Aires, 1982

Pintores Argentinos del siglo xx (4 vols). Buenos Aires, 1982

Pintura contemporánea de Nicaragua. Managua [1980s]

Roberto Pontual (ed.), *America Latina: Geometría Sensivel*. Rio de Janeiro, 1978

Nelly Richard, *Margins and Institutions: Art in Chile since 1973*. Art & Text (Special Issue). Melbourne, Australia [1986]

Jorge Rigol, *Apuntes sobre la pintura y el grabado en Cuba (de los orígines a 1927)*. Havana, 1982

Diego Rivera: A Retrospective (exh. cat.). Founders' Society, Detroit Institute of Arts, 1986

Marco Rivero, *Artistas Plásticas en Colombia: los de ayer y los de hoy*. Bogotá, 1982

Desmond Rochfort, *The Murals of Diego Rivera* (exh. cat.). Hayward Gallery, London, 1987

Antonio Rodriguez, *Diego Rivera: Mural Painting*. Mexico City, 1988

Antonio Ruiz: El corzo. Mexico City, 1987

Alberto Ruiz Sanchez and Edward J. Sullivan, *Alfredo Castañeda* (exh. cat.). Galeria de Arte Mexicano, Mexico City, and Mary-Anne Martin/Fine Arts, New York, 1989

Andrés de Santa María (exh. cat.). Musée Marmottan, Paris, and Museo Nacional, Bogotá, 1985

Segui: peintures, dessins et reliefs (exh. cat.). Présence contemporaine Aix-en-Provence, Cloître Saint-Louis, 1985

Seis Maestros de la Pintura Uruguaya (exh. cat.). Museo Nacional de Bellas Artes, Buenos Aires, 1987

Eduardo Serrano, *Cien Años de Arte Colombiano* (exh. cat.). Museo de Arte Moderno, Bogotá, 1986

Soto: Cuarenta años de creación, 1943–1983 (exh. cat.). Museo de Arte Contemporáneo, Caracas, 1983

Werner Spies, *Fernando Botero*. Munich, 1992

Rafael Squirru, *Arte Argentino Hoy*. Buenos Aires, 1983

Carla Stellweg, 'Rufino Tamayo en Venezia', *Excelsior* (Mexico City), 1 Sept 1968

Edward J. Sullivan, *Claudio Bravo*. New York, 1985

—, *Aspects of Contemporary Mexican Painting* (exh. cat.). Americas Society Art Gallery, New York, 1990

— and Jean-Clarence Lambert, *Alejandro Colunga 1966–86* (exh. cat.). Museo de Monterrey, Mexico, 1986

Osvaldo Svanascini, *Xul Solar*. Buenos Aires, 1962

Raquel Tibol, *David Alfaro Siqueiros: un Mexicano y su obra*. Mexico City, 1969

—, *Hermenegildo Bustos: Pintor del Pueblo*. Guanajuato, Mexico, 1981

Today's Art of Brazil (exh. cat.). Hara Museum, Tokyo, 1985
*Joaquín Torres-García 1874–1949: Chronology and Catalogue of the
Family Collection* (exh. cat.). University of Texas at Austin
Art Museum, 1974
Torres-García (exh. cat.). Museo Nacional de Artes Plásticas,
Montevideo, 1974
Marta Traba, *Historia abierta del arte colombiano*. Bogotá, 1984
UABC [Uruguay, Argentina, Brazil, Chile] (exh. cat.).
Stedelijk Museum, Amsterdam, 1989

Rigoberto Villaroel Claure, *Art in Latin America Today:
Bolivia*. Washington, D.C., 1963
Guillermo Whitelow, *Raquel Forner*. Buenos Aires, 1980
Edwin Williamson, *The Penguin History of Latin America*.
London and New York, 1992
Walter Zamini (ed.), *História General da Arte no Brasil* (2 vols).
São Paulo, 1983

List of Illustrations

Measurements are in centimetres and inches, height before
width before depth, unless otherwise specified

Antonio Caro 142 *Colombia* 1976. Print, 23 × 34 (9 × 13⅜)
Mario Carreño 144 *Light of the South* 1967. Oil on canvas, 85 × 120 (33½ × 47¼). Private collection
Leonora Carrington 81 *The Distractions of Dagobert* 1945. Egg tempera on panel, 74.9 × 86.3 (29½ × 34). Present location unknown. Photo courtesy of Pierre Matisse Gallery, New York. 82 *The Old Maids* 1947, 60 × 74.9 (23⅝ × 29½). Photo courtesy of Pierre Matisse Gallery, New York
Alfred Castañeda 150 *The Great Birth* 1983. Oil on canvas, 120 × 120 (47¼ × 47¼). Collection Secretaria de Hacienda y Credito Publico. Photo courtesy of Galeria de Arte Mexicana, Mexico City.
José Gil de Castro 114 *The Martyr Olaya* 1823. Oil on canvas, 204 × 134 (80⅜ × 52¾). Museo Nacional de Historia, Lima
Emiliano di Cavalcanti 24 *Mulatta with Parrot*. India ink, brush and ink and pencil on paper, 27.4 × 19.8 (10¾ × 7¾). Photo Christie's, New York
Jean Charlot 48–9 *Cortés lands in Mexico*, 1944; *Paratroopers land in Sicily*, 1944. Each fresco 3.35m × 20.1m (11ft × 66ft) from Brooks Hall, University of Georgia murals, Athens. Photo University of Georgia, Athens, GA
Ricardo Cinalli 162 *The Blue Box* 1990. Pastel on tissue paper layers, c. 310 × 220 (122 × 86⅝). Courtesy of the artist
Lygia Clark 106 *Rubber Grub* 1964 (remade by artist 1986). Rubber, 142 × 43 (55¾ × 16⅞). Museu de Arte Moderna do Rio de Janeiro. Donated by the artist
Alejandro Colunga 152 *The Weeping Woman* 1989. Oil on canvas, 41.2 × 36.2 (16¼ × 14¼). Courtesy of M. Gutierrez Fine Arts, Miami, FL
Rafael Coronel 90 *All Together* 1965. Oil on canvas, 139.7 × 139.7 (55 × 55). Art Museum of the Americas, OAS, Washington, DC. 91 *Titian* 1969. Oil on canvas, 129 × 140 (50¾ × 55⅛). Private collection. Photo courtesy M. Gutierrez Fine Arts, Miami, FL
Carlos Cruz-Díez 103 *Physichromie 198* 1965. Acrylic and coloured plastic panel, 71.4 × 177.8 (28⅛ × 70⅛). Photo courtesy of CDS Gallery, New York
José Luis Cuevas 88 *Man on a Seat* 1961. Ink on paper, 22.8 × 17.1 (9 × 6¾). Courtesy of Tasende Gallery, La Jolla, CA. 89 *The Ugly of this World I*, from the *Homage to Quevedo* suite, 1969. Lithograph, special edition XVI, 57.1 × 76.2 (22½ × 30). Courtesy of Tasende Gallery, La Jolla, CA
Ernesto Deira 122 *S/T* 1965. Oil on canvas, 152 × 152 (59½ × 59½). Jorge and Marion Helft Collection, Buenos Aires. Photo Casenave
André Derain 6 *The Italian Woman*, c. 1920–24. Canvas on plywood, 91 × 72 (35¾ × 28¼). Trustees of the Board of the National Museums and Galleries on Merseyside, Liverpool
Gonzalo Díaz 166 *Test Bench* 1988. Installation. Gallerie Arte Actual, Santiago
Diana Domingues 177 *TRANS-E, My Body, My Blood* 1991. Courtesy of the artist
Pedro Figari 18 *Candombe* 1920–30. Oil on board, 39.5 × 49.4 (15 × 19). Collection Estudio Actual, Ccs. Photo courtesy of CDS Gallery, New York. 22 *The Prayer Bell*. Oil on cardboard, 69 × 99 (27⅛ × 38⅞). Museo Nacional de Artes Visuales, Montevideo
Gonzalo Fonseca 110 *Katabasis II* 1975. Red travertine, 140 × 60 × 45 (55¼ × 23⅝ × 17¾). Museo Nacional de Artes Visuales, Montevideo
Raquel Forner 120 *Conquest of the Moon Rock* 1968. Oil on canvas, 120 × 160 (47¼ × 63)
Julio Galán 156 *What's Missing?* 1990. Collage on canvas, 228.6 × 198.1 (90 × 78). Courtesy of Annina Nosei Gallery, New York

José Gamarra 138 *Encounter with Conquistadores* 1989–90. Mixed media on canvas, 150 × 150 (59 × 59). Private collection, Bogotá. Photo Beatrice Hatala
Gego 100 *Reticularea* 1969. Inox steel, 540 × 350 (212½ × 137¾). Collection Galería de Arte Nacional, Caracas. Photo Asdrubal Perdomo (GAN)
Gunther Gerzso 112 *Blue-Red Landscape* 1964. Oil on canvas, 63 × 91 (24¾ × 3¾). Collection of Galeria de Arte Mexicano, Mexico City
Alberto Gironella 145 *La Beauté convulsive: Homage to André Breton* 1991. Photograph and collage in box, 108.9 × 62.8 × 12 (42¾ × 25¾ × 4¾). Courtesy of Galeria OMR, Mexico. Photo Laura Cohen
Mathias Goeritz 113 *Five Towers* 1957–8, Satellite City, Mexico City. Photo Bob Schalkwijk
Francisco Goitia 16 *Landscape at Zacatecas I, c.* 1914. Oil on canvas, 58 × 96 (22⅞ × 37¾). Museo Nacional de Arte, Mexico City. Photo INBA. 17 *Man Seated on a Trash Heap* 1926–7. Oil on canvas, 53 × 57 (20⅞ × 22½). Museo Nacional de Arte, Mexico City. Photo INBA
Enrique Grau 135 *Bather at Cartagena* 1968. Tempera on paper, 97 × 65 (38 × 25½). Photo Christie's, New York
Víctor Grippo 165 *Analogy IV* 1972. Potatoes, ceramic, metal plate setting, canvas, velvet and wood, 75 × 100 × 55 (29½ × 39⅜ × 21¾). Jorge and Marion Helft Collection, Buenos Aires
Oswaldo Guayasamín 54 *My Brother* 1942. Oil on wood, 40.3 × 32.4 (15⅞ × 12¾). Collection, The Museum of Modern Art, New York. Inter-American Fund. 55 *Marimbas*, oil on board, 34 × 51.1 (13⅜ × 20⅛). Photo Christie's, New York
Alberto Heredia 125 Three *Camembert Boxes* from the series, 1961–3. Wooden boxes with mixed media, each c. 32 × 17.5 × 5.3 (12⅝ × 6⅞ × 2). Artist's collection and Jorge and Marion Helft Collection, Buenos Aires
Saturnino Herrán 12 *Woman from Tehuantepec* 1914. Oil on canvas, 150 × 75 (59 × 29½). Museo de Aguascalientes. Photo INBA. 13 *The Offering* from *Our Gods* project, 1904–18. Charcoalon paper, 81 × 185 (31⅞ × 72¾). Museo de Aguascalientes. Photo INBA
Alfredo Hlito 95 *Chromatic Rhythm* 1945. Oil on canvas, 70 × 70 (27½ × 27½). Private collection, Geneva. Photo courtesy of Galerie von Bartha, Basle
María Izquierdo 83 *Poor Mother* 1944. Oil on canvas, 75 × 105 (29½ × 41¾). Photo Christie's, New York. 84 *The Open Cupboard* 1946. Oil on canvas, 62 × 50 (24⅜ × 19¾). Collection César Montemayor Zambrano, Monterrey. 85 *The Circus Riders Lolita and Juanita* 1945. Watercolour, 45.5 × 55.5 (17⅞ × 21⅞). Collection Francisco Gilardi. Photo INBA
Frida Kahlo 72 *Self-Portrait with Diego and My Dog, c.* 1953–4. Oil on masonite, 59.7 × 40 (23½ × 15¾). Photo Christie's, New York. 74 *Self-Portrait* 1940. Oil on canvas, 62 × 47.5 (24⅜ × 18¾). Iconography Collection, Harry Ranson Humanities Research Center, The University of Texas at Austin. 76 *The Fruits of the Earth* 1938. Oil on masonite, 40 × 60 (15¾ × 23¾). Banco Nacional de México, S.A.
Eduardo Riofrío Kingman 53 *Boy with Flute* 1941. Pastel on paper, 61 × 45.4 (24 × 17¾). Photo Christie's, New York
Gyula Kosice 92 *MADI Neon No. 3* 1946. Wood and neon, 56 × 41 × 18 (18⅛ × 16⅛ × 7). Musée de Grenoble. Photo courtesy of Galerie von Bartha, Basle
Guillermo Kuitca 158 *Triptych of Mattresses* 1989. Acrylic on 3 mattresses, each 200 × 140 (78¾ × 55⅛). Courtesy of Thomas Cohn, Arte Contemporânea, Rio de Janeiro. 159 *Vague Idea of a Passion* 1985. Acrylic on canvas, 173 × 125 (68⅛ × 49¼). Galerie Barbara Farber, Amsterdam
Wilfredo Lam 64 *The Window* 1936. Oil on canvas, 97 × 76 (38⅛ × 30). Photo Christie's, New York. 65 *The Jungle* 1943.

Gouache on paper mounted on canvas, 239.4 × 229.9 (94¼ × 90½). Collection, The Museum of Modern Art, New York. Inter-American Fund. 66 *The Entry* 1969. Oil on canvas, 115 × 145 (45¼ × 57). Private collection, Spain. Photo Bartoli
Julio Le Parc 102 *Series 29D, No. 11–9, 9–11, 9–11, 11–9.* Collage on paper, 70 × 70 (27½ × 27½). Photo Christie's, New York
Manabu Mabe 119 *Ecuador No. 2* 1973. Oil on canvas, 180 × 200.7 (70¾ × 79). Museu de Arte Contemporânea da Universidade de São Paulo
Rómulo Macció 124 *Politics* 1986. Oil on canvas, 200 × 200 (78¾ × 78¾). Private collection. Photo courtesy of Ruth Benzacar Galeria de Arte, Buenos Aires
Eduardo Mac Entyre 96 *Montage* 1960–70. Acrylic and wood, 120 × 120 (47¼ × 47¼). Private collection, Argentina. Photo Caldarella
Tomás Maldonado 94 *Development of the Triangle* 1951. Oil on canvas, 80 × 60 (31½ × 23¾). Collection von Bartha, Basle
Anita Malfatti 23 *The Idiot* 1915/16. Oil on canvas, 61 × 50.6 (24 × 19¾). Museu de Arte Contemporânea da Universidade de São Paulo
Antonio Mancini 10 *Return from Piedigrotta.* Oil on canvas, 77 × 64 (30¼ × 25¼). Galleria Nazionale di Capodimonte, Naples. Photo Soprintendenza alle Gallerie, Naples
Victor Manuel 31 *Gypsy Girl from the Tropics* 1929. Oil on panel, 46.5 × 38 (18¼ × 14¾). National Museum of Cuba, Havana
Roberto Márquez 154 *The Dream of Brunelleschi* 1991. Oil and mixed media, 184.1 × 142.8 (72½ × 56¼). Courtesy of Riva Yares Galleries, Santa Fe, NM, and Scottsdale, AZ. 155 *The Lost Dream of Shoël, Painter of Tigers* 1992. Oil and mixed media, 152.4 × 182.8 (60 × 72). Courtesy of Riva Yares Galleries, Santa Fe, NM, and Scottsdale, AZ
Raúl Martínez 141 *Always Che* 1970 (detail). Courtesy of Ludwig Forum Für Internationale Kunst, Aachen
Matta 67 *Composition* 1945. Oil on canvas, 124.5 × 143 (49 × 56¼). Photo Christie's, New York. 68 *Tendre Mie* 1955. Oil on canvas, 128 × 94.8 (50¼ × 37¼). Photo Christie's, New York. 69 *The Shadow of the Moment* 1966. Oil on canvas, 138.5 × 152 (54½ × 59¼). Photo Christie's, New York
Cildo Meireles 170 *Rods* 1978. Installation, 6 pieces of wood and rubber. Collection Gilberto Chateaubriand
Carlos Mérida 71 *The Bird the Serpent* 1965. Oil and pen and black ink on amate paper laid down on masonite, 78.5 × 60 (31 × 23½). Photo Christie's, New York
Beatriz Milhazes 178 *The Carnation and the Rose* 2000. Acrylic on canvas, 240 × 242 (94½ × 95). Courtesy of Edward Thorp Gallery, New York
Roberto Montenegro 70 *Portrait of the Photographer Hoyningen-Huene, c.* 1940. Oil on canvas, 66 × 56.8 (26 × 22½). Photo Christie's, New York
Armando Morales 139 *Family Reunion* 1983. Oil on canvas, 100 × 81 (39¼ × 31¼). Photo Galerie Claude Bernard, Paris
Edgar Negret 104 *The Bridge (Homage to Paul Foster)* 1968. Aluminium, 60.3 × 200.6 × 95.2 (23¾ × 79 × 37½). Museum of Art, Rhode Island School of Design. Nancy Sayles Day Fund for Modern Latin American Art
Ernesto Neto 176 *Nude Plasmic* 1999. Lycra fabric, sand, styrofoam and lavender installation, dimensions variable, exhibition dimensions 548.6 × 2100.6 × 518.2 (216 × 825 × 204) overall. Courtesy of the artist, Galeria Camargo Vilaca, São Paulo, and Bonakdar Jancou Gallery, New York

Luis Filipe Noé 123 *Introduction to Hope* 1963. Mixed media on canvas, 97 × 195 (38¼ × 76¾). Museo Nacional de Bellas Artes, Buenos Aires. Photo courtesy of Ruth Benzacar Galeria de Arte, Buenos Aires
Juan O'Gorman 50 *Mexico City* 1949. Distemper on masonite, 66 x 122 (26 x 48). Museo de Arte Moderno, Mexico City. Photo INBA. 51 *The Colonial Past*, mosaic, 27.3m x 46.6m (89½ft x 146ft). Central Library, Mexico Univesity, Mexico City, 1952. Photo Bob Schalkwijk
Pablo O'Higgins 47 *Indian Wedding in San Lorenzo*, from the National Museum of Anthropology mural, Mexico City, 1964. Fresco in a frame, 350 × 502 (137¾ × 197¾). Photo INBA
Alejandro Obregón 126 *Dead Student (or The Wake)* 1956. Oil on canvas, 55 × 69 (21⅝ × 27¼). Art Museum of the Americas, OAS, Washington, D.C. 128 *Shipwreck* 1960. Oil on canvas, 130 × 100 (51¼ × 39¼). Private collection
José Obregón 3 *The Discovery of Pulque* 1869. Oil on canvas, 189 × 230 (74¼ × 90½). Museo Nacional de Arte, Mexico City. Photo INBA
Tomie Ohtake 118 Untitled. Oil on canvas, 150 × 150 (59 × 59). Photo Christie's, New York
Hélio Oiticica 107 *Glass Bolide 4, 'Earth'* 1964. Collection Projeto Hélio Oiticica. Rio de Janeiro (dimensions and media not supplied in accordance with artist's criteria)
José Clemente Orozco 1 *Cortés and Malinche*, from the Escuela Nacional Preparatoria mural, Mexico City, 1926–27. Photo Bob Schalwjk. 8 *General view of the Hospicio Cabañas murals*, Guadalajara, 1938–9. Fresco. Photo Bob Schalkwijk. 38 *The Hour of the Gigolo* 1913. Watercolour, 28 × 45.5 (11 × 17¾). Museo de Arte Carillo-Gil, Mexico. Photo The Museum of Modern Art, Oxford. 39 *Destruction of the Old Order*, from the Escuela Nacional Preparatoria murals, Mexico City, 1926–7. Fresco. Photo INBA. 40 *The Table of Brotherhood*, from the New School for Social Research murals, New York, 1930. Fresco. Photo New School for Social Research, New York. 41–2 *The Franciscan friar and the horse from the Hospicio Cabañas murals*, Guadalajara, 1938–9. Fresco. Photo Bob Schalkwijk
Alejandro Otero 99 *Delta Solar* 1977. Stainless steel, kinetic, 8.2m × 14.2m (27ft × 46½ft). National Air and Space Museum, Smithsonian Institution, Washington, D.C. Gift of the People of Venezuela
María Luisa Pacheco 116 *Cosmos* 1968. Oil and wood on canvas, 121.9 × 101.6 (48 × 40). Courtesy of Armando J. Florez
Alandia Pantoja 59 *Bolivian Medicine*, 1957. The Workers' Hospital mural, La Paz
Amelia Peláez 30 *Still Life* 1942. Oil on canvas, 75.7 × 72 (29¾ × 28¼). Photo Christie's, New York
Emilio Pettoruti 27 *Fruit Dish* 1947. Oil on canvas, 27 × 35 (10¾ × 19¾). Photo courtesy of CDS Gallery, New York
Cândido Portinari 52 *Economic Cycle*, 1937–47. Ministry of Education mural, Rio de Janeiro. Fresco. Photo by courtesy of Projeto Portinari, Pontifical Catholic University of Rio de Janeiro. 56 *Portrait of Paulo Osir* 1935. Oil on canvas, 55 × 46.2 (21¾ × 18¼). Museu de Arte Contemporânea da Universidade de São Paulo. 57 *Tile decoration*, 1944. Ceramics made by Paulo Osir. Church of San Francisco, Pampulha, Belo Horizonte. Photo by courtesy of Projeto Portinari, Pontifical Catholic University of Rio de Janeiro
José Guadalupe Posada 37 *Calavera catrina*. Engraving
Alfredo Prior 157 *Paradise* 1988. Acrylic on canvas, 200 × 194 (78¾ × 76¾). Photo Ruth Benzacar Galeria de Arte, Buenos Aires

220

Vicente do Rego Monteiro 25 *Deposition* 1924. Oil on canvas, 109 × 134 (42¾ × 52¾). Museu de Arte Contemporânea da Universidade de São Paulo
Armando Reverón 19 *Coco-palm* 1944. Oil on canvas, 50.3 × 58.3 (19¾ × 22¾). Collection, Galería de Arte Nacional, Caracas. Photo Petre Maxim. 20 *Five Figures* 1939. Oil and distemper on canvas, 163 × 228 (64¼ × 89¾). Collection Galería de Arte Nacional, Caracas. Photo Petre Maxim. 21 *Aviary, c.* 1940. Bamboo, feathers, wire, metal, paper, charcoal, gouache and pastel, 55.7 × 120 (21¾ × 47¼). Collection Museo Armando Reverón, Macuto. Photo Petre Maxim
Diego Rivera 32 *Sailor at Lunch* 1914. Oil on canvas, 114 × 70 (44¾ × 27½). Gobierno del Estado de Guanajuato, Museo Casa Diego Rivera, Guanajuato. Photo INBA. 33 *Creation*, from the Anfiteatro Bolívar mural, Escuela Nacional Preparatoria, Mexico City, 1922–3. Encaustic and gold leaf, 7m × 12.2m (23½ft × 40ft). 34 *The Offering*, from the Secretaría de Educación Pública murals, Mexico City, 1923–8. Fresco, 415 × 237 (163¾ × 93¾). 35 Self-portrait from the Secretaría de Educación Pública murals, Mexico City, 1923–8. Fresco. Photo Bob Schalkwijk. 36 *Crossing the Barranca*, from the Palacio de Cortés murals, Cuernavaca, Mexico, 1930–31. Fresco. Photo Bob Schalkwijk. 73 *Dream of a Sunday Afternoon in the Central Alameda* 1947–8 (detail). Fresco. Hotel del Prado, Mexico City. Photo Bob Schalkwijk
Ofelia Rodríguez 163 *Dying Landscape in Midair* 1989. Acrylic, sewing and collage, 170 × 210 (67 × 82¾). Private collection. Photo courtesy of the artist
Julio Ruelas 11 *The Initiation of Don Jesús Lujan into the 'Revista Moderna'* 1904. Oil on canvas, 30 × 50.5 (11¾ × 20). Private collection
Antonio Ruiz 77 *The Dream of Malinche* 1939. Oil on wood, 29.5 × 40 (11¾ × 15¾). Collection Mariana Perez Amor. Photo Galleria de Arte Mexicano, Mexico City. 78 *The Bicycle Race, Texcoco* 1938. Oil on canvas, 36.8 × 41.9 (14½ × 16½). Philadelphia Museum of Art. Purchased Nebinger fund
Lázaro Saavedra 167 Untitled installation, 1989. Photo courtesy of Ludwig Forum für Internationale Kunst, Aachen
José Sabogal 60 *Young Girl from Ayacucho* 1937. Oil on wood, 76.2 × 76.2 (30 × 30). Extended loan to the Museum of Modern Art, New York
Doris Salcedo 173 *Untitled* 1995. Wood, cement, cloth and steel, 196.9 × 120 × 188 (77½ × 47¼ × 74). Collection of the Hirshhorn Museum and Sculpture Garden, Washington, D.C. Courtesy of Alexander and Bonin Gallery, New York
Andrés de Santa María 9 *The Annunciation* 1934. Oil on canvas, 133.5 × 173.5 (52½ × 68¾). Collection, Museo Nacional de Bogotá. Photo Julio Cesar Florez
Lazar Segall 5 *Profile of Zulmira* 1928. Oil on canvas, 62.5 × 54 (24¾ × 21¼). Museu de Arte Contemporânea da Universidade de São Paulo
David Alfaro Siqueiros 43 *Head of an Indian Woman* 1931. Oil on canvas, 34.5 × 42 (21½ × 16½). Private collection, Mexico City. Photo INBA. 44 *Untitled* 1947. Acrylic on composite board, 81.2 × 92.7 (32 × 36½). Photo Christie's, New York. 45 *Portrait of the Bourgeoisie*, from the Electricians' Union murals, Mexico City, 1936–7. Pyrolixin on cement. Photo INBA. 46 *The March of Humanity*, mural on the Polyforum Cultural Siqueiros, Mexico City, 1964. Painted metal relief on asbestos and metal sheets. Photo Mexican Government Tourism Office
Mario Sironi 7 *Multiplication, c.* 1941. Oil on canvas, 56.2 × 80 (22¼ × 31½). Collection, The Museum of Modern Art, New York. Gift of Eric Estorick

Jesús Rafael Soto 101 *Mural Signals* 1965. Various materials, 190 × 620 × 200 (74¾ × 244 × 78¾). Collection of the Museo de Arte Contemporaneo de Caracas Sofia Imber
Fernando de Szyszlo 115 *Abolition of Death* 1987. Acrylic on canvas, 200 × 180 (78¾ × 70¾). Latin American Arts Association, London
Enrique Tábara 117 *Superstition* 1963. Oil on canvas, 132 × 132 (52 × 52). Art Museum of the Americas, OAS, Washington, D.C.
Rufino Tamayo 86 *Watermelons* 1941. Oil on canvas, 43 × 56 (17 × 22). Marlborough Gallery Inc, New York. 87 *Women of Tehuantepec* 1939. Oil on canvas, 86 × 145 (33¾ × 57½). Albright-Knox Art Gallery, Buffalo
Francisco Toledo 149 *The Lazy Dog* 1972. Oil and sand on canvas, 66.7 × 84.8 (26¼ × 33¾). Courtesy of Mary-Anne Martin/Fine Art, New York
Rubén Ortiz Torres 174 *California Taco, Santa Barbara, California* 1995. Chromogenic photograph on Fujiflex Crystal Archive, edition of twenty, 50.8 × 61 (20 × 24). Courtesy of Jan Kesner Gallery, Los Angeles
Joaquín Torres-García 4 *Abstract Forms* 1929. Oil on canvas, 61 × 50 (24 × 19¾). Museo Nacional de Artes Visuales, Montevideo. 61 *Constructivist Painting* 1932. Oil on canvas, 56 × 39 (22 × 15½). Museo Nacional de Artes Visuales, Montevideo. 62 A set of wooden toys, 1928–9. Painted wood, 11 h. (4¼). Photo Christie's, New York. 63 *Cosmic Monument* 1939. Granite, 300 × 560 × 45 (118¾ × 220¾ × 17¾). Parque Rodó, Montevideo. Photo Museo Nacional de Artes Visuales, Montevideo
Tilsa Tsuchiya 143 *Moment in Red*. Photo Camino Brent Gallery, Lima
Tunga 171 *Lizart 5* 1989. Installation. Copper, steel, iron and magnets. Museum of Contemporary Art, Chicago
Remedios Varo 79 *Magic Flight* 1956. Oil on masonite with mother of pearl, 86 × 105 (33¾ × 41¾). Photo Christie's, New York. 80 *The Encounter* 1962. Oil on canvas, 64 × 44.5 (25¼ × 17½). Photo Christie's, New York
Jorge de la Vega 121 *And Even in the Office*, from the *Anamorphosis* series, 1965. Oil and collage on canvas, 130 × 202 (51¼ × 79½). Jorge and Marion Heltt Collection, Buenos Aires. Photo Casenave
José María Velasco 8 *The Hacienda of Chimalpa* 1893. Oil on canvas, 104 × 159 (41 × 62½). Museo Nacional de Arte, Mexico City. Photo INBA
Germán Venegas 153 Untitled, 1990. Wooden sculpture and mixed media, 244 × 251 × 28 (96 × 98¾ × 11). Courtesy of Galeria OMR, Mexico City. Photo Ricardo Vidargas, New York
Miguel Angel Vidal 97 *Reversible Topological Module with Concave and Convex Space* 1974. Acrylic and aluminium, 64 × 64 × 6 (25¼ × 25¼ × 2¼). Artist's collection
Manuel Vilar 2 *The Tlaxcotlán General Tlahuitcole doing Battle at the Gladiator's Stone of Sacrifice* 1851. Plaster. Museo Nacional de Arte, Mexico City
Eduardo Ramírez Villamizar 105 *Temple I* 1988. Steel. Artist's collection. Photo Julio Cesar Florez
Carlos Raúl Villanueva 98 The Great Hall, University City, Caracas, 1954. Photo Paolo Gasparini, courtesy of the Galería de Arte Nacional, Caracas
Alejandro Xul Solar 29 *Honourable Chief* 1923. Watercolour on cardboard, 28 × 26 (11 × 10¼). Jorge and Marion Heltt Collection, Buenos Aires. Photo Casenave
Nahum B. Zenil 151 *Bloodiest Heart* 1990. Mixed media on paper, 52 × 40 (20¾ × 15¾). Courtesy of Mary-Anne Martin/Fine Art, New York

Index

Italic numerals refer to plate numbers.